LEGENDARY
—— OF ——

ST. JOSEPH AND BENTON HARBOR
MICHIGAN

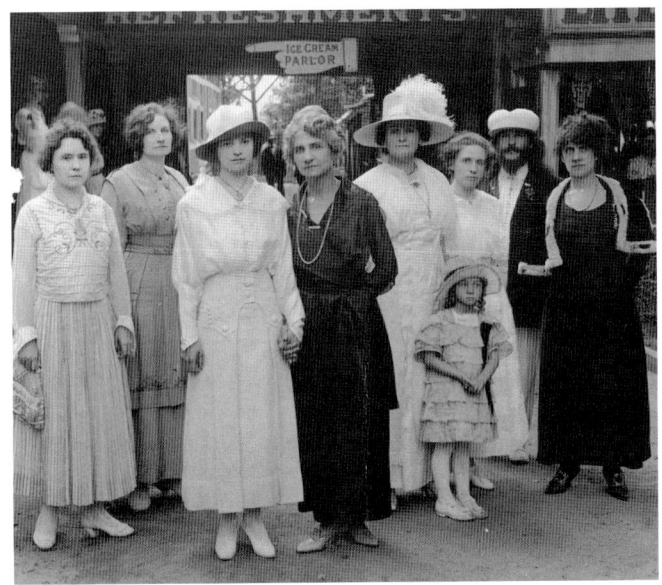

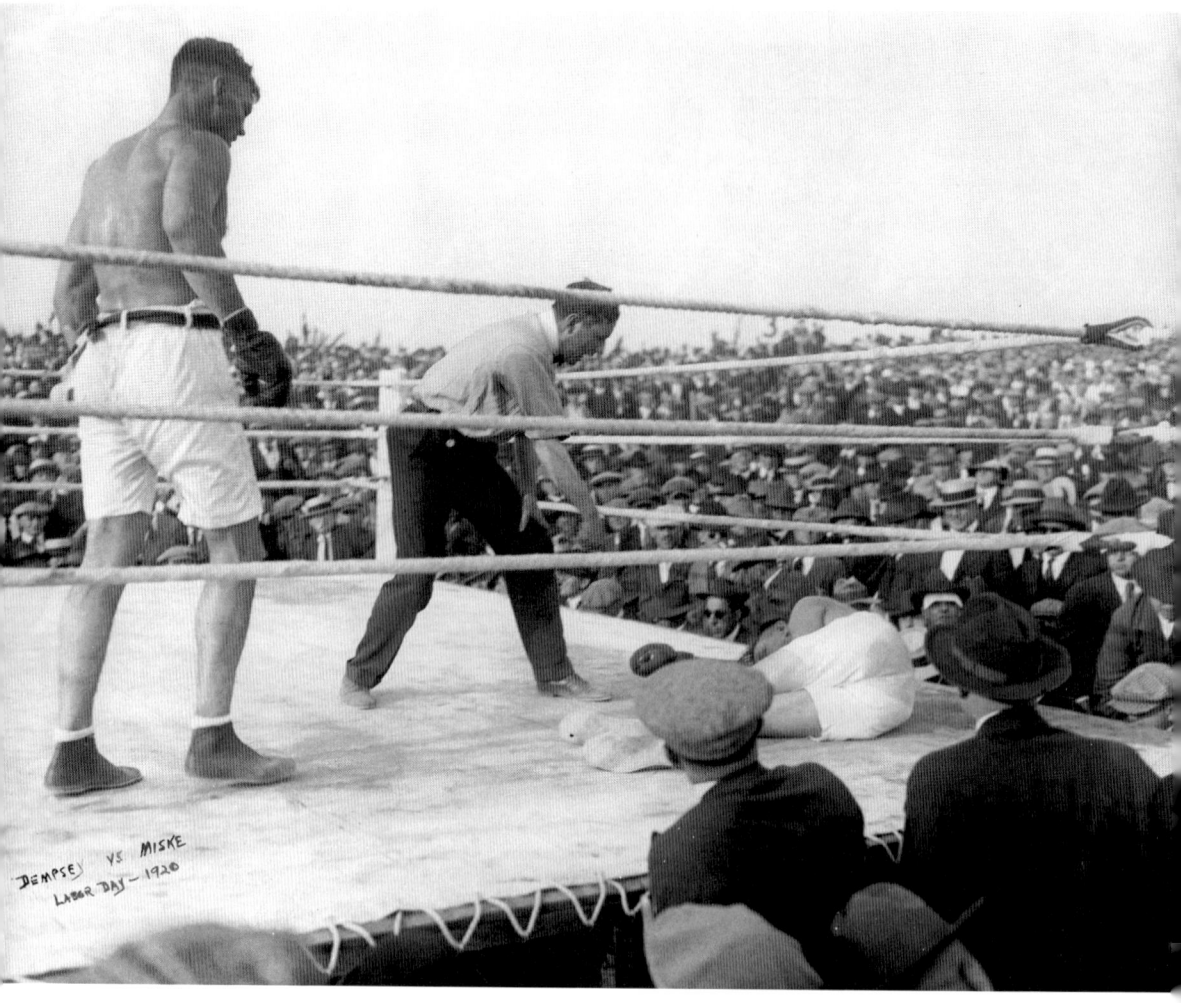

Jack Dempsey
The first boxing match to be broadcast on radio happened in Benton Harbor on Labor Day 1920. Jack Dempsey fought Billy Miske for the heavyweight championship. Dempsey won in the third round, retaining his title. According to Floyd Fitzsimmons, a local promoter, the event brought 11,346 people to Benton Harbor. For more information, see pages 82 and 83. (Courtesy of The Heritage Museum and Cultural Center.)

Page 1: Benjamin and Mary Purnell
Benjamin Purnell, the man with the cap, and his wife Mary, the woman wearing the feathered hat, founded the Israelite House of David and settled in Benton Harbor. During most of the 20th century, the Israelites played a crucial role in the cultural and economic development of St. Joseph and Benton Harbor. (Courtesy of The Heritage Museum and Cultural Center.)

LEGENDARY LOCALS
— OF —

ST. JOSEPH AND BENTON HARBOR
MICHIGAN

ELAINE COTSIRILOS THOMOPOULOS, PhD

Copyright © 2017 by Elaine Cotsirilos Thomopoulos, PhD
ISBN 978-1-4671-2516-1

Legendary Locals is an imprint of Arcadia Publishing
Charleston, South Carolina

Printed in the United States of America

Library of Congress Control Number: 2016952163

For all general information, please contact Arcadia Publishing:
Telephone 843-853-2070
Fax 843-853-0044
E-mail sales@arcadiapublishing.com
For customer service and orders:
Toll-Free 1-888-313-2665

Visit us on the Internet at www.arcadiapublishing.com

Dedication

To the forward-thinking board members, staff, volunteers, and donors of the The Heritage Museum and Cultural Center. Without them, this book would not have been possible.

On the Front Cover: Clockwise from top left:
Brothers to the End Motorcycle Group, motorcycle enthusiasts who are entrepreneurs and/or pastors (Photograph by Marvin Raglon; see page 119), Augustus Herring, aviation pioneer (Courtesy of The Heritage Museum and Cultural Center; see page 40), Ferdinand Ollhoff, lighthouse keeper (Courtesy of The Heritage Museum and Cultural Center; see page 108), Princella Tobias, publisher of *Benton-Michiana Spirit* (Photograph by author; see page 91), Chuck Nelson, director emeritus of Sarett Nature Center (Photograph by author; see page 79), Benjamin Purnell, founder of the House of David (Courtesy of Mary's City of David; see page 62), Connie Yore, proprietor of Days of Yore (Courtesy of Connie Yore; see page 58), Edgar Aber (on left), mayor and industrialist (Courtesy of The Heritage Museum and Cultural Center; see page 17), John Tucker, House of David baseball player (Courtesy of Mary's City of David; see page 73).

On the Back Cover: From left to right:
"Popcorn John" Moutsatson (Courtesy of Jeanne Govatos Wittmann; see page 55), Diana Koehler and Robin Allen, manager and owner of Forever Books (Photograph by author; see page 55).

CONTENTS

Acknowledgments 6

Introduction 7

CHAPTER ONE Courageous Explorers, Settlers, and Pioneers 9

CHAPTER TWO Inspiring Spiritual, Educational, and Civic Leaders 19

CHAPTER THREE Inventors, Industrialists, and Entrepreneurs 39

CHAPTER FOUR Unforgettable Members of the House of David 61

CHAPTER FIVE Talented Titans of Sports and Recreation 75

CHAPTER SIX Creative Artists and Literary Geniuses 87

CHAPTER SEVEN Unsung Heroes and Notorious Criminals 105

Bibliography 125

Index 126

ACKNOWLEDGMENTS

This book would have been impossible without The Heritage Museum and Cultural Center (HMCC) in St. Joseph. Nearly 40 percent of the photographs come from their excellent collection. Through their extensive archives and library, I discovered the fascinating stories of those who contributed to the development of St. Joseph and Benton Harbor. Thanks are owed to the hardworking, friendly, and knowledgeable staff and interns who have made the HMCC a treasure trove and who helped me so much! They have included Christine Arseneau, Caitlyn Perry Dial, Tracy Gierada, Claire Herhold, Molly Kruck, David Kohrman, Jennifer Richmond, and Amy Zapal. Also important are the HMCC members and volunteers who demonstrate their commitment to preserving community history.

Ralph Rumpf, a technical whiz who volunteers at the St. Joseph/Lincoln Township Senior Center, helped make the book a reality by boosting my computer skills. Richard Laurick and photographer Butch Welch also assisted me. A thank-you goes to executive director Shirley Reichert, who keeps the center humming; she made it an inviting place to work on my book and renew my energy by line dancing or practicing Tai Chi.

I commend the wise, wonderful people at Arcadia Publishing, Lily Watkins, Erin Vosgien, Caitrin Cunningham, and David Mandel, who offered invaluable assistance and support.

Caring and astute members of the following writers' groups helped me tremendously: the Day Writers' Group at the Box Factory for the Arts, led by Isabel Jackson; the Writers' Bloc Group at St. Paul's Episcopal Church in St. Joseph, led by Marnie Heyn; the writers' group at the Bridgman Library, led by Richard Blake; the writers' group at the Lincoln Township Library in Stevensville; and the writers' group at the Westmont Public Library in Westmont, Illinois.

Libraries and librarians assisting me include Benton Harbor Public Library (Jill Rauh and Geraldine Knox), Bridgman Public Library (Denise Malevitis, Kay O'Brien, and computer expert Ted Theisen), St. Joseph Public Library (Claire Gillespie), and Lincoln Township Library. Thanks also go to Silver Beach Carousel Museum, House of David, Mary's City of David, Berrien County Historical Association, and Professional Wrestling Hall of Fame.

I am grateful for those who told me stories, sent me photographs, and edited the book. They include Lesli Clarke, Pauline Couvelis, Diane DeFrance, Michael Eliasohn, Jim Faklis, Randy Fish, Dolores Frantz, Janet Frazier, Carolyn Graves, Beth Haire-Lewis, Bill Hanley, Robert Hatch, Richard Hensel, Michael Hoyh, Chuck Jaeger, Jim Jeschke, Barbara Johns, Barbara Johnson, Elowyn Ann Keech, David Knight, Gloria Koch, Donald Koch, Mollie Kruck, Willie Lark, Sylvia Lieberg, Harris Lindenfeld, Chriss Lyon, Michelle Rose Marcus, Robert Myers, Joan Nozicka, Anne Odden, Marvin Raglon, Daniel Schlender, David Schwarz, Jeanne Shuler, Marie Sussman, Ron Taylor, Perla Tolentino, Helen Willmeng, Jeanne Govatos Wittmann, Ken Wood, Connie Yore, and B.A. Ziebart.

My greatest supporter has been my husband, Nick, my closest friend for more than 50 years. I thank him with all my heart for encouraging me not only during the writing of this book but also throughout my life's journey.

INTRODUCTION

Two jewels, the Twin Cities of St. Joseph and Benton Harbor, developed side-by-side on the shores of Lake Michigan, spurred on by courageous settlers from the East who produced beautiful fruit from the rugged landscape and built the foundation of the cities. Eleazar and Joanna Morton ventured from New York to start a new life in the wilderness of forests and marshes. The house they built in Benton Harbor in 1849 is now a museum. Sterne Brunson arrived on the site of Benton Harbor in 1859. Along with Charles Hull and Henry Morton, Eleazar and Joanna's son, he organized the building of a canal. The canal enabled the growth of the town, originally called Brunson Harbor, into an important commercial center. In 1864, the town's name was changed to Benton Harbor, after Thomas Hart Benton, a Missouri senator who helped Michigan achieve statehood. Benton Harbor was incorporated as a village in 1866 and became a city in 1891.

Henry Morton's son James Stanley Morton, together with John Graham, started operating a fleet of steamships that transported not only produce from the "Fruit Belt" to Chicago but also tens of thousands of summer visitors from the polluted streets of Chicago to the pure beaches and invigorating mineral baths of the Twin Cities.

"The Father of St. Joseph," Calvin Britain, platted out lots and named the area Newberryport. The name was soon changed to St. Joseph. It was incorporated as a village in 1834 and became a city in 1891.

The cities spawned inventors and industrialists. In 1898, five years before the Wright brothers, aviation's forgotten pioneer Augustus Herring flew a motor-driven glider off the beach in St. Joseph. His plane lacked mechanical controls, unlike the one flown by the Wright brothers. More successful inventors manufactured products sold worldwide. They included an electric washing machine produced by brothers Louis and Frederick Upton and their uncle Emory (the company they started is known as Whirlpool); a perforator machine, invented by F.P. Rosback, used for checks and stamps in all corners of the world; and a record-changing machine invented by Walter Miller and produced by V-M.

Howard Anthony, owner of Heathkit, received a large supply of spare parts after World War II, with which he produced a kit that contained the parts and directions for an oscilloscope. His company then started building a wide variety of electronic kits, including those for radio and stereo.

For much of the 20th century, the Israelite House of David, a Christian commune, played an important role in the cultural and economic development of the area. In 1903, founders Benjamin and Mary Purnell and five followers arrived in Benton Harbor. By 1916, they had 1,000 members. The House of David became a national sensation because of their traveling jazz bands and baseball teams. Hordes flocked to their amusement park, where children delighted in riding on the miniature train or in the little cars they steered themselves. Adults relaxed in the beer garden built by the long-haired, bearded, teetotaling members of the Christian commune. Jazz bands, orchestras, singers, and vaudeville shows drew thousands. The House of David became a stalwart of the community. Their verdant farms contributed to making the Benton Harbor Fruit Market the largest non-citrus fruit market in the nation. Their art factory produced glistening pieces of sculpture coveted as souvenirs. The Israelites established restaurants, a car dealership, and a motel and nightclub in nearby Stevensville. Despite legal troubles in the late 1920s and a split of the colony into two separate entities in 1930, the Israelites did well into the 1960s. But by the 1970s, their membership had decreased, partly because of their vow of celibacy. They had run out of steam, as did the whole economy of the Twin Cities.

Many of the industries did not survive the downturn of manufacturing that occurred in the Rust Belt in the 1970s and 1980s. Both cities, but especially Benton Harbor, were affected. Today, they are regaining their groove. Benton Harbor boasts a new hotel and golf course. Art galleries, museums, restaurants, stores, and a thriving tourist business have replaced the industrial base.

Artists, musicians, and literary giants have played an important role in the Twin Cities. Poet Ben King belonged to the Whitechapel Club, a group of Chicago newspapermen and other prominent people who met in Chicago from 1889 to 1894. They named their club after the area where Jack the Ripper stalked young women and decorated their macabre meeting place with skulls, nooses, and knives. The nature poet and Northwestern University professor Lew Sarett, who sometimes appeared as an Indian or woodsman, was much in demand as a speaker throughout the nation. Handsome Monte Blue, a silent film star, lived in Benton Harbor, as did Ruth Terry, a movie star who appeared with Gene Autry and Roy Rogers. As a child, she won talent shows at Benton Harbor's Liberty Theatre. World-renowned jazz musician Gene Harris also got his start in Benton Harbor. As a young teen, Harris had his own local radio show.

Jazz trumpeter Ed Bagatini operates a St. Joseph music store and wows audiences with the music created by his ensembles. For decades, John Howard, director of the St. Joseph High School Band and the St. Joseph Municipal Band, inspired other musicians.

Present-day artists have jump-started the Twin Cities' return to vitality. They include sculptor Richard Hunt, who opened up a satellite studio in the decaying downtown of Benton Harbor, and talented glass artist Jerry Catania, who, with his wife, Kathy, renovated a dilapidated building that had been vacant for decades. It became Water Street Glassworks, which offers arts programs such as Fired Up!, which offers scholarships for teens. Painter Anna Russo-Sieber, director of ARS Gallery, and other faculty motivate youth through the "I Am the Greatest" Workshop, which is based on the life of Muhammad Ali. Robert Williams, award-winning portrait painter, put his efforts into the development of the Box Factory for the Arts in St. Joseph. With inspiring and generous individuals like these, the Twin Cities continue to blossom.

CHAPTER ONE

Courageous Explorers, Settlers, and Pioneers

Southwestern Michigan had been the home of Native Americans, including the Paleo-Indians, the Miami, and Potawatomi, for many centuries. One of the first Europeans to explore this area of wilderness was René-Robert Cavelier de La Salle. In 1679, this daring adventurer came from France to claim land for his king, as well as gain riches for himself through trading. He and his men built a fort close to the mouth of the St. Joseph River, where it flows into Lake Michigan. Nothing of the fort remains today.

It was not until nearly 200 years later that the wilderness La Salle encountered was tamed. Beginning in the 1830s, courageous settlers from the East struggled to make a new life for themselves, building log cabins and clearing the trees for farming. They suffered from diseases, like ague (reoccurring malarial fever), that are unknown today. These hardy pioneers built the foundation and heart and soul of St. Joseph and Benton Harbor.

Benton Harbor was first established as Brunson Harbor, named after the man who was one of the first settlers, Sterne Brunson. By the time it became a village in 1866, the name had been changed to Benton Harbor. It became a city in 1891, then the largest in Berrien County.

The city now known as St. Joseph also started with a different name, Newberryport. Platted by Calvin Britain, it became a village in 1834 and a city in 1891. By the 1880s, Junius Hatch, along with Calvin Britain and Lucius Lyon, gifted acreage overlooking Lake Michigan that is now known as Lake Bluff Park.

The Morton family influenced the early development of St. Joseph and Benton Harbor. Eleazar and Joanna Morton arrived in 1836 and built a log cabin. In 1849, they built the home in Benton Harbor that is now the Morton House Museum. Morton's son Henry saw the potential of a canal, which would allow the fruit growers to more easily gain access to the steamships that transported their fruit. Henry Morton, along with Charles Hull and Sterne Brunson, built the canal, thus enabling Benton Harbor to blossom. Henry's son James Stanley Morton, along with John Henry Graham, established the Morton and Graham Transportation Company. Their steamships transported both produce and tourists, mainly from Chicago, and further contributed to the Twin Cities' development.

René-Robert Cavelier de La Salle

This inscription is from the monument commemorating René-Robert Cavelier de La Salle in St. Joseph's Lake Bluff Park. One of the first Europeans to explore Southwestern Michigan, La Salle risked his life in the wilds of America to claim land for France and to get rich through trading. The former Jesuit novitiate built the first ship to sail the Great Lakes, the *Griffin*. He had sent her crew to deliver furs and then rendezvous with him in present-day St. Joseph, Michigan. After the *Griffin* departed, La Salle and three friars, ten Frenchmen, and a Mohican hunter traveled in four large canoes along the treacherous coast off Lake Michigan to reach the mouth of the St. Joseph River (then called the River of the Miami after the Native Americans who lived in the area). They arrived on November 1, 1679. While they waited for the *Griffin*, his men erected Fort Miami, a 40-foot by 80-foot structure near the mouth of the river. The *Griffin* never arrived and was never again seen. La Salle ventured to the mouth of the Illinois River and back. He and his men then made a horrendous 65-day journey to Fort Frontenac, their base of operations in present-day Ontario, Canada. They waded through half-frozen marshes, and Indians pursued them. When La Salle reached Fort Frontenac, he faced losses of property and the desertion of most of his men. To make things worse, on his return to Fort Miami, nothing but the charred shell remained of the fort. Undaunted, he continued on his journey to Illinois. Five of his men remained to watch the supplies, and while he was gone, they rebuilt the fort and started building a ship. La Salle returned and then journeyed out once more to explore the area that is now Louisiana. He met an untimely death in Texas, in 1687, killed by one of his own men. Fort Miami lasted only a few years. None of the fort remains. For the next 150 years, only Native Americans, French voyageurs, trappers, soldiers, and adventurers came to this area. William Burnett, a trader from New Jersey, established a trading post sometime between 1775 and 1782. It included a warehouse near the mouth of the St. Joseph River and a log store and home less than two miles up the river. (Photograph by author.)

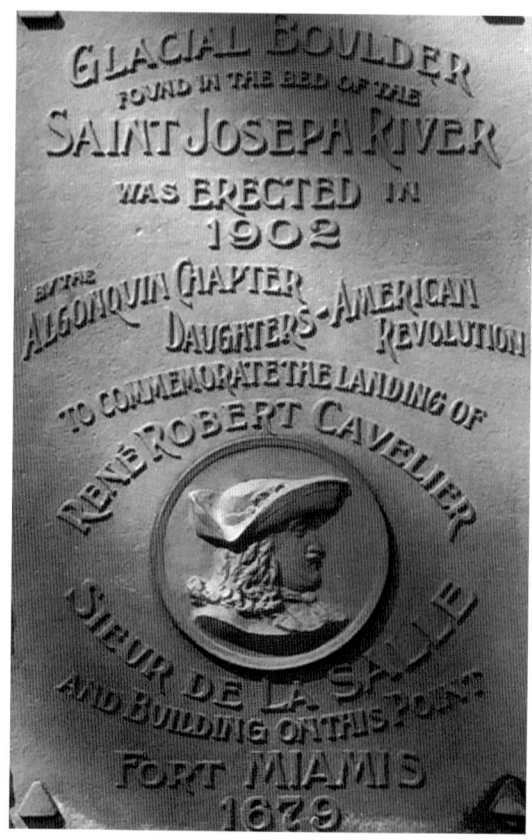

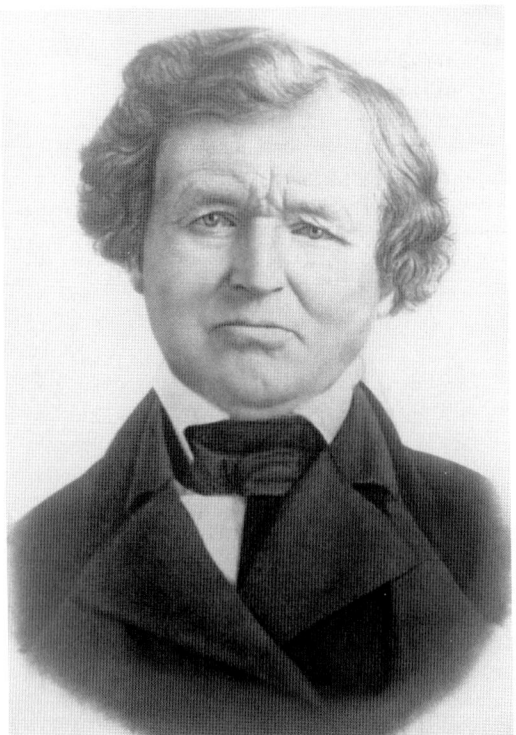 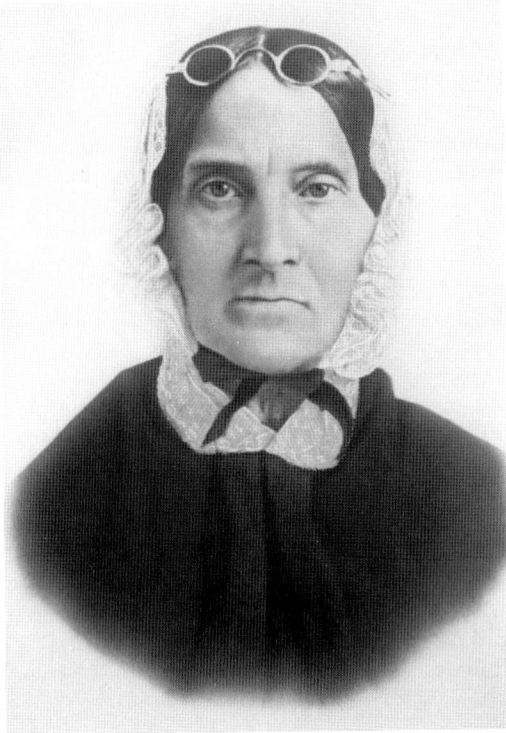

Eleazar and Joanna Morton
Eleazar and Joanna Morton settled in Benton Township in 1836, where he had purchased 160 acres. They had five sons and five daughters. Their first home, like that of other early pioneers, was a log cabin. In 1849, they built a house at 501 Territorial Road, now the Morton House Museum. According to Morton's grandson James Stanley Morton, as related in his book *Reminiscences of the Lower St. Joseph River Valley*, the Potawatomi Indians used to sleep on their porch when they came to the Twin Cities to sell their baskets. Morton and his son Henry planted orchards on the property and were pleased with the results of their labors. Morton not only farmed but also wrote for an agriculture magazine. He explained his philosophy of life in his book *A Key to True Happiness*. (Both, courtesy of HMCC).

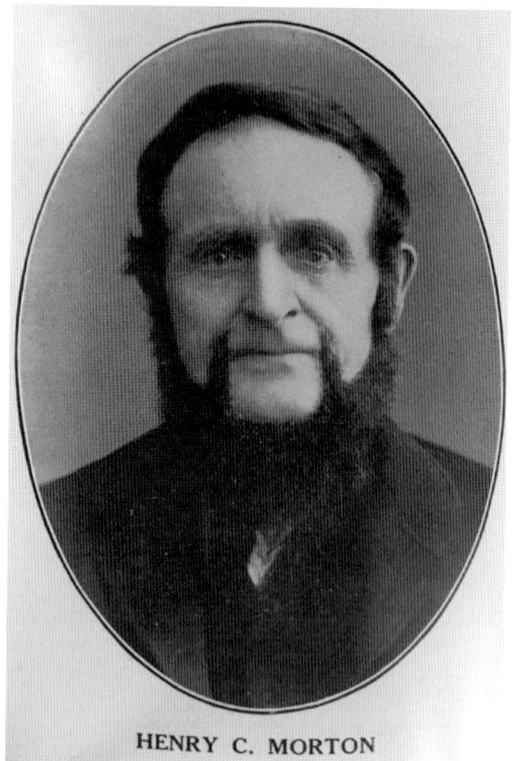

HENRY C. MORTON

Henry Morton
Henry Morton, Eleazar and Joanna Morton's son, realized that a canal connecting Benton Harbor (then called Brunson Harbor) with Lake Michigan would allow fruit growers to more easily get their product to market. In 1860, along with Sterne Brunson and Charles Hull, he pursued that goal. The canal, built by Martin Green, enabled Benton Harbor to become an important commercial center. (*Benton Harbor: The Metropolis of the Michigan Fruit Belt.*)

Sterne Brunson
Sterne Brunson arrived on the site of Benton Harbor in 1859. He, along with Henry Morton and Charles Hull, organized the building of a canal that spurred the growth of Benton Harbor, which was originally named Brunson Harbor after him. The town's name was changed to Benton Harbor in 1864 and was incorporated as a village in 1866. (*History of Berrien & Van Buren Counties, Michigan.*)

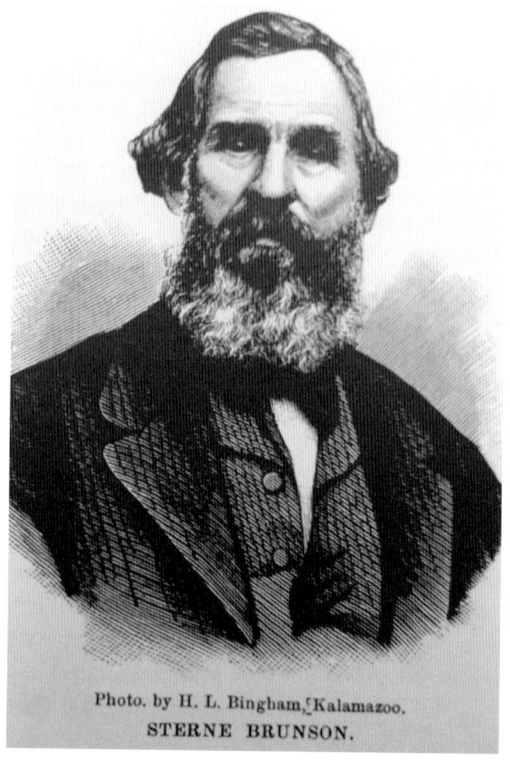

Photo. by H. L. Bingham, Kalamazoo.
STERNE BRUNSON.

Calvin Britain

Calvin Britain, described as a "tall, thin man with red hair," is called the Father of St. Joseph. In 1827, when he was 27, Britain came from New York to work at Carey Mission, near Niles. A couple of years later, he and Augustus Newell settled in present-day St. Joseph, near the mouth of the St. Joseph River. Seeing the possibility of the site, he platted out a village called Newberryport (seen below). Incorporated in 1834, it was later renamed St. Joseph. Britain began his political career by starting a movement to obtain statehood for Michigan. In 1835, he became a member of the first Michigan State Legislature and president of the village. In the 1850s, he served two terms as lieutenant governor. He, along with Lucius Lyon and Junius Hatch, donated land for Lake Bluff Park. (Both, courtesy of HMCC.)

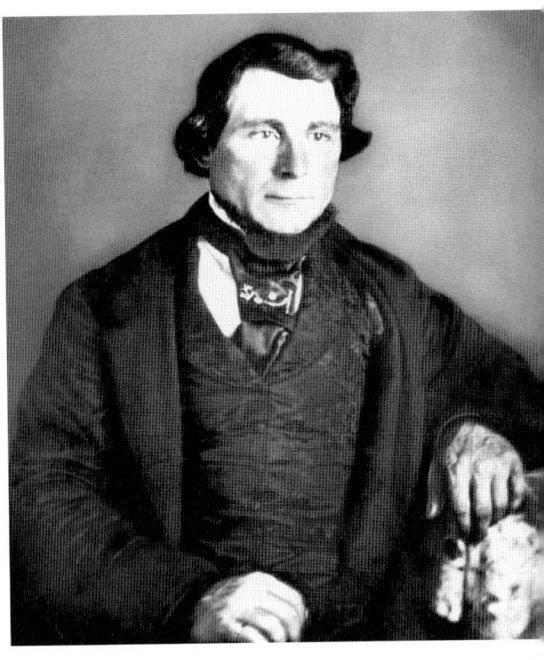

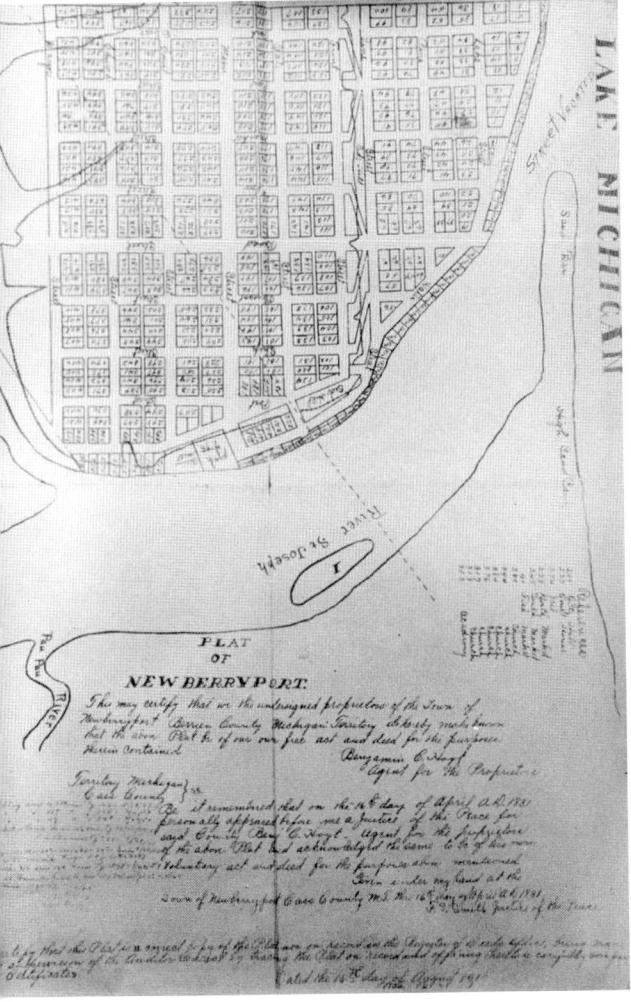

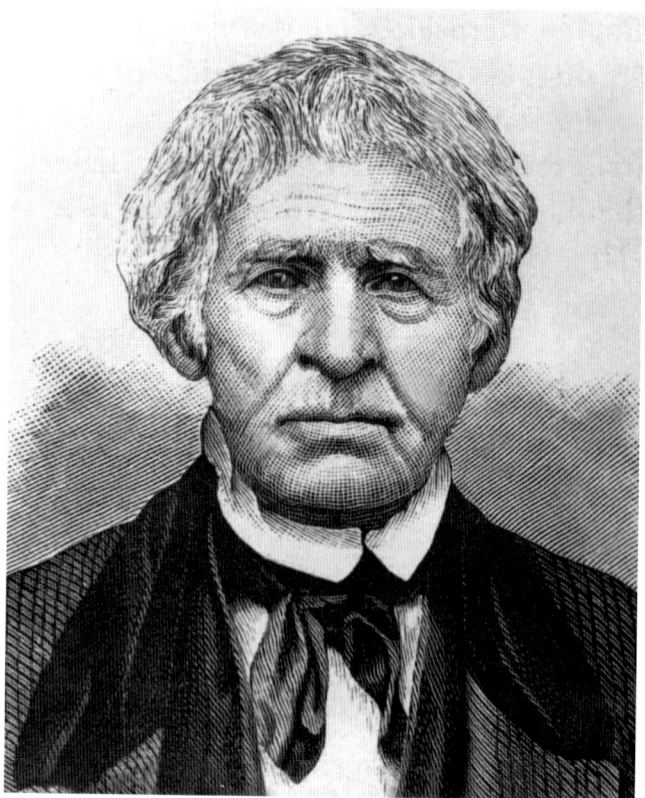

Phineas Pearl

Phineas Pearl's face shows the strength of character typical of the early Michigan pioneers. Born in Vermont in 1789, he married Fannie Hatch in 1813. They had three sons and two daughters. Around 1840, the family settled on a farm in Benton Township, joining other families in the area who came from the East. (Courtesy of HMCC.)

Junius Hatch

In 1834, Junius Hatch donated land to the village of Newberryport (later named St. Joseph) to be used for the "public common." That land, together with land donated by Calvin Britain and Lucius Lyon, became beautiful Lake Bluff Park. Hatch returned to Buffalo, New York. His sons Junius II, a lawyer, and Edward, head of St. Joe Iron Works, became dynamic leaders in St. Joseph. (Courtesy of HMCC.)

CHAPTER ONE: COURAGEOUS EXPLORERS, SETTLERS, AND PIONEERS

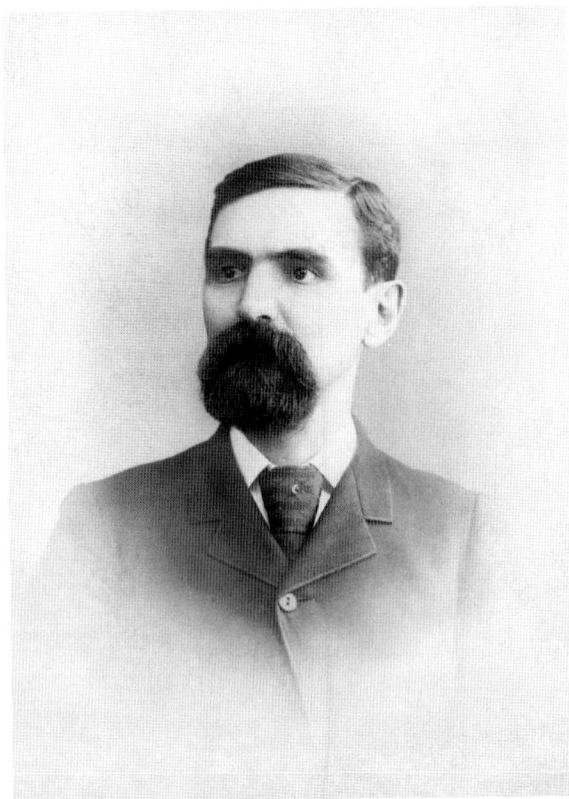

James Stanley Morton and John Henry Graham

James Stanley Morton, Henry Morton's son, together with John Henry Graham (seen below), furthered the growth of Benton Harbor. In 1873, 23-year-old Morton chartered the steamboat *Lake Breeze* and began to make regular trips across Lake Michigan between Benton Harbor and Chicago. In 1875, he partnered with Graham, as well as Andrew Crawford, to establish the Graham and Morton Transportation Company. By the turn of the century, the company had a thriving business. They transported thousands of excited tourists to the area each summer in their palatial steamers, as well as carried fruits and vegetables produced by the farms. Graham, prior to the steamship business, was in the lumber business along with Andrew Crawford. He was also president of the Alden Canning Company in St. Joseph and the St. Joseph Hotel Company. (Courtesy of HMCC.)

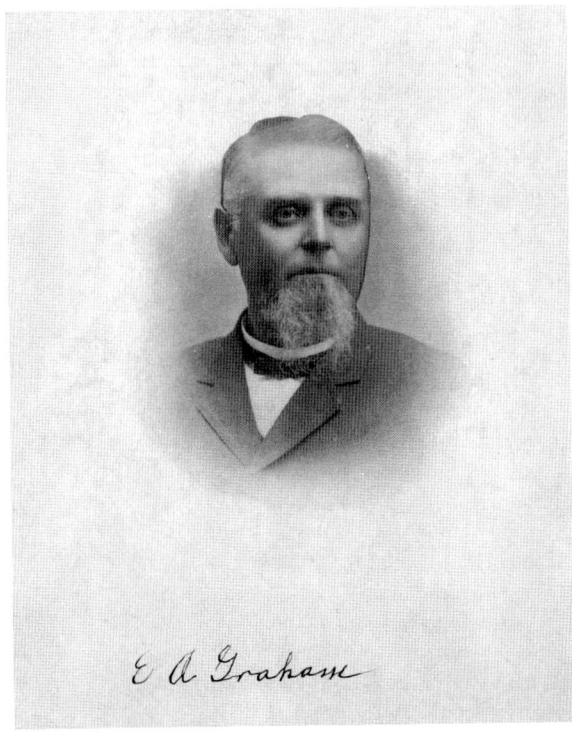

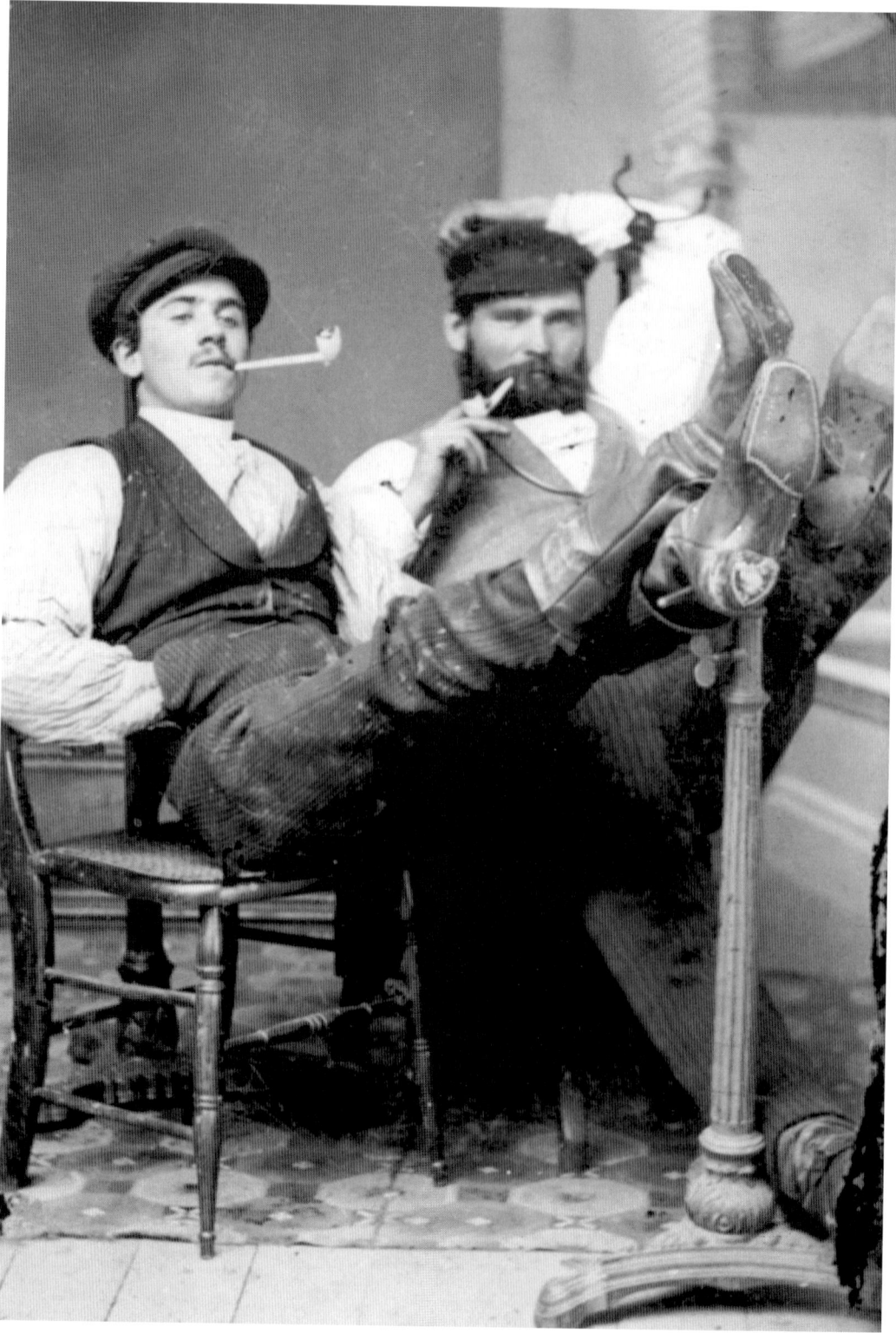

CHAPTER ONE: COURAGEOUS EXPLORERS, SETTLERS, AND PIONEERS

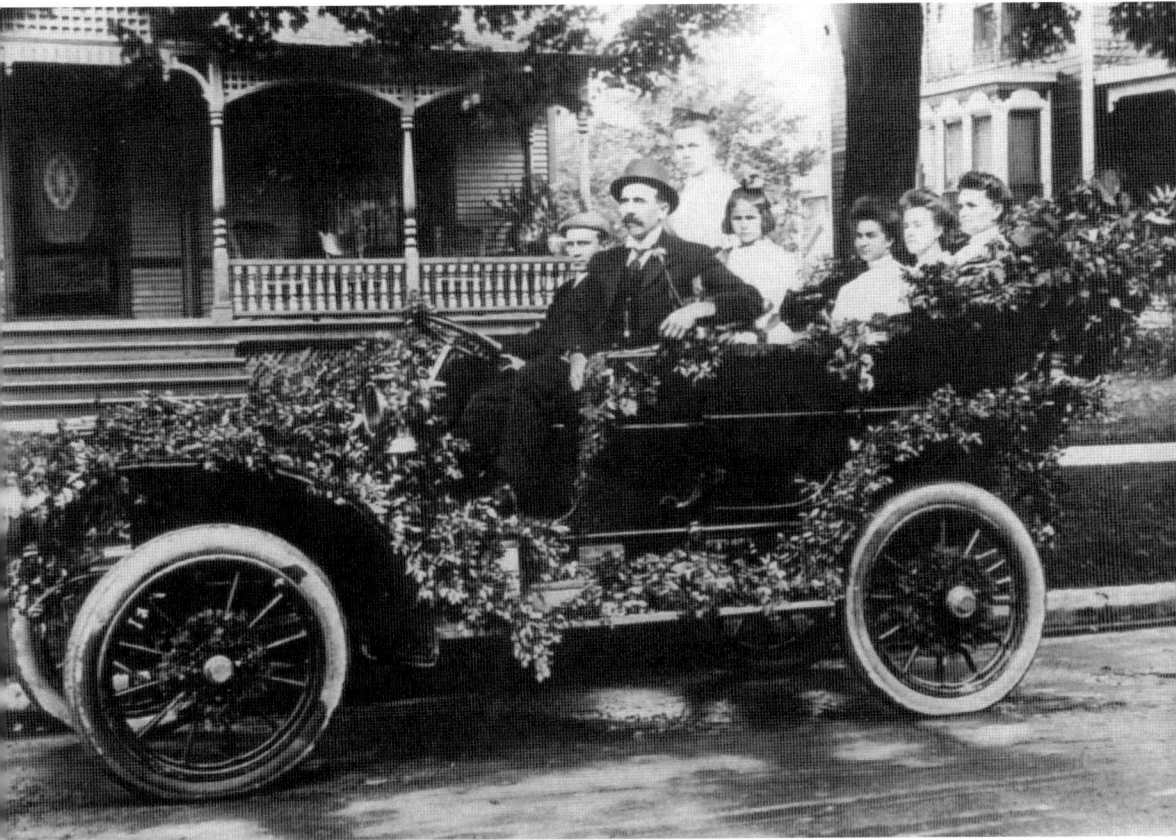

Edgar Aber

As a 16-year-old, Edgar Aber (at far left) worked as a lumberjack in the North Woods to support himself. He had been working since he was eight, when his older brothers left to fight in the Civil War, leaving him and his mother to fend for themselves. He and his wife, Susan Haberle, started their marriage in his hometown of Alpena, Michigan, where he manufactured furniture. During a smallpox epidemic, coffins made in an upstairs shop were run down a chute to wagons below; thus employees did not come in contact with infected people. The epidemic spurred him to move. He established a box manufacturing company in Texas. In 1904, after a business trip to St. Joseph, he decided to relocate his wife and nine children there. He established a manufacturing plant and hardware store in St. Joseph and was mayor of the city in 1907, 1908, and 1910. The photograph above shows him and his family in the 1913 Blossomtime Parade. (Both, courtesy of HMCC.)

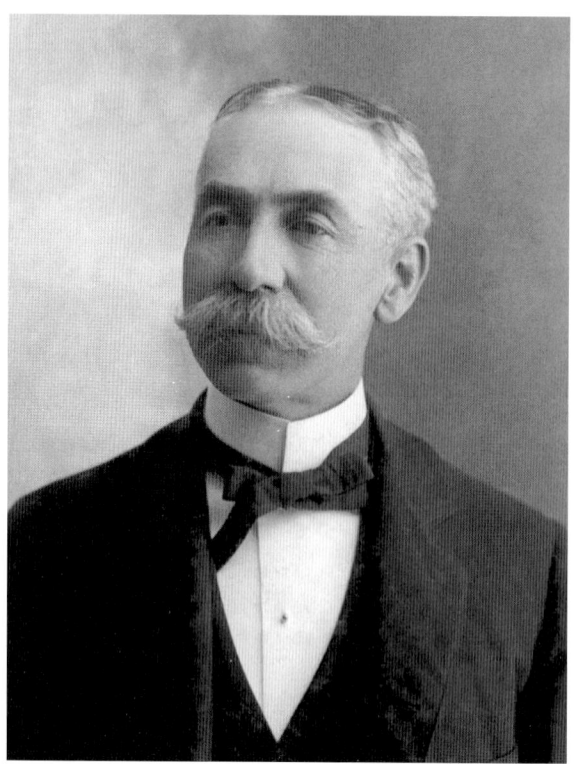

Col. William Worth Bean
Col. William Worth Bean, who came to the Twin Cities from Kentucky in 1889, brought the area into the modern age. In 1891, he helped found the Benton Harbor & St. Joseph Electric Light Company. The following year, he converted the streetcar system he had purchased from horsepower to electricity. (Courtesy of HMCC; photograph by F.C. Welsh.)

Patrick Yore
In 1888, Benton Harbor farmer Patrick Yore built the Yore Opera House in Benton Harbor to offer entertainment to the people of the Twin Cities, but his venture unfortunately ended in tragedy. In 1896, the opera house burned. The building's walls collapsed as firemen from St. Joseph and Benton Harbor battled the blaze. A total of 13 people died, and 12 of them were firemen. (Courtesy of Connie Yore.)

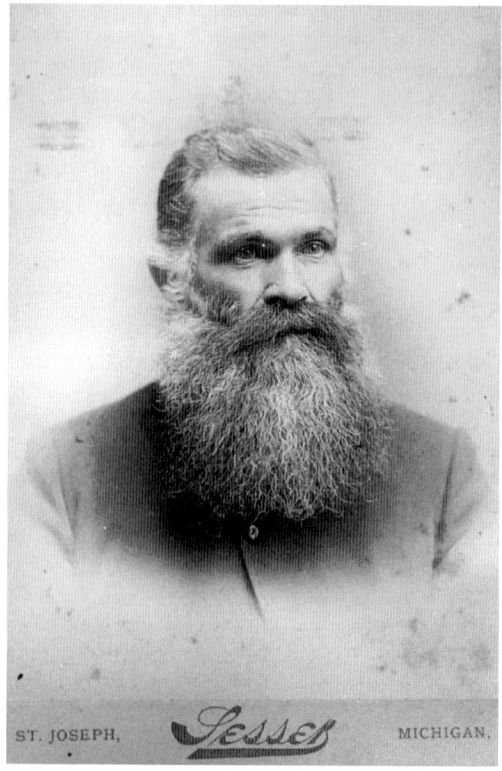

CHAPTER TWO

Inspiring Spiritual, Educational, and Civic Leaders

Leaders emerged to develop religious, educational, and community institutions that enhanced the quality of life. In the 1890s, Rev. James Gore had a dual responsibility, serving both St. Joseph Roman Catholic church in St. Joseph and St. John Mission Church in Benton Harbor. In the 1920s, the Rev. G.G. Bratzel arrived full of energy to become pastor of St. Peter's Evangelical and Reformed Church in St. Joseph. He breathed new life into the church by setting up an English-language Sunday school class, but that milestone was tempered by the warning that he should not take any students away from the German class.

The Very Rev. Christos Moulas and Rabbi Joseph Schwarz served their congregations with compassion. Both experienced horrors during World War II. Moulas, priest at Annunciation Greek Orthodox Church, had been wounded in battle in his native land during the war. He and his wife, Vasiliki, survived the Axis occupation and the Greek Civil War. He served the parish in Benton Harbor for 27 years, retiring in 1982.

Rabbi Schwarz left Germany in 1938 with his wife, Anneliese, to seek refuge in Manila, only to be confronted with the Japanese occupation of the Philippines from 1943 to 1945. In 1949, he was assigned as rabbi to Temple Beth El. He served Temple Beth El as rabbi until 1971 and then Temple B'nai Shalom as rabbi emeritus until 1980.

George Edgcumbe, who founded Benton Harbor College in 1886, and Theodosia Arnold, who was hired as the librarian at Benton Harbor Library in 1915, advanced the educational needs of the community. In 1923, Arnold complained that "the drunken bums and painted ladies" who frequented the park benches outside of the library disturbed the patrons. She served as librarian for 46 years.

John Klock not only educated the community through the *News-Palladium* but also helped them when he was mayor. After he had given up the newspaper to become an industrialist at Malleable Foundry, he said, "I felt lost. I was taken out of the whirl of life and planted on a shelf."

Physicians and lawyers played an important role in the advancement of the community. In 1898, Dr. Henry V. Tutton performed a lifesaving appendectomy on a kitchen table, the first such operation the short, slender, 29-year-old doctor had done. This served to motivate the community to realize the dream he had of building a hospital. Dr. Hattie Schwendener, one of the first female physicians in the area, led in organizing the Young Women's Christian Association (YWCA), and Dora Bella Whitney, who became a lawyer 14 years before women had suffrage, served on the library and school boards and presided over the Michigan Women's Christian Temperance Union.

Modern-day leaders include volunteers Richard Hensel, an active participant in building and creating the identity of the Benton Harbor Arts District, and Priscilla Upton Byrns, who guided the development of the Fort Miami Heritage Center, now known as The Heritage Museum and Cultural Center, in St. Joseph.

Rev. James Gore
From 1890 to 1899, Rev. James Gore served as priest of St. Joseph Catholic Church. During his pastorate, the parish grew and there was an addition of a chapel and spire. Besides serving the parishioners at St. Joseph, Reverend Gore also ministered to the people attending St. John Mission Church in Benton Harbor until 1895, when Fr. Dennis Mulcahy became the first resident priest there. (Courtesy of HMCC.)

Rev. Louis Nuechterlein
Rev. Louis Nuechterlein was the pastor of Trinity Lutheran Church in St. Joseph from 1911 to 1948. Shortly after his arrival, he introduced the English language by preaching a sermon in English every month. Soon, there were both German and English services each Sunday. During his tenure, attendance increased, the church school expanded, and in 1925, a new church was erected. (Portrait by Janet Frazier.)

Rev. G.G. Bratzel

"I look back to my pastorate at St. Peter's as the most strenuous in my ministry. I cannot forget it because the effects have remained with me until now. The District President, who recommended me to the field, informed me that the church would be closed within a year if I did not go there and energetically take over to bridge the crisis," said the Rev. G.G. Bratzel in a letter written in 1957 on the occasion of St. Peter's Evangelical and Reformed Church's 75th anniversary. He assumed the pastorate of St. Peter's Church in St. Joseph in 1925 and remained until 1929. During his ministry, the church membership grew dramatically. He writes that the church secretary, during the first Easter, had to stay until 1:00 p.m. to have all 110 members' signatures affixed to the roll book and that, in October of the same year, 60 more members were added. To spark new life into the church, he introduced an English-language Sunday school, although he had been warned not to take any pupils away from the German school—which he did not. When he reported that both classes had 110 members, it was decided to build two Sunday school rooms of equal size. In a letter, he wrote, "In reviewing the lesson at the close of the class period, my attention was called to the fact that I spoke one minute longer to the English Dept. than to the German, and I was to watch myself so as not to let it happen again. So there was tension from within and tension from without." Reverend Bratzel got so stressed that he went to his family physician, Dr. King, who informed him that there was no medicine available for his relief. Although the stress level for Bratzel was high, he did seem to accomplish what he was sent to do. He says, "Enthusiasm ran high in those days." The congregation seemed appreciative since they presented him with a Dodge sedan on his birthday. (Courtesy of HMCC.)

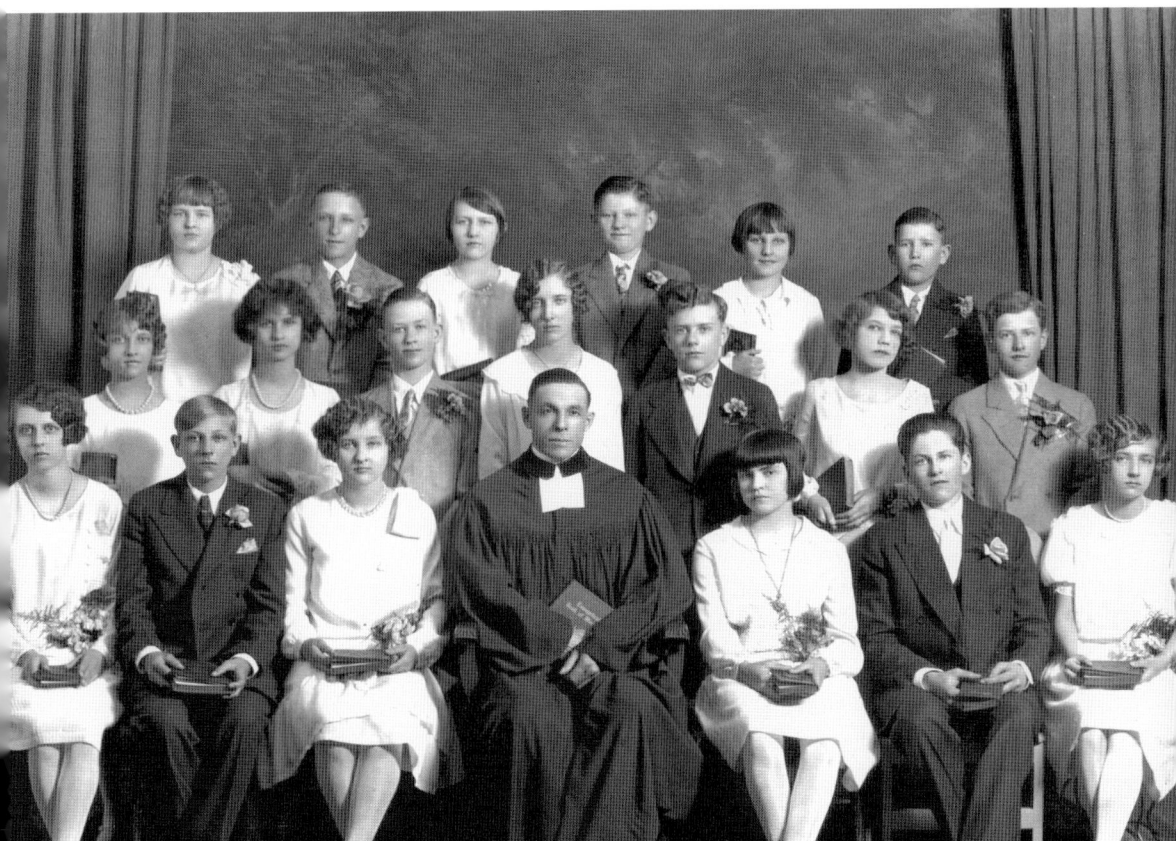

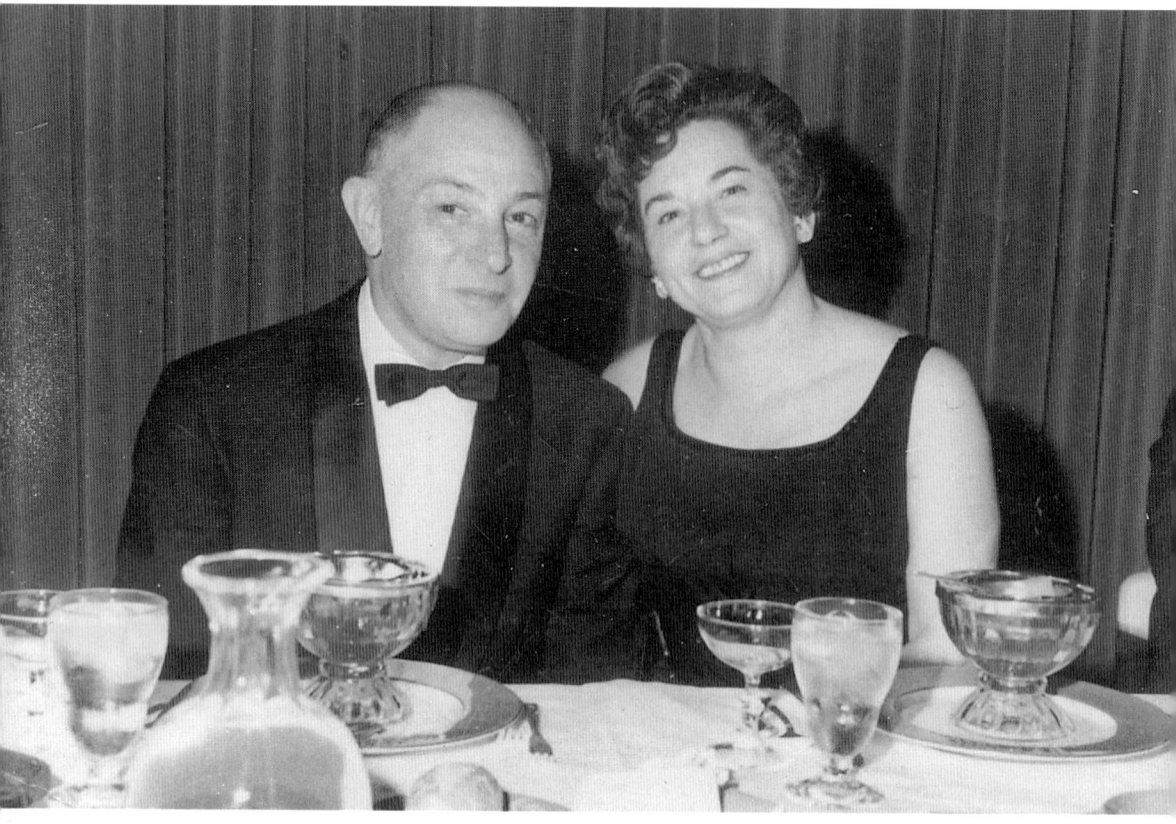

Rabbi Joseph Schwarz

Rabbi Joseph Schwarz, shown with his wife, Anneliese, in 1969, served the Reform congregation Temple Beth El in Benton Harbor from 1949 to 1971 and was rabbi emeritus at Temple B'nai Shalom until 1980. A native of Germany, he and his wife escaped to Manila in 1938, a few months prior to Kristallnacht, the four-day pogrom instigated by the Nazis against the Jews. His parents, who remained in Germany, died in a Nazi concentration camp. For 11 years, Rabbi Schwarz ministered to Manila's Jewish community. He experienced the Japanese takeover of the city in 1942 and witnessed the devastating destruction of the "Pearl of the Orient" by American bombs during the Battle of Manila in 1945. After the war, Rabbi Schwarz led the effort to set up several community houses to accommodate those unable to manage on their own. He also organized health services and began plans for rebuilding the synagogue, which had been destroyed by a fire set by Japanese naval troops. Since the economy of Manila was in ruins after the war, Rabbi Schwarz felt that his two young sons, Michael and David, would have a better future in the United States. The Jewish community regretted his departure. They especially admired him for his courage during the Japanese occupation from 1942 to 1945. When the Japanese authorities published an anti-Semitic article, he met with them to complain. As reported in the book *Escape to Manila*, at his farewell service, the president of the community said, "His personal diplomacy and his quiet but firm stand against threat won the status of 'third party aliens' for the more that 1,200 Jewish refugees from Germany and Austria, avoiding their internment." In 1949, Rabbi Schwarz was appointed rabbi of Temple Beth El in Benton Harbor. He not only helped those in his synagogue but also reached out to others. He became president of the Twin City Ministerial Association and the Twin City Area Interfaith Conference on Religion and Race. He was also a board member of the county mental health association and the drug treatment center. In 1971, Temple Beth El merged with Temple B'nai Sholom. The combined congregation became Temple B'nai Shalom, and he was appointed rabbi emeritus. He continued rabbinical duties until 1980. He, along with his wife, had served the community for 30 years. (Courtesy of David Schwarz.)

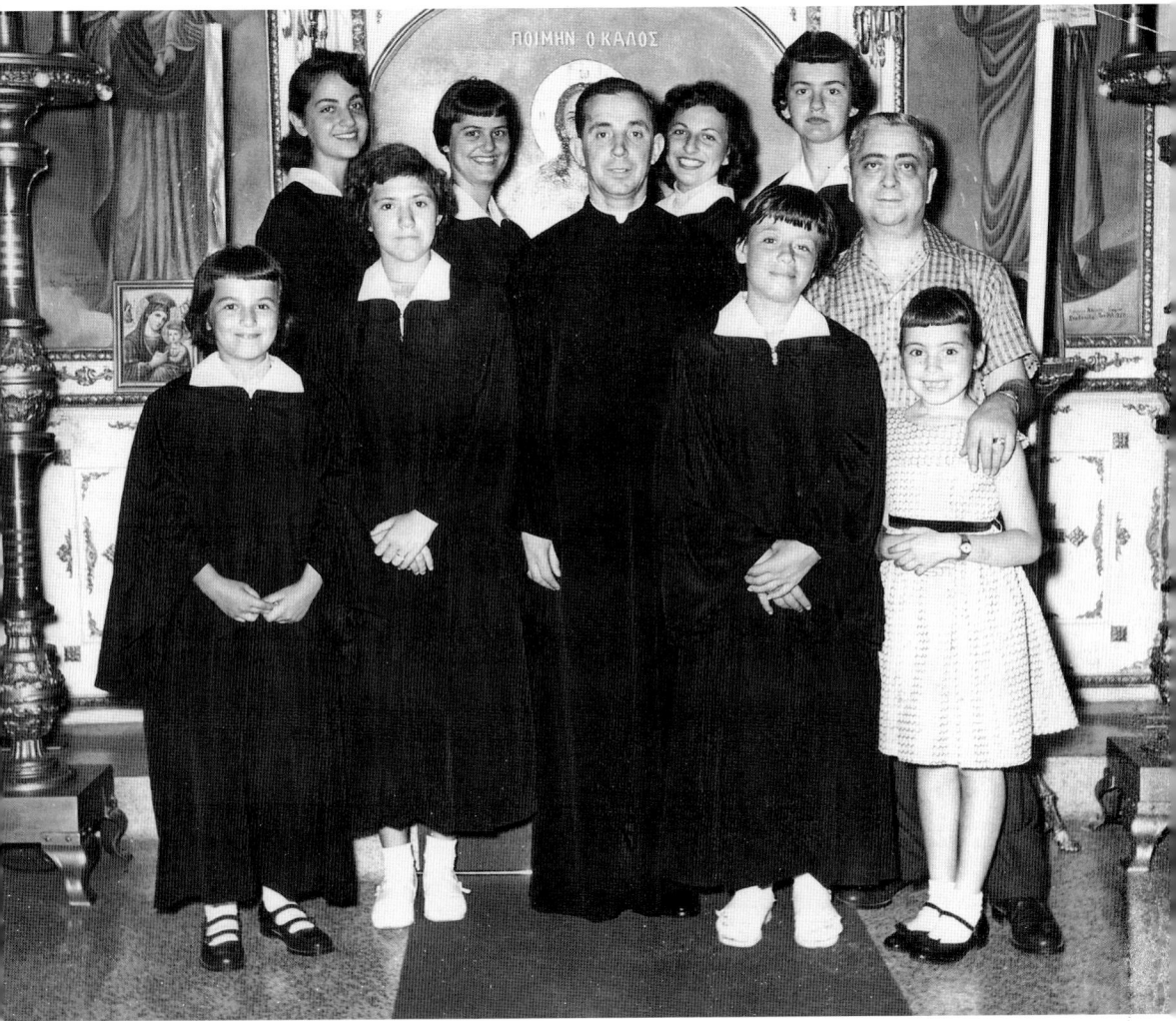

Very Rev. Christos Moulas
This c. 1955 photograph is of the Very Rev. Christos Moulas with the Annunciation Greek Orthodox Church choir. He served the church in Benton Harbor for 27 years, retiring in 1982. Soon after he arrived with his wife, Vasiliki, and three daughters, Evangeline, Patty, and Demetra, the headline of the *News-Palladium* announced, "New Minister Makes Greek Church Hum." A strong, dynamic leader, he organized a choir, Bible study, and Sunday school, and he taught Greek.

The Very Reverend Moulas, who was born in Greece, served as a captain in the Greek army and was wounded during World War II. He and his wife lived through the occupation of the Axis powers in Greece and the Greek Civil War prior to coming to the United States with their family in 1947. (Courtesy of Jeanne Govatos Wittmann.)

George Edgcumbe

George Edgcumbe, cofounder of Benton Harbor College, had a rough start in life. He immigrated from England to Canada with his family when he was six. He spent much of his childhood years as an invalid, confined to his bed. When he was 13, his father and two brothers were found frozen to death on Lake Ontario. Even before completing college, Edgcumbe began teaching in Canada. Years later, he earned his doctorate from Illinois Wesleyan University. Edgcumbe, who had worked as superintendent of Benton Harbor Public Schools, became head of Benton Harbor College, a preparatory and normal school, in 1886. Under his charge, the college thrived. In May 1887, it had 10 students; by 1894–1895, 476 students. After an accident in 1913, Edgcumbe retired. About two years after his death in 1917, the college died, too. (Both, courtesy of HMCC.)

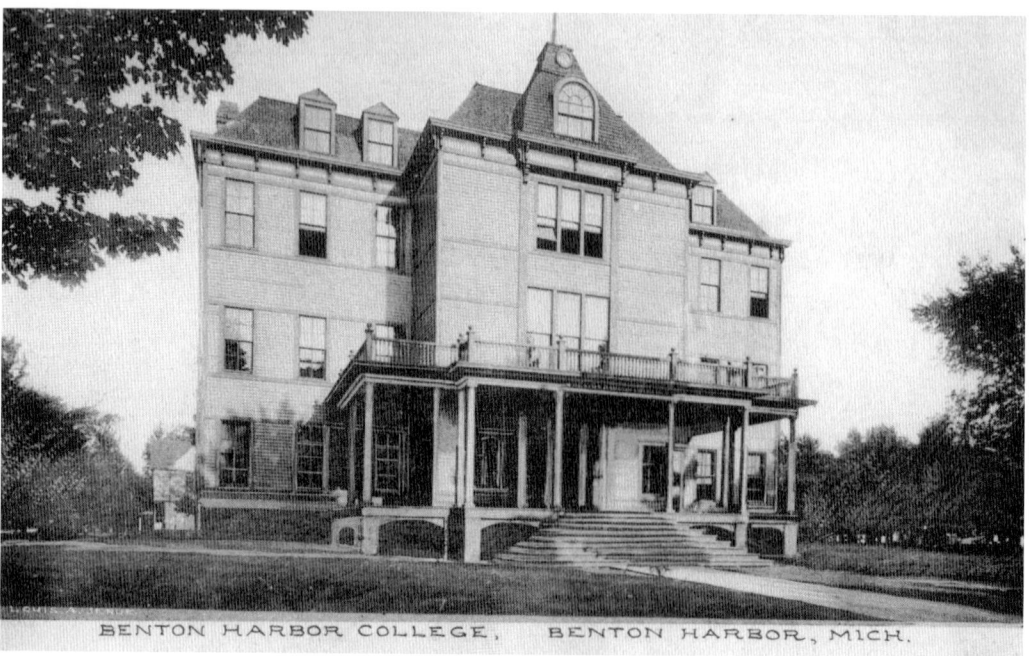

Eleanor Whitney
During Eleanor Whitney's tenure as the Benton Harbor Library director (1951–1969), the library outgrew its quarters. In 1968, she coordinated the movement of 56,000 books to the new library. Whitney stands in front of her childhood abode. She and her sister were adopted by loving parents, Humphrey and Eleanor Gray, and lived in this Benton Harbor home with them and their son, Lumen. (Courtesy of Benton Harbor Public Library.)

Theodosia Falkingham Arnold
Theodosia Falkingham Arnold was head librarian at the Benton Harbor Library from 1915 to 1951. After her complaint that "the drunken bums and painted ladies" who frequented the park benches outside of the library disturbed the patrons, the city removed the benches. When the city manager wanted the retirement of elderly employees, the library board said they could not find anyone half Arnold's age with as much vitality and creativity. (Courtesy of Benton Harbor Public Library.)

Priscilla Upton Byrns

"There's just no slowing her down," declared the headline of a 2005 *Herald-Palladium* article about 75-year-old Priscilla Upton Byrns. Eleven years later, the same can be said: "There's just no slowing her down." She takes after her father, Frederick Upton, one of the founders of the Whirlpool Foundation, and her mother, Margaret, who both volunteered for the betterment of the community. Byrns now serves as president of the board of the St. Joseph/Lincoln Township Senior Center, where she brightens the day with her smile and twinkling eyes. The board has responsibility for the 28,755-square-foot building and programs that reached 18,740 people in 2014. Byrns has also demonstrated her leadership skills in other organizations, including the YWCA, Girl Scouts, Antiquarian Society, Michigan Symphony League, Frederick S. Upton Foundation, Indian Hills Garden Club, Monday Musical, and St. Joseph's First Congregational Church. She sings in the choirs of the latter two. An organization especially dear to her heart is The Heritage Museum and Cultural Center (previously known as the Fort Miami Heritage Society). It was originally housed at the former First Congregational United Church of Christ at Main and Market Streets. Byrns spearheaded an effort to save the church so that it could be used as a museum and cultural center. It was the church she attended as a child and where she married Chester Byrns, who became a Berrien County judge. Her dream came true when Fort Miami Heritage Society purchased the building in 1989, restored it, and named it the Landmark Center. In 1994, fire consumed the building, but she did not despair. She headed a fundraising drive that collected the money necessary to erect a new museum and cultural center on the property. In 1996, a surprising boost to her effort came when her children decided to donate the rest of the money needed to start building. Her three daughters and son revealed the donation to her in a poem, just after she and her husband had returned from celebrating their 43rd wedding anniversary. The new building, white, pristine, and gleaming, is more architecturally suited to housing the museum than the restored church had been. It is her pride and joy, especially since her son, Stephen Byrns, designed it. The board decided to name the building the Priscilla U. Byrns Heritage Center, a fitting tribute. (Photograph by author.)

Roland Bert (R.B.) Taber, MD

Dr. R.B. Taber opened his practice as a physician/surgeon in Benton Harbor in the early 1900s and served the community for 39 years. He died in 1939 at the age of 67. From 1917 to 1920, he was a lieutenant commander in the US Navy Reserve Force at Great Lakes Naval Station, Illinois, where he treated sailors suffering from the influenza epidemic. (Courtesy of HMCC.)

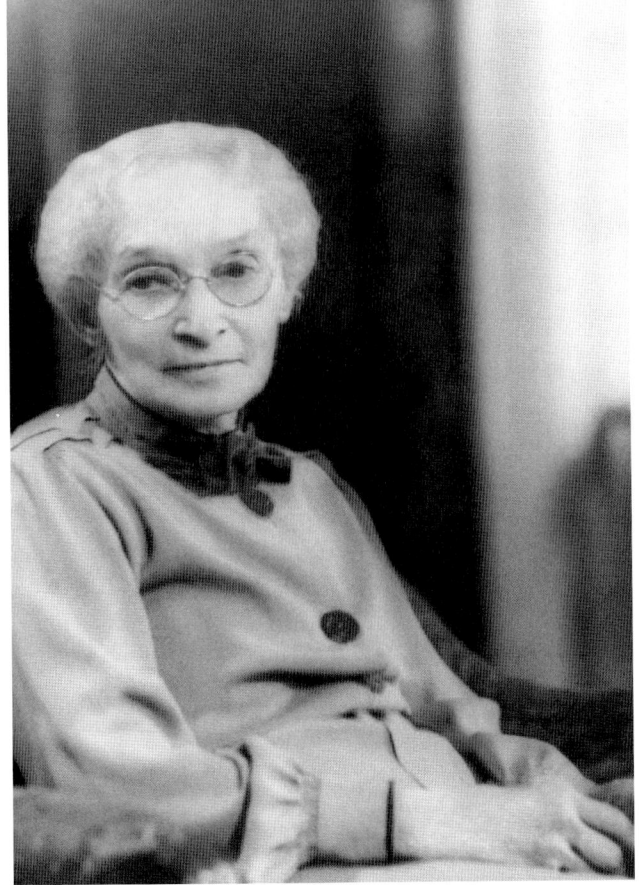

Hattie Schwendener, MD

Dr. Hattie A. Schwendener, one of the first women physicians in Berrien County, came from Ohio at the turn of the century. She was a charter executive board member of the YWCA in St. Joseph. Their programs included a reading group for women factory workers, tourist aid, and programs for children. (Courtesy of HMCC.)

John Bell, MD

Dr. John Bell, the son of a Canadian farmer, was probably the first physician in Benton Harbor. In 1862, he opened a drugstore and began his medical practice. His younger brother George (pictured to the left along with siblings Dorothy Bell Collins, Jane Bell Collins, Mary Bell Ricaby, and John) later joined him in the drugstore and practice of medicine. John became the president of the Benton Harbor Improvement Association and was one of the founders of Benton Harbor College. The Benton Harbor community elected him village president in 1877 and mayor for two terms in the 1890s. In 1900, he, his brother George, Edward Nichols, and George Mills built the 1,000-seat Bell Opera House in Benton Harbor. When he died in 1901, at age 61, he was laid in state at the Bell Opera House. (Both, courtesy of HMCC.)

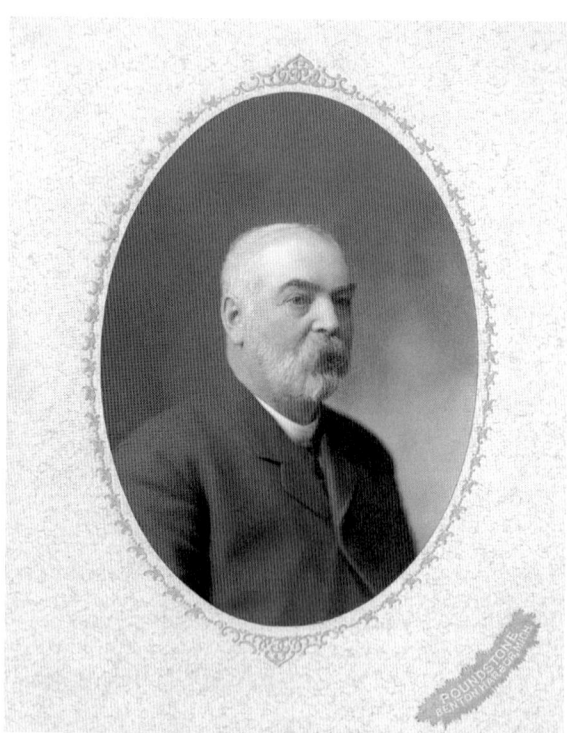

Henry V. Tutton, MD
In 1898, Dr. Henry V. Tutton performed a lifesaving appendectomy on a kitchen table, the first such operation the short, slender 29-year-old doctor had done. Dr. F.H. Lindenfeld, whose mother was a colleague of the doctor, wrote about him in a 1985 *Herald-Palladium* article titled "Dr. H.V. Tutton: Giant Mind in Small Town." Based on his own experience as a doctor, Lindenfeld imagined this scene as follows: "The patient's kitchen is prepared for the operation and Doctor Tutton surveys the operating room just before the operation is to begin: flickering light of kerosene lamps reveal bedbugs crawling slowly across the kitchen wall; the unfamiliar odor of antiseptics fills the air, pan of water bubbling on the stove are filled with instruments. Terror paralyzes the patient as his eyes dart from the face of Doctor Tutton and this strange scene in his once friendly kitchen to the faces of his family: anxious, prayerful and horrified. Confidence in Doctor Tutton is his only hope which he clings to as driftwood at sea." According to Lindenfeld, "Doctor Tutton was known as a sensitive cultured man, well read, adept at the piano and could converse in depth on almost any topic." However, it puzzled him as a child why his mother "would tolerate language from Doctor Tutton that would have sent her scurrying for a bar of soap if she had heard it from me." Years later, Lindenfeld realized that "the love, gratitude and esteem people bore for Doctor Tutton caused them to accept his language as a part of the total package." Tutton had unsuccessfully tried to raise funds for a hospital in 1894, but after the publicity that followed the successful appendectomy, the community rallied to the cause. In 1899, Mercy Hospital opened in a two-story building at Vineyard Avenue and Ross Street in Benton Harbor. Tutton performed the first operation, which was for acute appendicitis. (Courtesy of HMCC.)

Dora Bela Whitney
Dora Whitney was born in 1874 on a 1,100-acre farm in Benton Township, where Crystal Springs Cemetery and Sorter School are now located. Even as a young child, she believed that women could do as much as men could do. An excellent student, she pursued a career in law and became the first woman lawyer in Berrien County. In 1906, 14 years before women could vote, she started in private practice. She worked together with her husband, Harris, until he died in 1935 in an automobile accident. She did not retire until about 1960. Her effectiveness as a young lawyer was headlined in a February 28, 1907, edition of the *Weekly Press*: "Wife saves husband's case." The Whitneys became the first couple to practice in front of the US Supreme Court. During the first 20 years of its existence, Whitney managed the juvenile detention facility. Her experience there motivated her to speak throughout the state of the need for Michigan to establish juvenile courts. In 1931, she advocated for stricter gun control and believed that jobs and education were the way to prevent crime. An energetic woman, she served many community and civic organizations. For 16 years, she presided over the Michigan Women's Christian Temperance Union and traveled throughout the country speaking against the sale of alcohol. She also served on the board for the Benton Harbor School District for 16 years and on the library board for 14 years. In addition to her career as a lawyer, she and her husband raised four children. She died at age 93. (Courtesy of Harris Lindenfeld.)

CHAPTER TWO: INSPIRING SPIRITUAL, EDUCATIONAL, AND CIVIC LEADERS

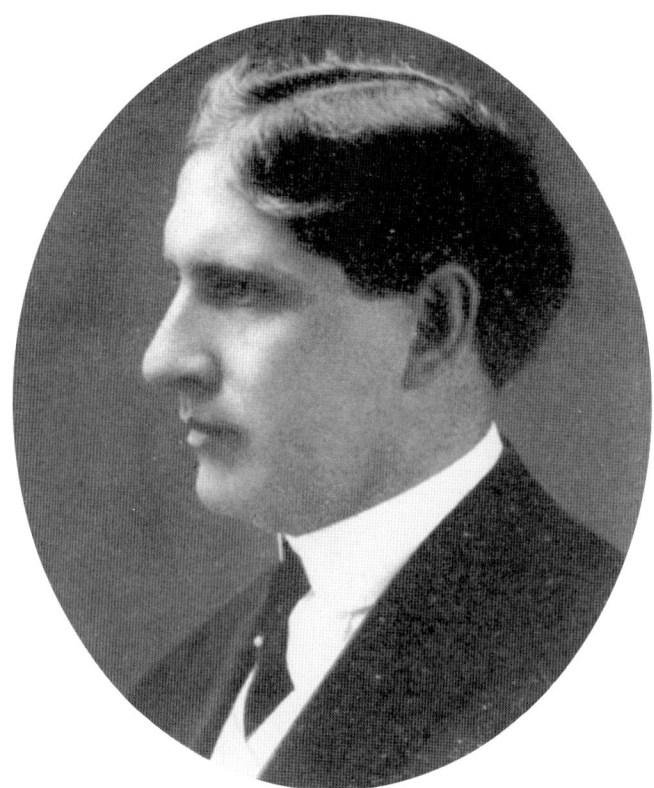

Humphrey S. Gray
Humphrey Gray received nationwide attention as one of the team members who defended William Z. Foster. He had been arrested after local and federal law enforcement authorities raided a Communist Party of America meeting in Bridgman on August 22, 1922. The trial resulted in a hung jury. Gray's greatest accomplishments surmounted those achieved in the courtroom. Gray, who came to Benton Harbor from Ludington, Michigan, used his intellect and heart to improve his new community. In 1895, together with John Klock and J. Stanley Morton, he established the *Evening News* in Benton Harbor. In 1900, he became city attorney. This forward-looking leader helped organize the Benton Harbor–St. Joe Railway and Light Company, as well as the interurban between South Bend and Benton Harbor. As secretary to the Benton Harbor Development Company, he lured industries to the city, including Squire Dinges Pickle Company, Covel, Ross-Carrier, and Malleable. In addition to practicing law, he became Secretary of Malleable Industries. In 1919, he founded First Community Church of Benton Harbor (Good Samaritan), a nondenominational church that by 1926 offered a myriad of services, including a supervised recreation hall and a Labor Day picnic for thousands of workers. It closed on January 1, 1930. *The Centennial History of Michigan* notes that he established a summer camp for girls and boys. He also was president of the Michigan Children's Aid Society. When Gray and his wife, Eleanor, became aware that young women who left their families to work in the Twin Cities needed a decent place to stay, they donated a brick building. The Eleanor Club, a residence for working women, opened in 1919. Gray and his wife delighted in their children, Lumen and Emily. Tragedy struck when 13-year-old Emily died. The adoption of two sisters, Martha and Eleanor, softened their blow. To keep the memory of Emily alive, the Grays donated six playgrounds to the city. During the 1953 Man of the Year Award presentation, this is how he was described: "A good many years have come and gone since Humphrey S. Gray, a young determined attorney came to town. But he had the foresight to know what must be done if both he and the community were to grow and become great. He met the challenge. He had more than vision. He had the will." (*Benton Harbor: The Metropolis of the Michigan Fruit Belt.*)

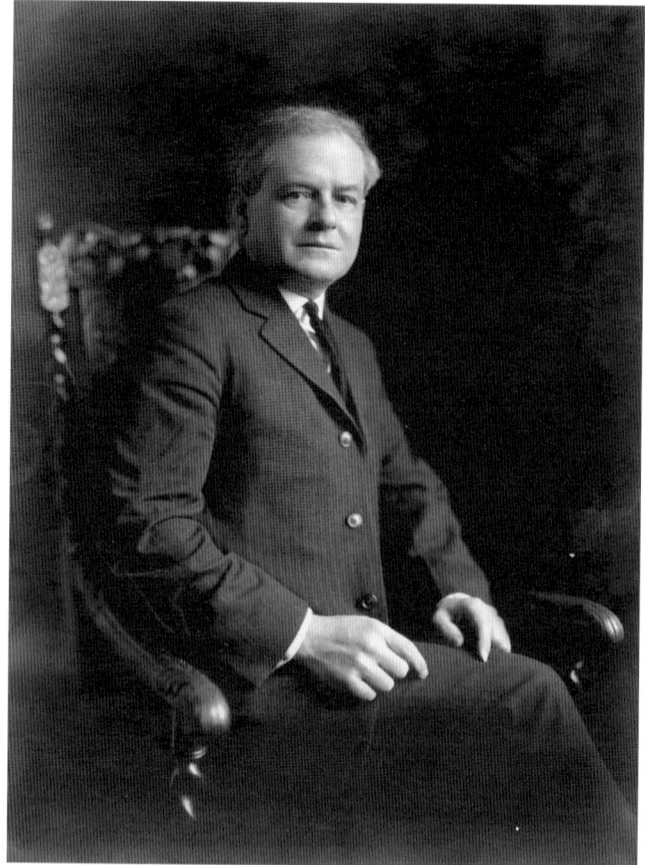

John Nellis Klock

John Klock was born in Brier Hill, New York, in 1865, in a room over a grocery store. As he explains in *Autobiography of John Nellis Klock*, at the age of 11, he was taken out of school and put at work in a printing office because of a breakdown in his father's health. By age 22, he had established his own newspaper in Owosso, Illinois. At 30 years of age, he came to Benton Harbor and bought and converted the *Morning News* into the *Evening News*, which he operated for 10 years. After he bought the *Daily Palladium*, that paper and the *Daily Palladium* were united under the name *News-Palladium*. After a few years, Klock sold it to another company. Klock took over the management of Malleable Foundry, as well as investing in another foundry in Indiana. As he explained in his memoir, "Although there was more money to be made in manufacturing than running a small city daily, I felt lost. I was taken out of the whirl of life and planted on a shelf. An editor who has all the confidence of the public is consulted about everything. In him is confided more secrets than the family doctor or the minister. He is the first to learn of the sordid things of life, of family difficulties, of public dishonesty, of impending events which may mean very much to the well-being of the community. Much is related in confidence, and it is a wise editor who can discern what to suppress. If a newspaper should publish all the things that people say and do it could almost bring on a revolution." He returned to the newspaper business after World War I. Along with Stanley Banyon and W.J. Banyon, Stanley's brother, he reacquired the *News-Palladium*. Thus, he gave his friend Stanley, who had just returned from the war, the opportunity to publish and edit the newspaper. Klock was active in the civic affairs of the city. As a member of the Benton Harbor Development Company, he lured needed industry to the city. He was also a member of the library and school boards, as well as mayor for three terms. He and his wife, Carrie, gave the people of Benton Harbor Jean Klock Park, a half-mile of Lake Michigan frontage. It was named in memory of their baby girl. (Courtesy of HMCC.)

Olga Krasl

The vivacious Olga Krasl, an accomplished painter, was an original member of the St. Joseph Art Association and a past president. The association started in 1962 when local artists presented their first art fair. Krasl and her husband, George, an inventor and industrialist, believed in the power of the arts. Before George died, he had set up a trust, which included the association. With these funds, the Krasl Art Center became a reality. At the ground-breaking ceremony in 1978, she noted, "We wanted to do something for the community and to make life more worthwhile. I'm happy to be able to do this—art was always one of my loves." She stayed active with the Krasl into her 90s. She died in 1997 at 99 years of age. This portrait was created by Phyllis Rhoads in 1980. (Courtesy of Krasl Art Center.)

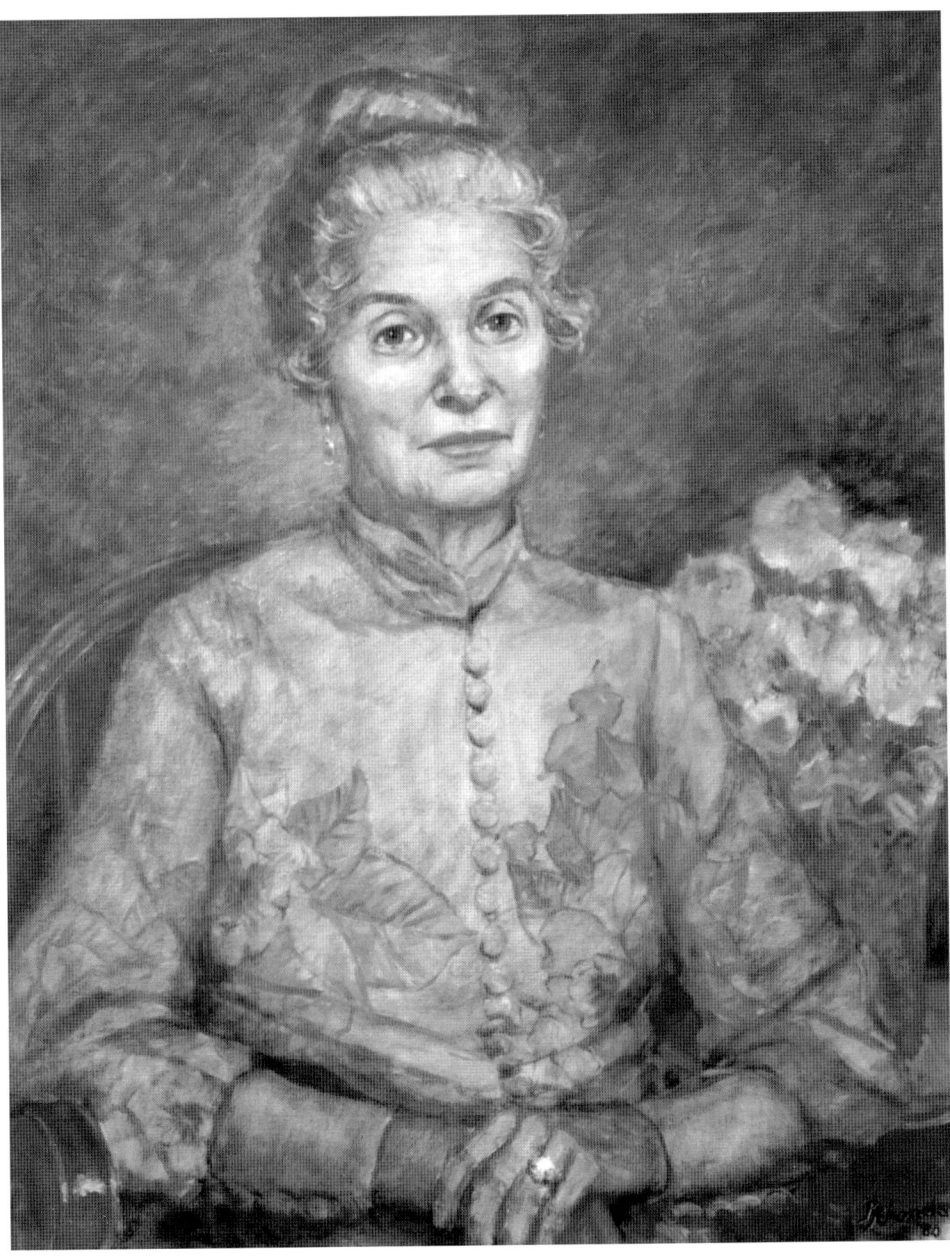

Barratt O'Hara

Even as a youth, Barratt O'Hara was a go-getter. At 15, he enlisted in the Spanish-American War. As a corporal, he participated in the 1898 Siege of Santiago. O'Hara returned to Benton Harbor to complete high school and work for the *Benton Harbor Evening News*. He became a journalist, lawyer, and politician. O'Hara served Illinois as lieutenant governor and, for nine sessions, as US representative. (Courtesy of HMCC.)

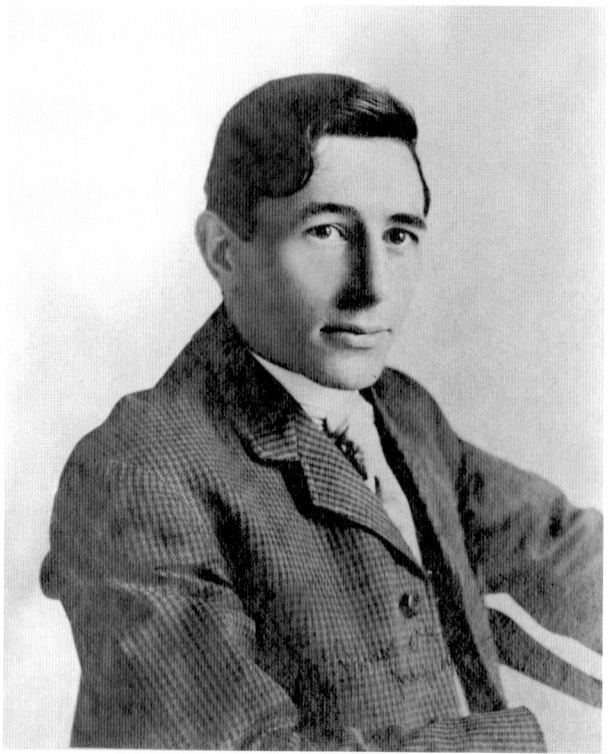

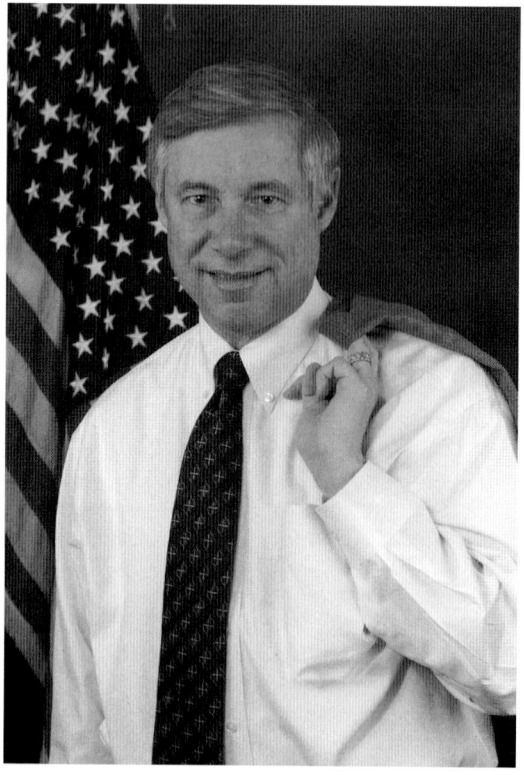

Fred Upton

St. Joseph native Fred Upton entered the political arena after he graduated from the University of Michigan. He worked for Congressman David Stockman (R-MI) from 1976 to 1980 and in the Office of Management and Budget from 1981 to 1985. In 1986, he was elected to the House of Representatives. He has served as chairman of the House Energy and Commerce Committee since 2011. (Courtesy of Fred Upton.)

Pat Moody
One of the last lines of Pat Moody's bio sheet stands out: "Have never missed a day of work or school due to illness in my entire lifetime." A man of unbounded energy and enthusiasm, he juggled two jobs from 1994 to 2013. From 5:30 to 9:00 a.m., he hosted his radio show *Moody in the Morning* and then bounded off to work as executive vice president at Cornerstone Alliance Chamber of Commerce in Benton Harbor. Since 2000, besides continuing with the radio show, he has kept hundreds of thousands informed via his weekly column "Moody on the Market" in *MailMax* and more recently via his webpage. The list of his volunteer activities and awards would fill a small book. Moody is also an accomplished amateur photographer whose work has appeared in *Lake Magazine*. (Courtesy of Pat Moody.)

Richard Hensel
Richard Hensel has been an advocate for social justice, the arts, literacy, and historic preservation since 1988. He has served on the boards of the New Territory Arts Association, Benton Harbor Public Library, and the Benton Harbor Planning Commission and initiated the founding of the OutCenter. Hensel is currently the producer of *Harbor Lights TV*, a public television production showcasing Southwest Michigan. (Photograph by author.)

The OutCenter
From left to right are founders of the OutCenter, Donna Moynihan, Dawn Outwin, Richard Hensel, Katherine Martin, Zina Darling, Ron Robinson, and Charles Long. The OutCenter, which was founded in 2003, is located in Benton Harbor. It provides support and advocacy to the LGBT community and their families and works to establish respect, understanding, and nondiscrimination of LGBT people in Southwest Michigan. (Courtesy of Richard Hensel.)

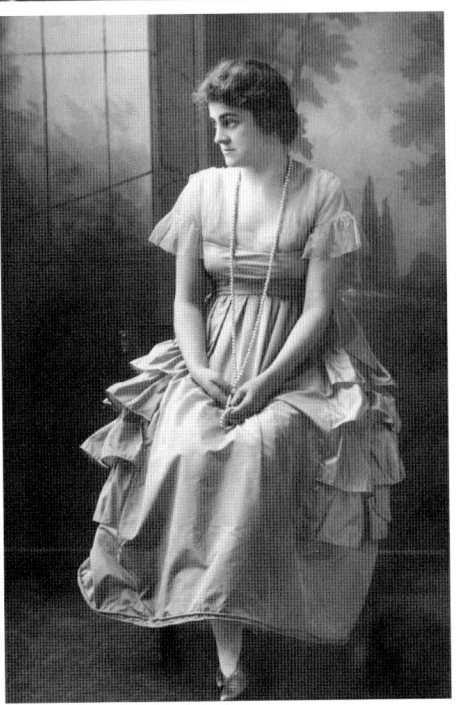

Fred Palenske and Maud Preston Palenske
The library in St. Joseph is named after Maud Preston Palenske, who is pictured as a young woman at left. Maud Palenske's family, the Prestons, were active in the early development of St. Joseph, including establishing a lumber company. In 1919, Maud's husband, Fred Palenske, with her help, established the Industrial Rubber Company in St. Joseph. After it burned down in 1921, he rebuilt it into a thriving company, which, during World War II, made gas masks and other supplies. He sold it in 1961. After Maud died in 1959, he gave $275,000 to build a new library in her memory and that of the Prestons. It was dedicated in 1966. After his death in 1970, an additional $175,000 of his estate went to the library. It was used for the new addition, which was completed in 1981. (Both, courtesy of HMCC.)

Wilbur M. Cunningham

"Warm hearted, trustworthy, pure in deed and thought and dedicated to his community and his country." Thus, Wilbur M. Cunningham is described in the October 27, 1966, issue of the *News-Palladium*. Cunningham, a star football player for Benton Harbor High School, graduated from the University of Michigan Law School in 1912. The following year he opened a law office in Benton Harbor. He served in the Navy during World War I, earning the rank of lieutenant commander. For 23 years, Cunningham was Benton Harbor's city attorney, and for four years, he served as prosecuting attorney for Berrien County. While he was in this position, he brought the gangster Fred "Killer" Burke to court. Burke was sentenced to life imprisonment for killing the 25-year-old St. Joseph policeman Charles Skelly. Cunningham was a leader in various civic organizations and served for 12 years as president of the Benton Harbor Board of Education. Cunningham was recognized as one of the leading amateur authorities on Indian artifacts. The Michigan Archeological Society repeatedly elected him as president. His books *A Study of the Glacial Kame Culture in Michigan, Ohio, and Indiana*; *Land of Four Flags: an Early History of the St. Joseph Valley*; and *The Letter Book of William Burnett: Early Fur Trader in the Land of Four Flags* contributed invaluably to understanding the early prehistoric people of the area and the history of the first Europeans who ventured to Southwest Michigan. (Courtesy of HMCC.)

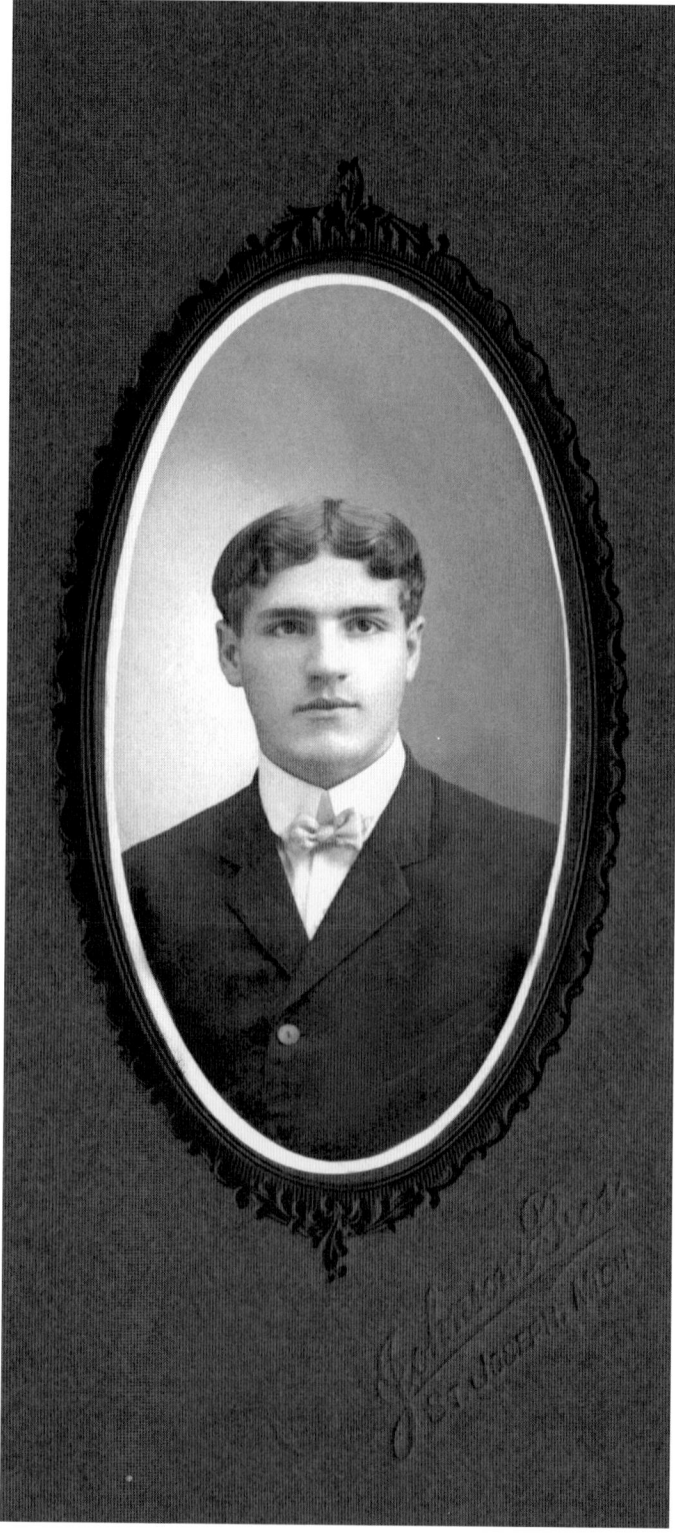

CHAPTER THREE

Inventors, Industrialists, and Entrepreneurs

The hardy settlers of St. Joseph and Benton Harbor labored long hours to clear the land for farming. Their work produced delicious peaches, apples, and other produce. The area soon became known as the "Fruit Belt."

By the early 20th century, a vibrant manufacturing industry had also developed, and stores lined the main streets of St. Joseph and Benton Harbor. Many dynamic, innovative people were attracted to the opportunity the cities afforded. They included Augustus Herring, an airplane pioneer who flew his motor-driven glider off the sands of Silver Beach in 1898, five years before the Wright brothers' flight. His plane, however, lacked a mechanical way to control it. Emory Upton designed an electric-powered motor for the washing machine patent that his nephew Louis had obtained. The company Louis, his brother Fred, and uncle started became known as Whirlpool. Other inventors included F.P. Rosback, who created a perforator machine used in all corners of the world for checks and stamps, and Walter Miller, whose record-changing machine was produced by his company, the V-M Corporation. Howard Anthony, owner of Heathkit, received a large supply of spare parts after World War II, with which he produced a kit that contained the parts and directions for an oscilloscope. His company then started building a wide variety of electronic kits, including those for radio and stereo.

From the 1940s through the 1960s, the vibrant downtowns of St. Joseph and Benton Harbor serviced the employees of the factories, the farmers, and tourists. Charlie and Leo Andrews became proprietors of Candyland, a popular hangout renowned for their candies and soda fountain treats. Their brother George helped operate the Michigan Hotel and its exclusive Palm Garden Restaurant. Many entrepreneurs, lured by the possibility of prosperity, opened shops.

Unfortunately, by the 1980s, there was a downturn. The area lost its manufacturing base, becoming part of the Rust Belt. Benton Harbor became just a shell of its old self, with many abandoned buildings. However, by the beginning of the millennium, the ramshackle buildings started to be renovated. Today, the downtown has been transformed into a lively arts district, with art galleries, music and dance studios, restaurants, and a nearby golf course and hotel. Even though the beloved Babe Couvelis recently passed away, Babe's Lounge, which he established in 1958, continues under the direction of his wife, Pauline, and son Jim.

The city of St. Joseph also put a lot of effort into updating its downtown. In summer, thousands of tourists wander in and out of trendy stores, such as the independent bookstore Forever Books established by Robin Allen; Third Coast Surf Shop, created by Lake Michigan surfer Ryan Gerard; or Bound for Freedom, where Austin and Kelsey Bock sell free-trade goods with the goal of helping people around the globe achieve dignity and independence.

During the past two decades, the citizens of the Twin Cities have witnessed a redefinition of their cities and the prospect of a bright future.

Augustus Herring

Augustus Herring, shown with his dog Tatters, piloted his newfangled flying machine off the Indiana Dunes in 1897. This machine, except for a compressed-air engine, was identical to the one he flew the following year in Michigan. On October 11, 1898, in an 8-to-10-second flight against a strong headwind, he took flight for 50 feet along Silver Beach in St. Joseph. Eleven days later, he delighted crowds with another triumph on this sandy beach, this time flying 73 feet. Although Herring was one of the first to take off in an engine-powered machine he designed, he never got the recognition that the Wright brothers received five years later. The Wright brothers invented the first machine that could be controlled mechanically, unlike Herring's, which he controlled by body movement. Herring was born in Georgia in 1867. His father, a prominent businessman, wanted his son to become a doctor, like his brother, or a lawyer. But Herring dreamed of building a flying machine and wanted to get the scientific training to "conquer the air." In 1884, he enrolled at Stevens Institute of Technology. After completing his mechanical engineering training, he worked with aviation pioneers, including Samuel Langley and Octave Chanute. In 1898, after a disagreement with Langley, Herring took a job as an engineer with the Truscott Boat Manufacturing Company in St. Joseph. Here, he had access to machine shops to build his flying machine and a beach where he could test it. While residing in St. Joseph, he designed bicycles and started the magazine *Gas Power*. Herring moved his family to Freeport, New York, in 1903. For many years, he continued his aviation design career. However, none of his airplanes were very successful. He died in 1925. (Courtesy of HMCC.)

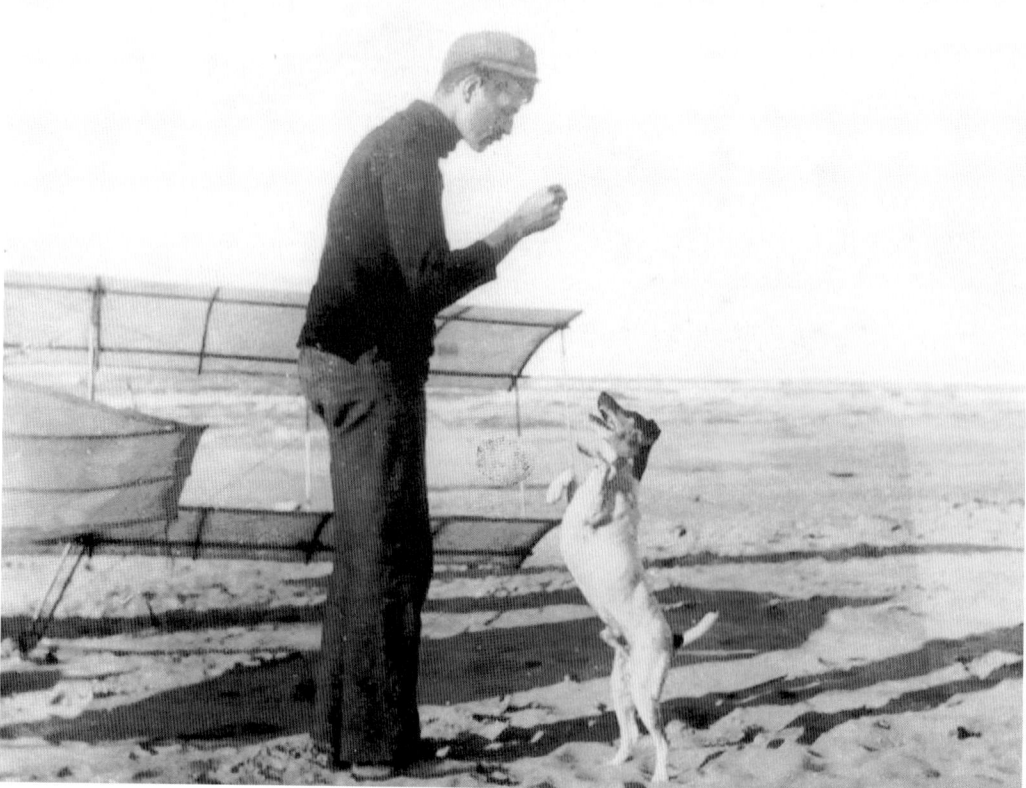

F.P. Rosback
Inventor and industrialist F.P. Rosback accumulated about 161 patents, which garnered him recognition and honors, including a gold medal during the 1900 World's Fair in Paris. He kept company with such luminaries as Henry Ford, Cyrus McCormick, Harvey Firestone, and Thomas Edison. Rosback was five when he emigrated with his family from Germany to the United States in 1851. Abraham Lincoln lived just down the street from their home in Springfield, Illinois. The family moved to Chicago, where Rosback attended high school. In 1863, 17-year-old Rosback joined the Union army; he marched to the sea under the command of General Sherman. After the end of the Civil War, he married and went to work for the McCormick Harvester Company. In 1881, he invented a grain-binding mechanism, which he sold to Cyrus McCormick. Thus, he had enough capital to start his own business in Chicago, the Rosback Company. The Rosback Company moved to Benton Harbor in 1905. Here, they manufactured several of his inventions, including the rotary round-hole perforator. By the time he died in 1927, checks in Paris, Prague, Hong Kong, and in all corners of the world were made using a Rosback perforator machine. Stamps sold throughout the world were also perforated on this type of machine. After Rosback's death, the company continued under the guidance of his two sons, Fred and Walter. The Rosback Company, which from 1980 has been situated in St. Joseph, remains a family business. His great-grandchildren continue his legacy. (Courtesy of F.P. Rosback Company.)

Louis and Emory Upton

Louis Upton, above, was 17 when his father died. He and his younger brother Frederick helped support his mother and sisters by operating a butter-and-egg route, selling apples, and cleaning barns and stables around LaGrange, Illinois, where the family lived. By his early 20s, Louis became well-respected insurance salesman, but lost $500 of his hard-earned money in a venture to manufacture household equipment. He was asked to select something of value from the failed venture. Upton chose patents to a washing machine. Louis's uncle, Emory Upton, a mechanical genius, devised a system that enabled the machine to be powered by electricity. In 1911, the two of them established Upton Machine Company, a precursor to the Whirlpool Corporation, in Benton Harbor, where Emory had a machine shop. Family friend Lowell Bassford invested $5,000 in the company, helping get it off the ground. Frederick also joined the company. They worked hard to make the newly formed company a success, but their venture almost came to a halt shortly after their founding, when they delivered their first order of 100 machines. The machines did not work! They offered to recall the machines and replace a defective gear. The customer, impressed with the integrity of the company, doubled the order. The elderly Emory resigned in 1916, leaving the younger Uptons in charge. In 1917, Louis Upton made a move that was unheard of. He gave 50 to 60 senior employees paid vacations. A letter to the employees' wives instructed: "Plan some fishing trips or picnics—take the St. Joseph River boat trip, have some beach parties and so forth. Don't let Bill clean out the basement or the chicken coop or have him do odd jobs around the house, you and the family get out in the sun and the fresh air and just have a good time." In 1929, the Upton Machine Company merged with the Nineteen Hundred Washer Company. The new firm was called the Nineteen Hundred Corp. In 1950, the firm was renamed Whirlpool. In 1949, Upton stepped down as president of the company. Elisha "Bud" Gray succeeded him. In 1952, Louis died. Louis is remembered not only as a visionary entrepreneur who, together with his brother Frederick, led the company to prominence worldwide, but also as a down-to-earth and generous man who the children of St. Joseph and Benton Harbor referred to as "Uncle Lou." (Courtesy of HMCC.)

Frederick and Margaret Upton
Frederick and Margaret Upton are relaxing at their home in St. Joseph. Frederick Upton joined his brother and uncle in the Upton Machine Company, precursor of Whirlpool, in 1911. He held leadership positions at Whirlpool and served on its board until 1975. He became the driving force behind the founding of the Mercy-Memorial Medical Center in 1950. In 1954, Frederick and Margaret established the Frederick S. Upton Foundation, which has given millions of dollars in grants to the community. The couple had four children, David Frederick, Stephen Edward, Priscilla Jane (Byrns), and Sylvia Carol (Wood). One of their grandchildren is Fred Upton, who has served his community in the US House of Representatives since 1986. Kate Upton, the superstar model, is a great-grandchild. (Courtesy of HMCC.)

William Vail

In 1904, William Vail founded Vail Rubber Works in Chicago. The former railroad engineer's idea of making rubber railroad ties did not work out. Not a quitter, he manufactured rubber horseshoes to protect horses from the cobblestones. That petered out after the onset of the automobile. A forward-looking entrepreneur, Vail then manufactured rubber gaskets for the burgeoning paper industry. By 1920, after a stint in Muskegon, Vail Rubber Works settled in St. Joseph, making rubber coverings for steel rollers. After the death of William Vail in 1935, the company was run by his son-in-law William M. Hanley, then Vail's grandson Joseph Hanley, and since 1989, by Vail's great-grandson Joseph W. "Bill" Hanley, who is currently in charge. He is pictured at left. The company continues as a family business, designing and manufacturing rubber and polyurethane roll covers. (Both, courtesy of Vail Rubber Works.)

CHAPTER THREE: INVENTORS, INDUSTRIALISTS, AND ENTREPRENEURS

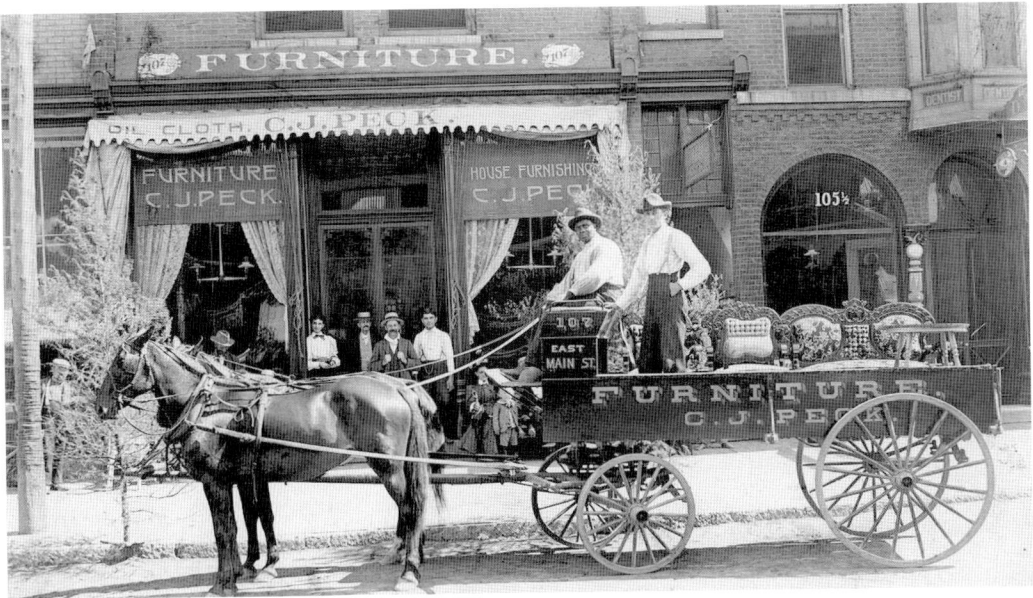

Henry Wims
In the 1880s, former slave Henry Wims (on the left) came to St. Joseph where his wife's parents lived. He worked for Peck Furniture in Benton Harbor but decided to venture out on his own. The Graham & Morton Co. awarded well-respected Wims the contract for cleaning the rugs on their steamships. His business thrived and expanded to include a taxi and dray service. (Courtesy HMCC.)

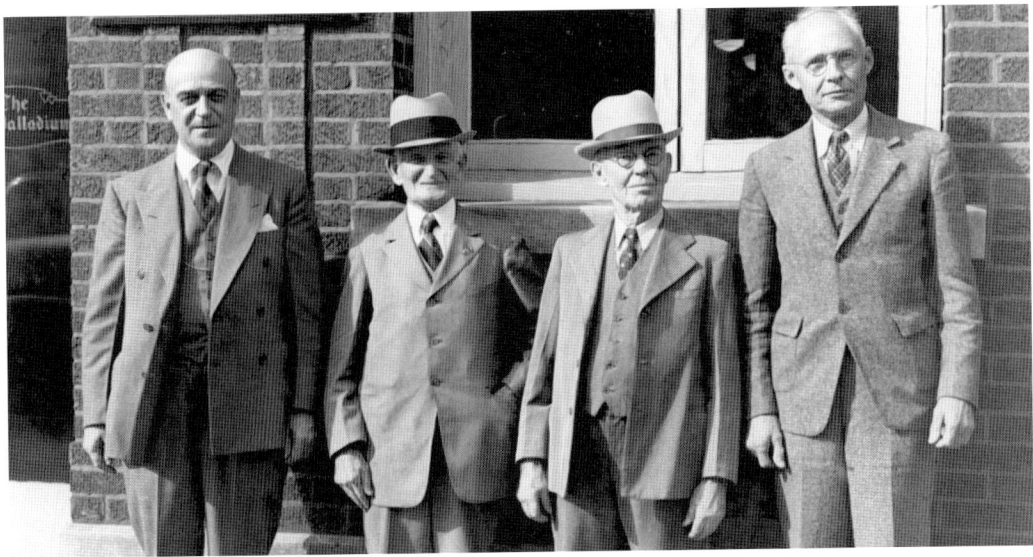

Edward Brammall
Edward Brammall stands next to newspaper publisher Stanley Banyon, who is on the left. The others are unidentified. Brammall fixed Mary Todd Lincoln's icebox while working in Chicago as a tinsmith and plumber. In 1873, he founded Benton Harbor's Brammall Supply Company, which sold plumbing and mill supplies. He sold the business in the early 1900s but continued coming in until his death in 1946 at age 96. (Courtesy of HMCC.)

James, Waldo, and Lester Tiscornia

St. Joseph residents are familiar with the Tiscornia brothers, James (on the left), and Waldo (on the right), and their nephew Lester. The Tiscornias, in concert with their company Auto Specialties Manufacturing Company (AUSCO), gave St. Joseph residents the beach that is just north of the lighthouse, the Waldo V. Tiscornia Field in Riverview Park, and the Tiscornia Foundation, which continues to award college scholarships. James started AUSCO in Chicago in 1908. The company relocated to Joliet and then to St. Joseph in 1915. At that time, they manufactured a product that held a touring car's convertible top in place. In 1917, James's brother Waldo came to help him run the company. James was president until he died in 1960, and his brother Waldo took over until his retirement in 1964. Waldo was active in local politics, as well as working as executive vice president at AUSCO. He served in the city council starting in 1937 and as mayor of St. Joseph from 1942 to 1955. James and Waldo formed a company baseball team during the Depression. They built a state-of-the-art stadium that included an automatic plate duster that blew the dust off home plate with a flip of a switch, a microphone that arose from the earth, and a ball box that miraculously delivered 12 new balls from the ground. Company players took home several state championships and won the National Semi-Pro Championship in 1946. The brothers took the baseball team very seriously. Waldo's *Benton Harbor News-Palladium*, May 15, 1968, obituary said, "He is remembered at his colorful best to a generation of area sports fans who delighted to see Sportsman Tiscornia charge onto the field at the umpire after a disputed call on one of his ball players." Lester Tiscornia, nephew of the brothers, was with AUSCO from 1947 to 1989 and assumed presidency of AUSCO in 1964. He and his wife, Bernice, were very active in the community, serving on several boards. In the 1970s, AUSCO employed 2,000 people, but by 1988, it had filed for Chapter 11 bankruptcy protection. In 1990, another group bought its assets. AUSCO continues to function in Benton Harbor, but no longer under the direction of the Tiscornia family. (Courtesy of HMCC.)

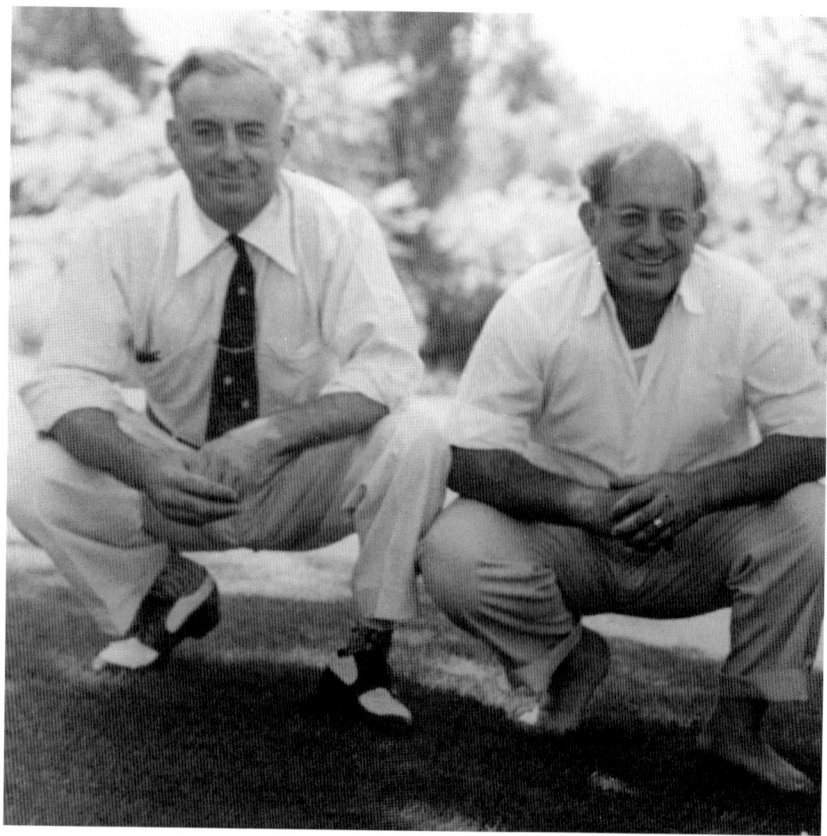

Frank Gillespie

When Frank Gillespie, pictured above with grandson Frank, opened his pharmacy in 1905 at 220 State Street in St. Joseph, he threw out the whiskey barrels kept by the previous owner of the pharmacy. As Dee Sykora reported at an Antiquarian Society presentation, "The first Monday evening that the store was open, a group of men filed in and headed for the back. 'Where are you going?' inquired the new proprietor. 'We're the City Commission,' they responded. 'We're after our free whiskey.' 'Just a minute there,' said Gillespie. He rummaged through the back room, rolled the one remaining whiskey barrel into the alley, and before their startled eyes, he broke it: 'You've had your last free drink here.'" Gillespie enjoyed concocting pharmaceuticals. He sometimes improved the brands offered by pharmaceutical companies and sold them at less. He offered a hair tonic called Dr. Hirsute's, which in Latin means "Dr. Covered with Hair." Gillespie was born in 1878 in a log cabin near Delton, Michigan. His father died when he was two, shot by his best friend in a hunting accident. To support her seven children, his mother farmed. Frank wanted to do more than farm. According to his son Bill, he said, "You can learn two things in Delton. You can go to the post office and learn Morse code or go to the pool hall and learn pool. After that you can't learn anything else. You might as well leave." He left, working at various jobs while he studied pharmacy in a correspondence course. He met his wife, Helen, in St. Joseph after opening his first store. Their six children helped in his business. Four sons became pharmacists and daughter Ruth worked in the store for 40 years. Three sons, Collins, Robert, and Bill, took over their father's business after he died in 1955. Dick set up his own drugstore at 2020 Washington Avenue in St. Joseph in 1960. Son Tom decided to become a policeman instead, serving as St. Joseph chief of police from 1974 to 1993. Although the original Gillespie drugstore on State Street was sold in 1986, the Gillespie legacy continues. Gillespie's granddaughters Amy Gillespie-Zimmerman and Kelly Gillespie-Karsten bought the Washington Avenue store. (Courtesy of the Gillespie family.)

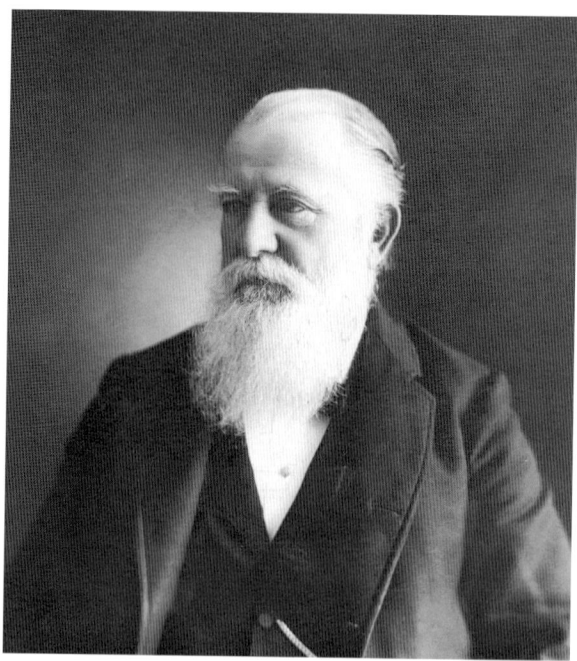

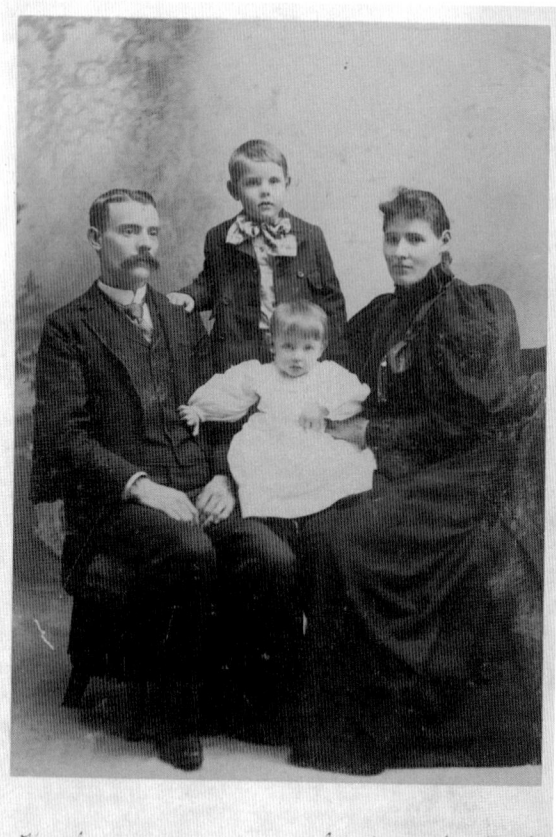

Thomas Truscott

Thomas Truscott, born in England in 1826, immigrated to Chicago in 1870. In 1876, he established the Truscott Boat Company in Grand Rapids. They moved to St. Joseph in 1891. After Truscott died in 1905, the company was in good hands. His sons Henry (pictured with his family), James, and Edward managed it. The factory manufactured all components of the boats, from the engines to the draperies. From 1906 to 1908, it employed 600 to 700 people. The beautiful hand-carved Venetian gondolas and small steamers used at the 1893 Columbian Exposition in Chicago were manufactured by Truscott. The company also supplied gondolas, water taxis, and little electric boats to the World's Fair in Chicago in the 1930s. The Great Depression took its toll on the company. The family sold the company to outside interests in 1940. (Both, courtesy of HMCC.)

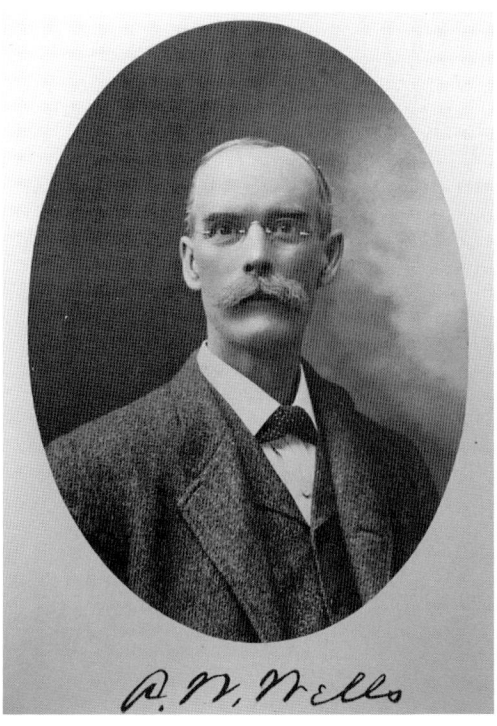

Abel Wells

Abel Wells, a Canadian immigrant, settled in St. Joseph in 1868 where he started manufacturing baskets and boxes for the fruit industry. Around 1878, he joined the St. Joseph Knitting and Spinning Works Company, which had been founded by retired minister Samuel Cooper and his sons. The company, located below the bluff in St. Joseph, was renamed Cooper and Wells. It became known for its "Iron Clad" stockings. Pictured below is a c. 1895 photograph of employees standing in front of the factory. Cooper and Wells employed women as well as men. In 1920, to accommodate the single nonresident working women, the company, then under the direction of Wells's son J. Ogden Wells, erected a dormitory. The $50,000 building, named Lakeside, offered room and board to 50 to 60 women. (Left, *A Twentieth Century History of Berrien County*; below, courtesy of HMCC.)

Walter Miller

For more than nine decades, the Miller family has operated businesses in Benton Harbor. Pictured is the patriarch, Walter, who was born in a village in the Swiss Alps. He immigrated to the United States in 1906. He received an electrical engineering degree from Purdue University. In 1922, short on cash, but confident about his abilities, he started a tool-and-die business in a 15-square-foot shop in Benton Harbor. His Pier Manufacturing Company earned a reputation for quality service. The company reincorporated as New Products Corporation in 1922 and continues in operation. Other companies this astute businessman established included Modern Plastics, Plastic Masters, Bangor Plastics, Regal Manufacturing, Stanley Tool, Kaywood, and V-M. The latter factory, which operated from 1944 to 1977, was directed by his son Victor Miller. The V-M Company was well respected in the recording industry and by the general public for their phonographs and tape recorders. During World War II, several of the companies Miller established concentrated on the war effort. During the war, Walter invented a navigation system that allowed pilots to more precisely target their bombs. For this effort, he was given a commendation for helping win the Battle of Britain. In 1941, Walter handed over operation of New Products to his 28-year-old son Stanley. Walter wanted to spend more time on plastics and record changers; he invented one of the early record changers, which allowed the playing of one record after another. But Walter was interested in more than manufacturing or engineering. He hunted, fished, and climbed mountains. He had a 160-acre farm just outside of Benton Harbor, which was the site for the first Blessing of the Blossoms, a tradition that continues in Southwest Michigan. In the 1930s, together with Emil Prushak, he developed a method of hybridizing plants so that they could withstand the ravages of disease. When Stanley died in 2001, his wife, Phyllis, at age 85, and their daughter Cheryl took the reins of New Products. Under Cheryl's guidance, it is thriving as a worldwide supplier of aluminum and zinc products. Walter Miller established a strong work ethic in his family and, leading by example, taught them to reach out to the community. In his obituary, the *Herald-Press* quoted many who praised his philanthropy. Fredrick Upton summed it up, "His generous deeds and many kindnesses were evident wherever he went." (Courtesy of New Products Corporation.)

Fred Cutler

Fred Cutler wore two hats in 1932. He was head of Cutler and Downing Hardware in Benton Harbor (see photograph below) and sheriff of Berrien County. While Fred Cutler served as sheriff of Berrien County, he housed the notorious criminal Fred "Killer" Burke in the jail. Cutler died while in office, and his wife was appointed to his job. Cutler started in the nursery/hardware store business when he became part owner of the Cutler and Downing Company Nurseries around 1905. He became sole owner when his partner John Downing died in 1908. In 1915, the store sold from 400,000 to 500,000 trees annually, as well as farm implements and supplies. (Left, *Benton Harbor: The Metropolis of the Michigan Fruit Belt*; below, courtesy of HMCC.)

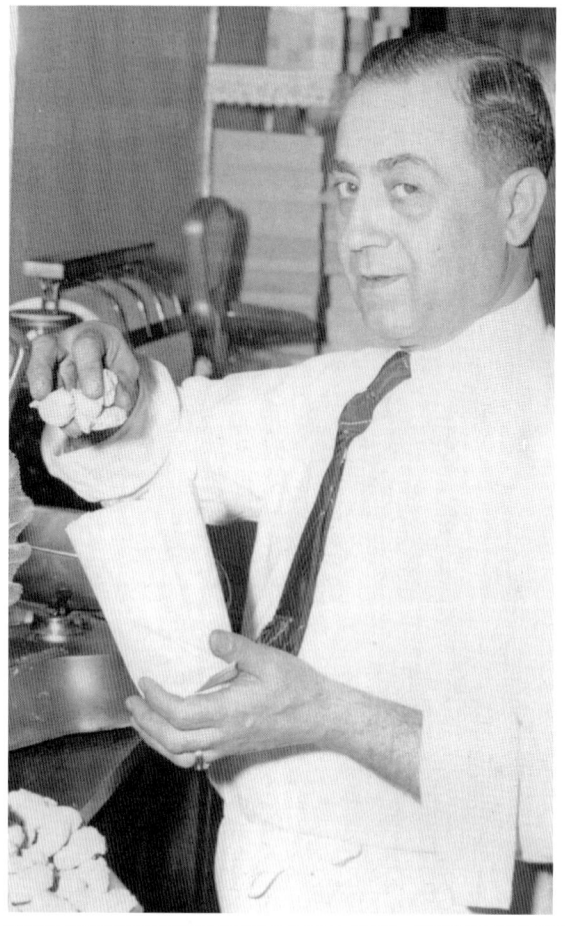

Zacharias "Charlie" and Leo Andrews

Charlie Andrews, seen filling a bag of candy, and his brother Leo, pictured below, were proprietors of Candyland, a popular hangout that not only served delicious homemade chocolates, English toffee, and peanut brittle, but also had a soda fountain that served "forty different sundaes." According to his daughter Helen Willmeng, Charlie immigrated to America in 1910 but returned to Greece in 1913 for service in the army. Before he returned, he became a chauffeur and bodyguard for President Gounaris, his godfather, and then chauffeur and bodyguard to King Constantine I. In 1947, he moved to Benton Harbor from Indiana, and he and his brother Leo bought Candyland at 152 East Main Street in Benton Harbor from the Govatos family in 1947. Previously, the Moutsatson family had owned it. Candyland was sold in 1968. (Both, courtesy of Helen Willmeng.)

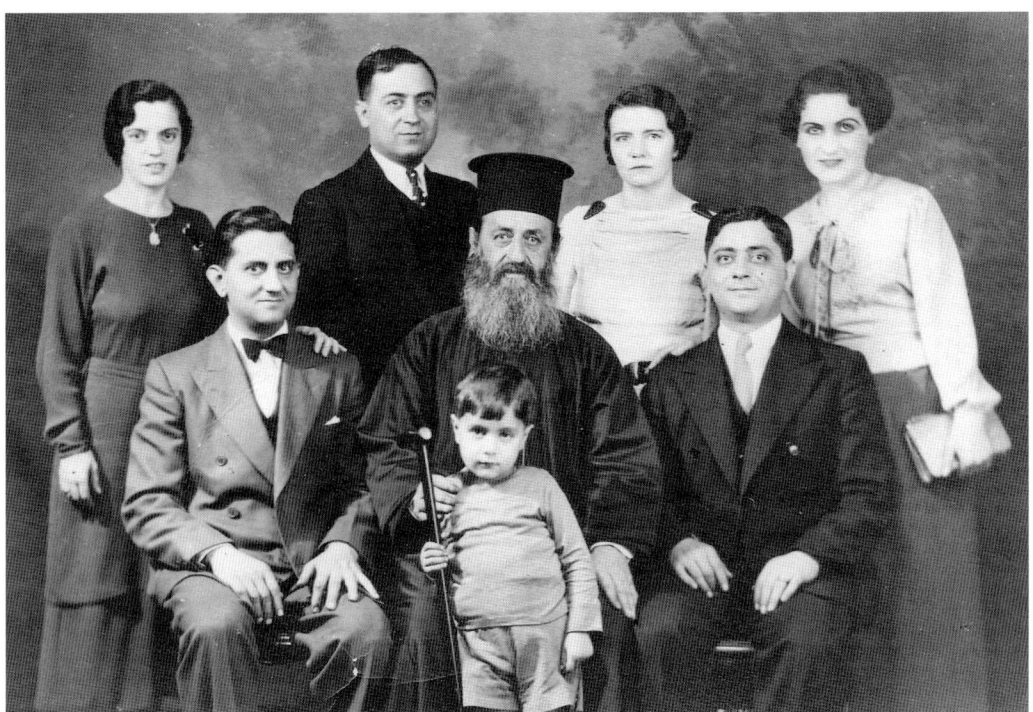

George and Stavroula Andrews
Pictured to the right in this 1936 Andrews family portrait are Stavroula (standing) and George Andrews (seated). Their son Andrew stands in front. Others pictured are, from left to right, his father, brothers, and sisters-in-law: Helen (Leo's wife), Leo, Zacharias, Rev. Andrew Andrikopoulos, and Harriet (Zacharias's wife). If it had not been for Stavroula's marriage to George Andrews, she may never have seen her father again. Her father, John Dorotheon, and mother, Evdokia, had married in Greece in 1905. When he immigrated to America a few years later, he left her and their one-year-old daughter, Stavroula, behind on the Greek island of Samos. Like many Greek immigrant men, Dorotheon probably intended to make some money in the United States and then return. However, he remained in America, sending money home to support his wife and daughter. Dorotheon and his brother Nick, as well as cousin Alex Gust, opened the Hotel Michigan in Benton Harbor. John longed for his wife and daughter. He could bring Evdokia to Benton Harbor since she was the wife of an American citizen, but according to a June 6, 1928, *News-Palladium* article, he met nothing but frustration in his attempts to bring his daughter. For over two years, he struggled with the immigration authorities, but to no avail. George Andrews, a handsome Greek confectioner from Indiana, came to the rescue when he announced his intent to marry Stavroula. Andrews and his future father-in-law journeyed to Paris, where the marriage took place. As the wife of an American citizen, Stavroula could finally meet her father, a father she had never known. George and Stavroula settled in Benton Harbor, and he joined his father-in-law in the management of the Hotel Michigan. The hotel became renowned throughout the area, especially for its Shangri-La Bar and the upscale Palm Garden Restaurant. The Dorotheon and Andrews families became active members of the community and contributed to the building of the Annunciation Greek Orthodox Church in Benton Harbor. Stavroula was known for her delicious Greek cooking. A 1950 *News-Palladium* article features her and her recipes for lamb and macaroni, chicken with artichokes with *avgolemono* sauce, and zwieback delight *(plakountio)*, recipes that have been handed down from mother to daughter for generations. Andrews and his wife had four children: Andrew, Margie (Souliotis), John, and Joantha (Argoudelis). (Courtesy of Helen Willmeng.)

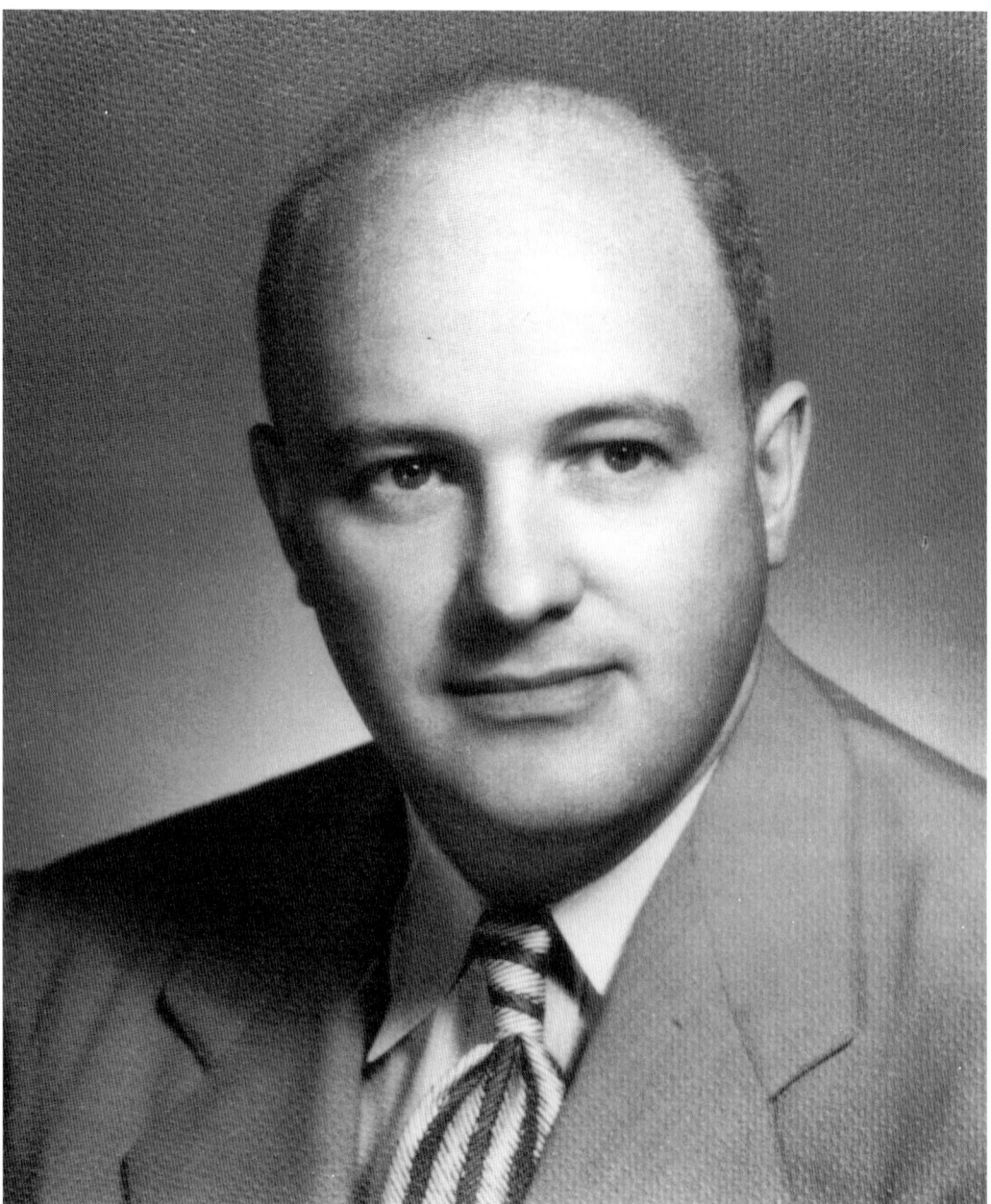

Howard Anthony
In 1934, Howard Anthony purchased a company that had been manufacturing airplane parts and moved it to Benton Harbor. The company's founder, Edward Heath, had died in an airplane crash. Under the management of Anthony and his wife, Helen, the Heath Company grew. In 1946, the company bought a large supply of surplus parts. With the parts, they produced a kit that enabled a customer to build an oscilloscope for a fraction of the cost of a factory-built oscilloscope. Thus, they started the business of building a wide variety of electronic kits, including those for radio and stereo. In 1954, 42-year-old Anthony took off on a twin-engine plane, test driving it prior to purchasing it. The plane crashed during a storm over the Smoky Mountains. He, the pilot, and four of his friends perished. (Courtesy of HMCC.)

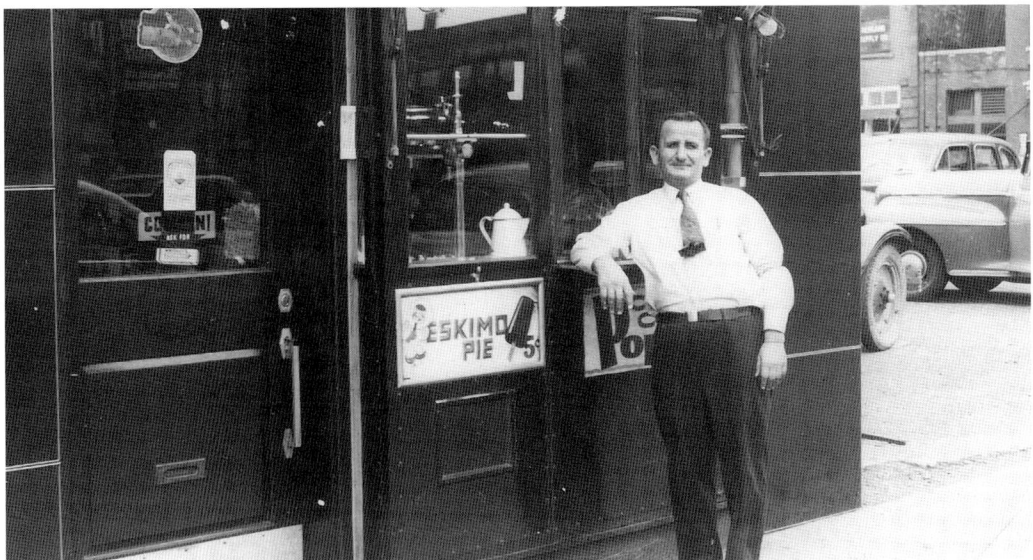

"Popcorn John" Moutsatson
Children of all ages loved Popcorn John. For three decades, they lined up to buy his treats at a little store in Benton Harbor next to the movie theater. Out of the windows, he served "the best popcorn in the world," according to Margie Souliotis. Inside were gleaming jars of assorted penny candies, caramel apples, and caramel corn. In 1958, he retired to return home to Greece. (Courtesy of Jean Govatos Wittmann.)

Robin Allen and Diana Koehler
Robin Allen (right), a former high school history teacher whose passion is books, opened award-winning Forever Books in downtown St. Joseph on April Fool's Day in 1999, knowing little about selling books. She and manager Diana Koehler, who has been with her since the beginning, nurtured the venture so that it is now a go-to destination for locals and tourists alike. (Photograph by author.)

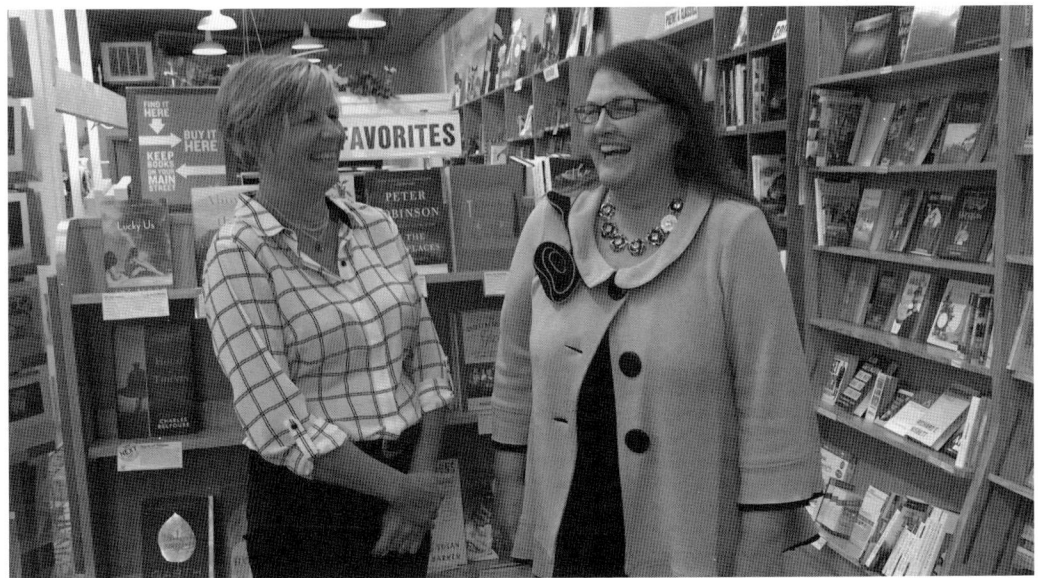

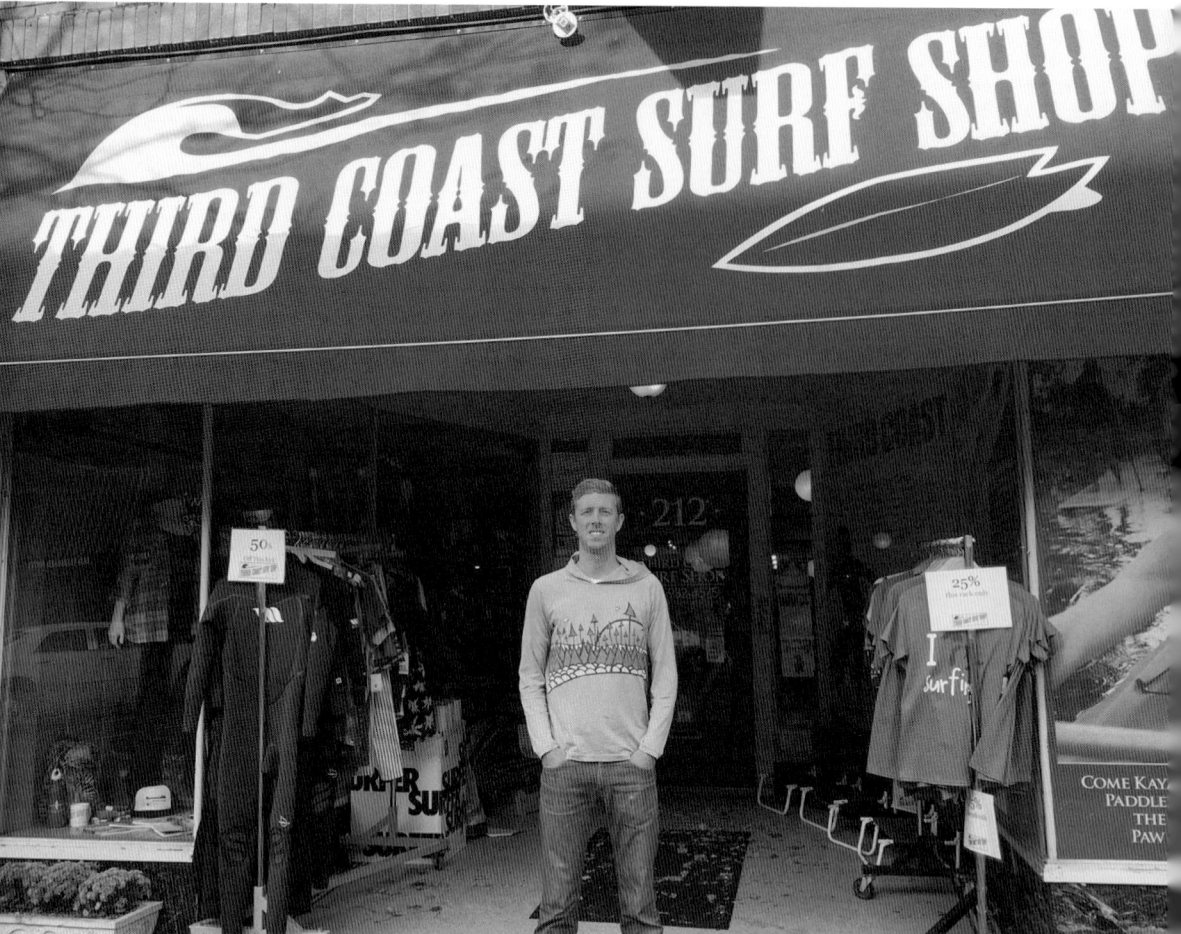

Ryan Gerard
Despite snow and ice, Ryan Gerard rides the waves of Lake Michigan. He first tried surfing at Tiscornia Park in 1998. For a few years, he pursued his passion in California. Now living in St. Joseph, he owns Third Coast Surf Shops in New Buffalo and St. Joseph as well as Third Coast Paddling in Benton Harbor. (Photograph by author.)

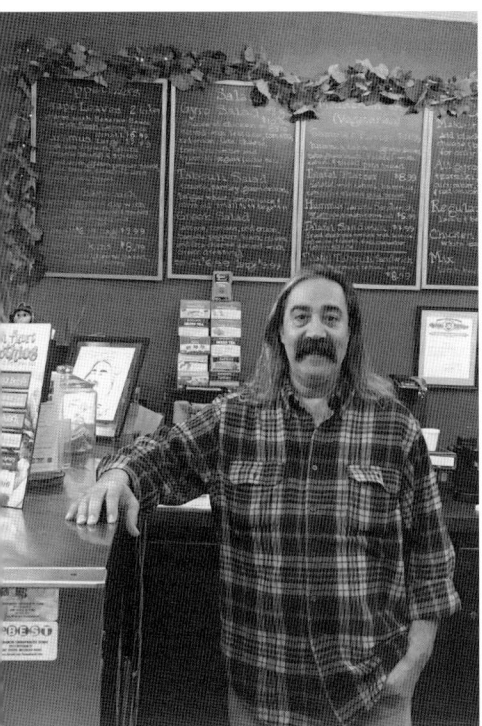

Steven Moustapha Tamim
When Steven Tamim immigrated to the United States, the only English he knew were the songs of singers like Janice Joplin and John Lennon. After several business ventures in America, he returned to what he loved as a 16-year-old in Casablanca, Morocco, where his friends said he "could touch anything and make it taste good." He now demonstrates his Middle Eastern culinary expertise at St. Joseph's Beachside Deli. (Photograph by author.)

Abel Abarca Martinez and Jayme Cousins
Abel Martinez and his wife, Jayme Cousins, opened the Mason Jar Café at 210 Water Street in 2014, with the goal of serving tasty locally grown and organic food. People flock to the restaurant, where they enjoy comfort food with a unique slant, such as grit cakes with goat cheese, topped with two eggs. (Photograph by author.)

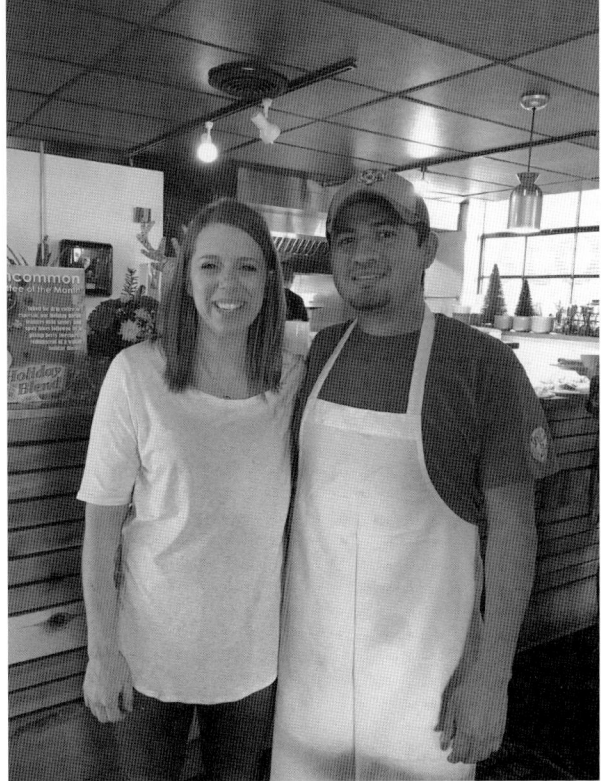

Connie Yore

Connie Yore greets shoppers with a smile when they enter Days of Yore Antiques in downtown St. Joseph. She has been in the antique business for over 50 years. The store is comfortable and cozy, with thousands of antiques, including furniture, jewelry, clothing, postcards, books, and other collectibles, artfully arranged throughout. One cannot help but notice the banners and photographs of Silver Beach and other local attractions. Connie, who graduated from Michigan State University, moved to St. Joseph in 1971. Since then, she has been an aficionado of the local history of the twin cities and strives to keep it alive. She and her late husband, Michael Yore, started the Old St. Joseph Neighborhood Preservation Society. Together with another couple, Bill and Bette Womer, they organized St. Joseph's Venetian Festival, a lively event of food, music, fireworks, and a boat parade with twinkling lights. From 1979 to 2011, it attracted tens of thousands of visitors each year. To add even more spice to their lives, they spearheaded a local chapter of Sports Cars of America as well as the Parrothead Club, a social club that partied with the purpose of raising money for charity. As a board member and volunteer of Silver Beach Carousel, she has enjoyed being part of the collective effort to bring back a taste of Silver Beach Amusement Park, which shut its doors in 1971. She takes pride in the carousel, with 48 colorful hand-carved figures and two chariots, which opened to the public in 2010. She also finds time in her busy schedule to volunteer at The Heritage Museum and Cultural Center, where her expertise in local history and antiques, as well as her donation of photographs and artifacts, is much appreciated. This dynamic lady also founded the local chapter "Burnett's Traders No. 567" of Questers International, whose purpose is to preserve and restore existing landmarks, as well as to educate through the research and study of antiques. In 2015, she had the honor of being elected president of Michigan Questers. (Courtesy of Connie Yore.)

Austin and Kelsey Bock

Walking into Bound for Freedom, Austin and Kelsey Bock's store in downtown St. Joseph, feels like being at home. It exudes a warm welcoming atmosphere, with couches in the back on which people can relax with a hot cup of coffee or tea. The store, which opened in 2014, presents a feast for the eyes, put together with care and artistic flair. Kelsey has painted murals on the walls. Colorful hand-knit scarves and hats, as well as intricate beaded necklaces, decorate the store. These and a variety of other products, including organic dried fruits, are spread across the store. Although they are young, in their 20s, Austin and Kelsey know what they want out of life. Their goal is to help people around the globe achieve dignity and independence. They say, "Every purchase that is made at Bound for Freedom goes directly to helping and supporting a cause we have selected to partner with. Whether it is giving sex trafficking victims a safe outlet and sustainable jobs or child soldiers rehabilitation opportunities, every product sold moves to equip others toward freedom." In 2009, Austin, who grew up in St. Joseph, and Kelsey, who grew up in Japan, met in an accounting class at Indiana Wesleyan. They married two years later. Each of them has traveled extensively. What they saw on travels to the Dominican Republic, Colombia, Brazil, Thailand, and Guam appalled them. People lived in stick houses, without running water; children did not attend school. Sex workers, victims of trafficking, were being exploited in red light districts in Amsterdam, Netherlands, and Chang Mai, Thailand. By selling fair trade products and social justice merchandise, they do their part in combating injustices such as these. On a wall, Kelsey has painted their motto: "Saving Lives is not a Trend, it's a Lifestyle." (Photograph by author.)

James "Babe" Couvelis

This photograph of Babe Couvelis, the proprietor of Babe's Lounge, shows him to the right of his parents, William and Jennie, and his brother Steve. Over 1,500 people attended Couvelis's wake and funeral in 2015. They laughed remembering his antics as a practical joker and cried about losing this loving and lovable 84-year-old community icon. Despite his age, Couvelis retained the humor and spirit he had as a child growing up in Benton Harbor. As a youth, he worked alongside his Greek immigrant father at Harbor Lunch in Benton Harbor. In 1958, he opened Babe's Lounge on Main Street in Benton Harbor. It was relocated to Riverview Drive in 1975. Couvelis made each of his customers feel special. They became his friends. His legacy, Babe's Lounge, continues operating under the direction of his son Jim and wife, Pauline. (Both, courtesy of Pauline Couvelis.)

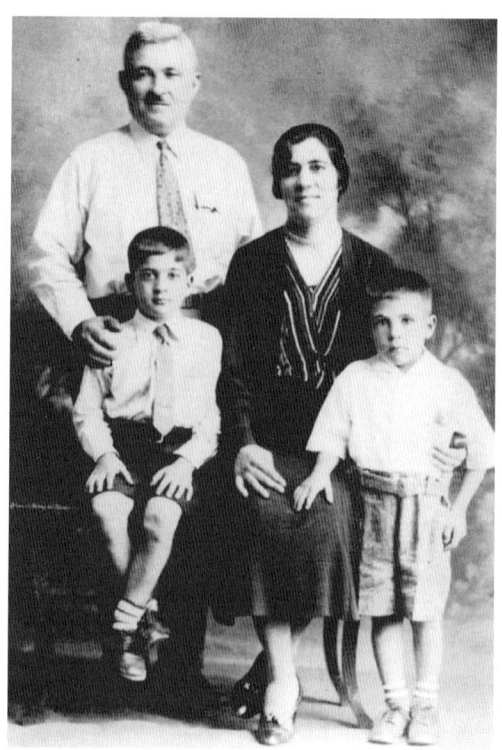

CHAPTER FOUR

Unforgettable Members of the House of David

One cannot talk about the people who contributed to the development of the Twin Cities without including the brothers and sisters of the Israelite House of David, a Christian commune established in Benton Harbor in 1903 by Benjamin and Mary Purnell.

The House of David became a national sensation because of their traveling jazz bands and baseball teams. Hordes flocked to their amusement park, where children squealed over the miniature trains and little cars they steered themselves. Adults relaxed in the beer garden built by the long-haired, bearded, teetotaling members of the Christian commune. Jazz bands, orchestras, singers, and vaudeville shows drew thousands.

But the House of David was more than an entertainment magnet. Their verdant farms contributed to making the Benton Harbor Fruit Market the largest non-citrus fruit market in the nation. An art factory produced glistening pieces of sculpture prized as souvenirs. The Israelites established restaurants, a car dealership, and even a motel and nightclub in nearby Stevensville. They became self-sufficient, producing everything needed, like food, buildings, clothing, musical instruments, and religious books.

Although the Purnells had arrived at Benton Harbor with only five others, soon their numbers soared. They came from throughout the United States, Australia, and Europe. By 1916, their membership grew to 1,000. Partly because of their practice of celibacy, their numbers dwindled by the 1970s, and in 2015, only five members remained. Three were from the House of David and two from Mary's City of David, a group that separated from the original House of David in 1930.

They split into two separate communities after the death of leader Benjamin Purnell. Half of the members followed Judge H.T. Dewhirst, and half followed Purnell's widow, Mary. The community she established only a couple of blocks away from the original House of David was named the Israelite House of David as Reorganized by Mary Purnell (known as Mary's City of David).

The House of David's troubles began a few years before Benjamin Purnell's death. In 1923, he went into hiding for four years after being subpoenaed by a grand jury. He was brought to trial in 1927. Contrary to popular opinion, he was never charged with sexual misconduct. Purnell died shortly after the trial in 1927.

The happy and sometimes sad stories of the Israelites unfold in this chapter. They include diverse personalities such as the Hannafords, who played in jazz venues throughout the country; Jackie Mitchell, the blond 19-year-old pitching wonder who created a stir when she played with her bearded, long-haired teammates; Mabel Hornbeck who, even though she was deaf, competently managed the vegetarian restaurant that served Mary's City of David's Jewish resort guests; and Ron Taylor, who is still hard at work preserving the legacy of the House of David and Mary's City of David.

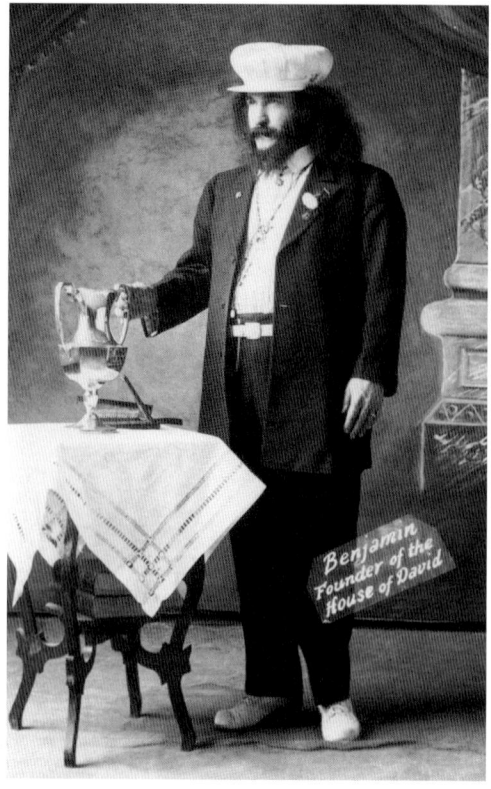

Benjamin Franklin Purnell

Benjamin Purnell and his wife, Mary, founded the Israelite House of David in 1902 and settled in Benton Harbor with five followers in 1903. By 1916, they had 1,000 members. This Christian religion was established in England by Joanna Southcott, who was known as the first messenger. They believed that 144,000 couples would be gathered and be received body and soul into a "heaven on earth," with their children leading the world into a "perpetual state of harmony and connection to God." They thought that God sent his teachings concerning the second coming of Christ through seven divine messengers. Six other messengers followed Southcott's death in 1814. Benjamin and Mary believed themselves to be the seventh and last messenger. They preached that the people gathered in their commune would prepare for the second coming of Christ by leading a pure life. Benjamin was a charismatic religious leader as well as a capable businessman, despite having had little formal education. With his guidance, the community became a major contributor to the economy of the Twin Cities. The House of David's Eden Springs Amusement Park attracted thousands of visitors. Its traveling baseball teams and talented musicians achieved national renown. The House of David farms not only produced for their own community but also for the Benton Harbor Fruit Market. Benjamin relished these successes, but in December 1927, he died a broken man. Former member Isabella Pritchard claimed that he kept a harem and that he seduced and raped from 200 to 500 girls. Pritchard asked the court to break up the colony and sell its assets to compensate former members. Facing a subpoena, Benjamin disappeared from 1922 to 1926, hidden in Diamond House on the House of David grounds. By 1927, he was frail, suffering from advanced diabetes and tuberculosis. He could hardly speak above a whisper when he testified in court. Contrary to popular belief, Purnell was never found guilty of sexual misconduct. On November 10, 1927, Circuit Court Judge Louis Fead filed his opinion declaring the colony guilty of promoting perjury and that Purnell was operating a fraudulent enterprise in the guise of religion. He ruled that Purnell and his wife be exiled from colony grounds. Purnell died shortly thereafter. Two years later, the ruling was overturned on the grounds that Fead lacked proper jurisdiction to preside over the trial. (Courtesy of HMCC.)

Mary Purnell
In 1903, Mary Purnell and her husband, Benjamin, established the House of David in Benton Harbor. The followers of the House of David believed in celibacy, abstaining from alcohol, and not trimming their hair or beards. When her husband died in 1927, there was a power struggle about who would be the leader of the community. Mary contended that since both she and Benjamin were the "Seventh Messenger," she should lead the community. Judge H.T. Dewhirst, chairman of the House of David Board, vehemently argued against that, believing Benjamin alone was the "Seventh Messenger." In 1930, the community officially split in two, in some cases pitting family against family. Half of the House of David (214) remained with Dewhirst. Half (215) followed Mary. She established the Israelite House of David as Reorganized by Mary Purnell (referred to as Mary's City of David) two blocks away. Even though most of the land, the amusement park, and buildings had been retained by Dewhirst's followers, Mary made the best of what she had. She catered to summer visitors by establishing a welcoming atmosphere for Romanian Jews of Chicago—even building them a synagogue. From the 1930s until the 1960s, they came to the resort, where they enjoyed vegetarian cuisine at Mary's Restaurant. Mary had also retained an unfinished hotel in downtown Benton Harbor. When completed in 1931, Mary's City of David Hotel, built with a special material that shimmered in the sunlight, provided a steady source of income. Mary's City of David also had productive farms that Southwest Michigan's farmers envied. Mary had successes, but she also suffered heartaches. Prior to her coming to Benton Harbor, her 16-year-old daughter Hettie was burned to death in a munitions factory explosion. She could be identified only by the ring that Mary's friend Cora Mooney had given her. Her son Coy, who had suffered from alcohol addiction, died of pneumonia in 1924 when he was 43. She also experienced ugly court trials, the death of her husband, and the breakup of the House of David. Nevertheless, Mary maintained a positive outlook. Into her elder years, she continued to inspire her followers with her inner strength and unwavering faith. Beginning in 1947, she led 700 consecutive nights of religious meetings. She died at 90 years of age in 1953. (Courtesy of HMCC.)

Francis Marion Thorpe

Francis Thorpe is the bearded man pictured to the right of Benjamin Purnell. They are on the steps of the Berrien County jail following Purnell's arraignment in 1926. Thorpe assisted Purnell's legal team during his three-month trial in 1927 and wrote the books *Crown of Thorns: House of David Victory* and *Legal Troubles Reviewed* in 1929 and the *Mantel of Shiloh* in 1946. Thorpe, who joined the House of David in 1905, served the Israelite community for 53 years. From 1914 to 1931, he did an excellent job in managing the baseball teams even though he did not play baseball himself. When the House of David split into two factions, he became one of Mary Purnell's staunchest supporters, serving on the City of David's governing board. (Courtesy of HMCC.)

CHAPTER FOUR: UNFORGETTABLE MEMBERS OF THE HOUSE OF DAVID

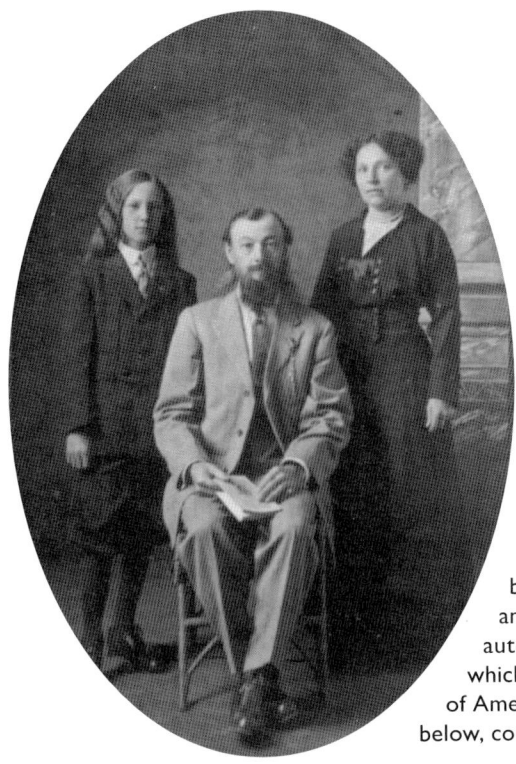

Louis and Albert Baushke
This portrait is of either Louis Baushke's or Albert Baushke's family. Brothers Louis and Albert, Benton Harbor carriage makers, were early followers of the Purnells, as were other members of the Baushke family. A total of 22 Baushke family members joined the colony in 1903. The two brothers established a foundation for the nascent Israelite House of David by donating properties and money. In 1895, Louis and Albert had built one of the first gasoline-powered automobiles made in the United States, seen below, which is now on display at the Antique Automobile Club of America (AACA) Museum. (Above, courtesy of HMCC; below, courtesy of AACA Museum.)

The Mooney Family
Silas and Cora Mooney and their son, Paul, were three of the five people who accompanied Benjamin and Mary to Benton Harbor. Cora was Mary's closest friend. R. James Taylor in *Portraits: the Face of a Century in Faith*, noted the following: "It was said that when the two ladies, Cora with brilliant red hair and Mary with raven black hair, would wear their tresses down often on excursions into town. It apparently drew attention both in length and beauty of their hair." Silas worked on Israelite farms and unlike this formal photograph wore bib-overalls, work boots, and an old felt brim hat. Paul, a baseball player, supposedly was offered $20,000 to sign a contract with the Chicago Cubs. He refused. Paul eventually left the House of David. His parents stood with Mary after the split and remained steadfast supporters. (Courtesy of Mary's City of David.)

CHAPTER FOUR: UNFORGETTABLE MEMBERS OF THE HOUSE OF DAVID

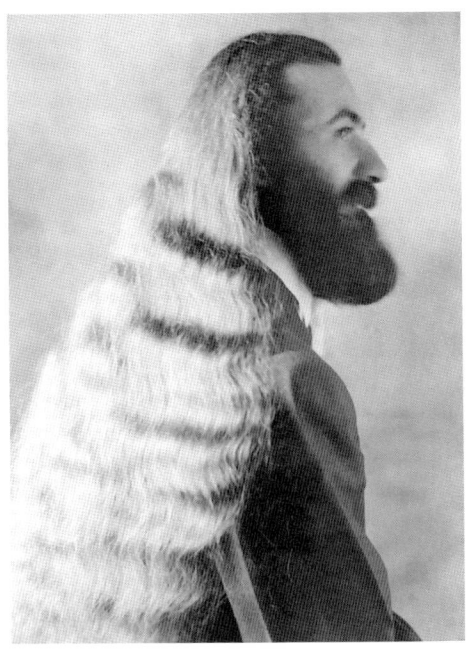

Frank Rosetta
Creative genius Frank Rosetta came to the House of David with his family in 1907, at age 13. He excelled in both music and art. The prizewinning 1929 Blossomtime Grand Floral Parade float pictured below was designed by him. For the next three decades, the floats he created won prizes for the House of David. By 1938, he had become manager of the arts department at the House of David. The hydro-stone process he developed made the smooth shimmering pearl-like ceramics and sculptures produced by the House of David artisans highly prized souvenirs. Their sizes ranged from small figurines to seven-foot statues. Unfortunately, the process of producing hydro-stone is lost. Rosetta took it to his grave. (Both, courtesy of Mary's City of David.)

Mabel Hornbeck

Mabel Hornbeck and her husband, Estelle, were one of 20 couples married at a House of David mass wedding in 1910. For 30 years during the summers, she managed Mary's Vegetarian Restaurant, which Jewish vacationers who stayed in cabins on the property appreciated since the meals were kosher. Although completely deaf from a childhood accident, Hornbeck read lips, even those that were partially hidden by Israelite beards. (Courtesy of HMCC.)

Frank Wyland

Frank Wyland, here with his dog Lucky, played baseball for the House of David. Powerfully built and strong in character, he was one of those responsible for keeping the peace. A loyal friend of Benjamin Purnell, he stayed at his side throughout his court appearances in 1926 and 1927. After the split-up of the two factions following Purnell's death, he chose to join Judge Dewhirst. (Courtesy of HMCC.)

CHAPTER FOUR: UNFORGETTABLE MEMBERS OF THE HOUSE OF DAVID

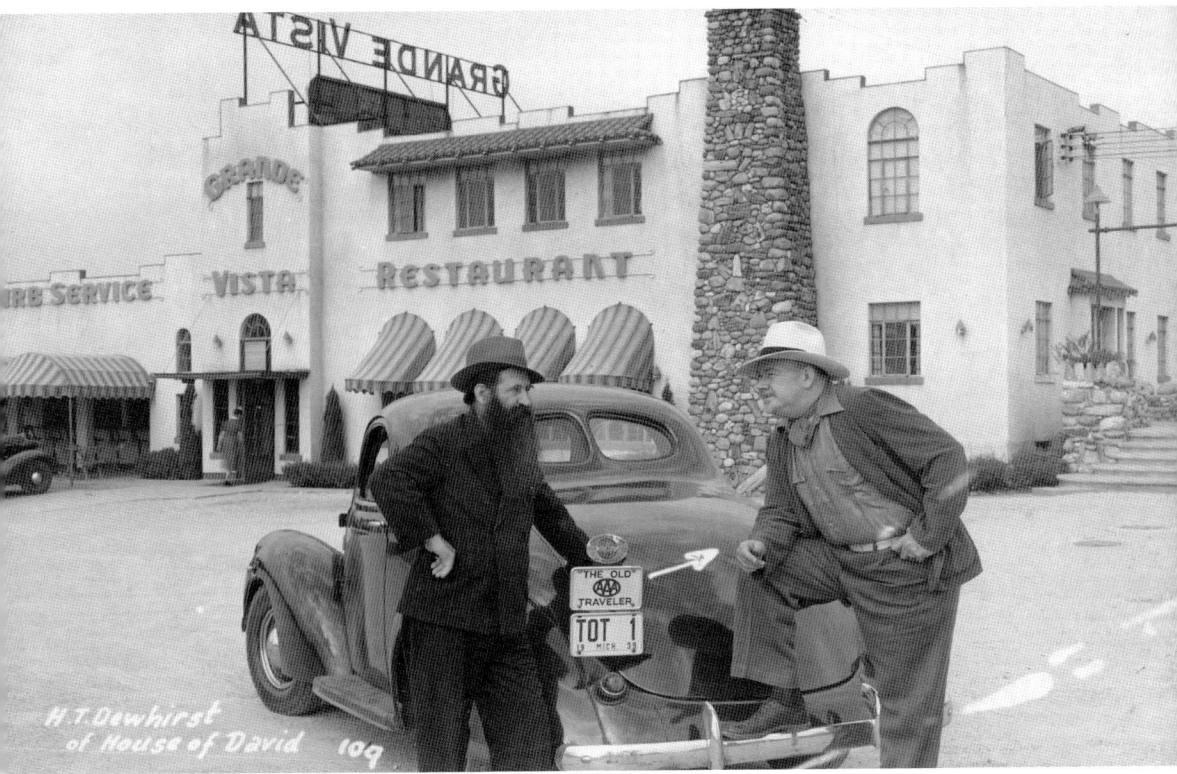

Judge H.T. Dewhirst
Judge H.T. Dewhirst of the House of David is shown on the left with an unidentified man at the Grande Vista, a House of David motel and restaurant in Stevensville. After Benjamin Purnell's death in 1927, a controversy raged within the House of David about who should take charge—his widow, Mary Purnell, or Dewhirst. By 1930, the House of David had split in two. Half of the members of the House of David remained with Dewhirst and half followed Mary Purnell, who established Mary's City of David two blocks away. Dewhirst, who had been a judge in the Superior Court in San Bernardino, California, came to the House of David with his wife and two sons in 1921. He proved himself a capable and intelligent leader whom Benjamin Purnell relied upon. During the 1920s, he provided legal counsel for the community, including during the trial of Benjamin Purnell. Under Dewhirst's leadership, the House of David thrived. He and his followers counted the following as accomplishments: an enormous cold storage facility four stories high; one of the first refrigerated dairy barns; an auto dealership and service garage; and the Grande Vista, a Stevensville motor lodge that wowed visitors with its fancy restaurant and the courtyard fountain that glowed with multicolored lights. The generosity of Dewhirst and the House of David during the Depression endeared him to the people of St. Joseph and Benton Harbor. He offered free entertainment at Eden Springs Park, as well as charitable contributions. He also hired indigent men to work at the House of David industries. During World War II, the House of David's production of food assisted the war effort. German prisoners worked along with House of David members to bring the produce to market. When Dewhirst died in 1947, the community and the press lauded him for his accomplishments. (Courtesy of Israelite House of David.)

Joseph Hannaford

In 1905, Joseph Hannaford, his wife Rachael, and their children journeyed to Benton Harbor as part of the contingent of 85 families from Melbourne, Australia. Hannaford, who owned and operated the largest music store in Melbourne, excelled in making string instruments. His wife, Rachael, an accomplished harpist, and his five sons and daughter played in the House of David bands and orchestras. After the eldest son, Ephraim, left the colony to join a New York jazz band, the family became immersed in jazz. During the Roaring Twenties, the House of David jazz bands that the family assembled toured nationally as the Shaveless Sheiks of Syncopation and the Syncopep Serenaders. In 1906, Hannaford was elected president of the Israelite board and remained an important leader until he died in 1947. (Courtesy of HMCC.)

CHAPTER FOUR: UNFORGETTABLE MEMBERS OF THE HOUSE OF DAVID

Clarence "Chic" Bell
As a child, Chic Bell came from Australia to the House of David with his family in 1905. He was amongst the 85 Australians who marched down the streets of Benton Harbor to band music when they arrived. An excellent trumpet player, Bell became a leader of House of David musicians. He initiated and became the emcee for "Amateur Night," a popular entertainment that Twin Cities elders remember fondly. Bell also participated in the Twin Cities Symphony Orchestra when it started in 1951. (Courtesy of HMCC.)

Manna Woodworth

Manna Woodworth, musician, conductor, and composer, joined the House of David in 1911 at 15 years of age. Woodworth, an outstanding musician, learned to play 11 instruments. During his career at the colony, he directed House of David bands and composed the march "Parade of the Blossoms" in honor of the Blossomtime Grand Floral Parade. (Courtesy of HMCC.)

Virne Beatrice "Jackie" Mitchell Gilbert

In 1931, Jackie Mitchell struck out both Babe Ruth and Lou Gehrig in an exhibition game between the Lookouts and the Yankees. The 19-year-old southpaw joined the House of David Eastern Team in 1933 and was a nonmember, paid player for one season. The blonde beauty created quite an audience sensation when seen amongst the bearded Israelites. (Courtesy of Mary's City of David.)

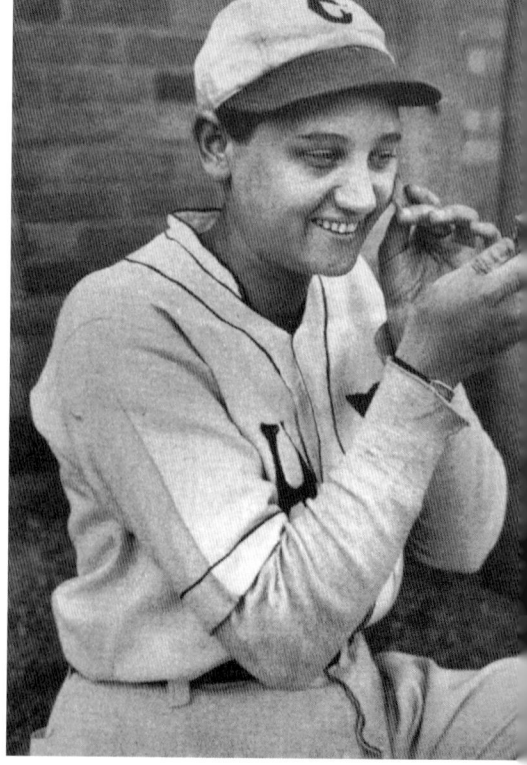

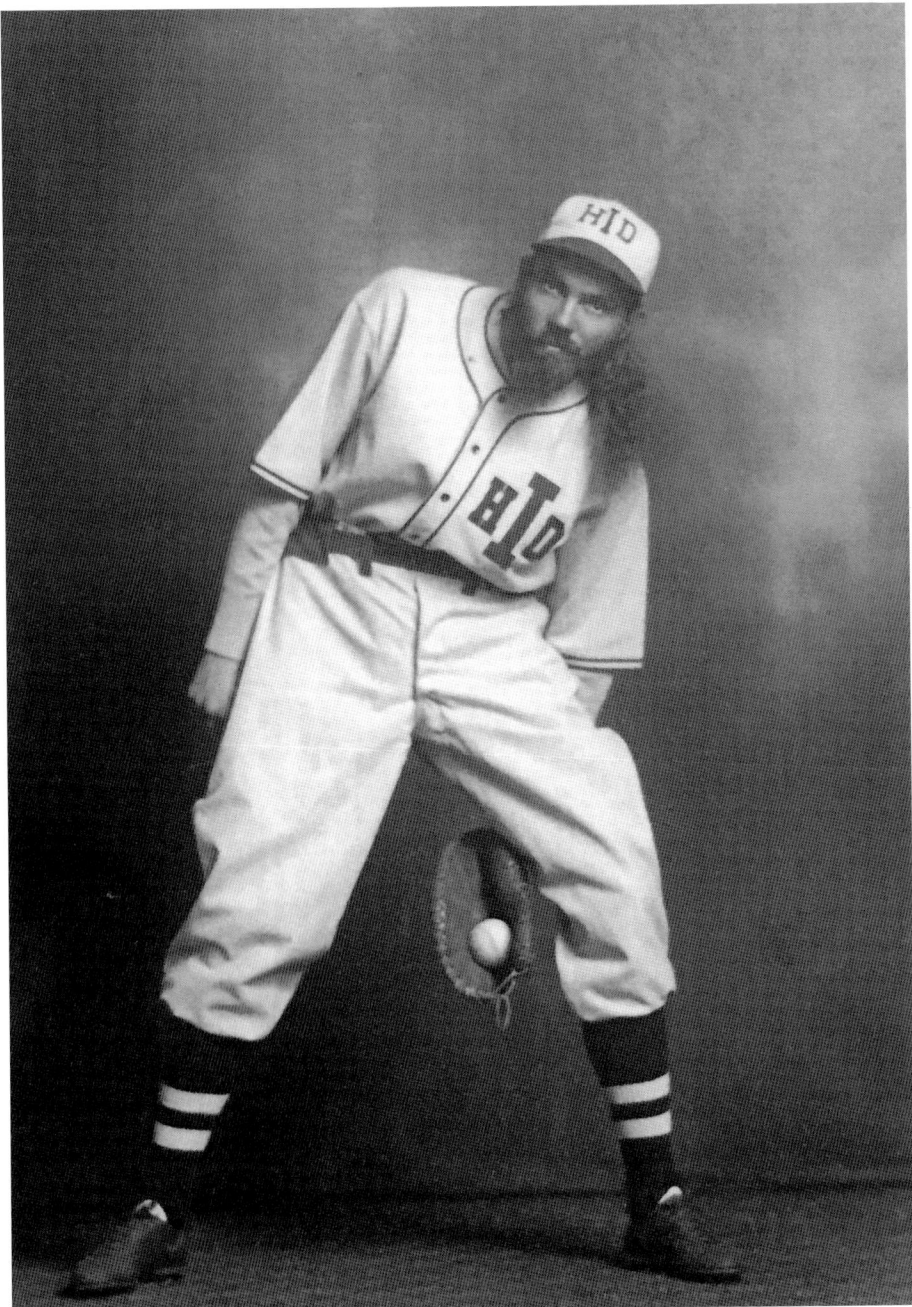

John "Longjohn" Tucker
John Tucker delighted fans by catching baseballs between his legs and behind his back in the Pepper Game. A 1934 poster said this fast-moving demonstration was "worth the price of admission alone!" Tucker had come to the House of David as a 13-year-old with his family in 1915. From 1923 to 1934, he played first base for the House of David and then Mary's City of David. He managed Mary's teams until 1942, when he left to join Auto Specialties baseball team in St. Joseph. After they stopped playing in 1957, he coached Little League. (Courtesy of Mary's City of David.)

R. James "Ron" Taylor

Ron Taylor, a slight soft-spoken man, puts heart and soul into preserving the legacy of Mary's City of David on Britain Avenue in Benton Township. Because of his tenacity and passion, Mary's City of David, with 81 buildings upon 140 acres, received approval for listing in the National Register of Historic Places as a "historic district." Taylor not only serves on the governing board, manages rental property, and supervises contractors, but he also gets dirty making repairs on the buildings, planting flowers in the garden, and plowing snow. As a scholar, he has explored the history of the commune and shared his knowledge by writing books and conducting tours. On Sundays during the summers, visitors can often catch him at the expansive museum that he designed and curated. Until 2014, he played first base on the City of David's vintage baseball team, a gentleman's game following pre–Civil War rules that include not swearing or spitting. Taylor came to Mary's City of David to work in the greenhouse in 1974, and three years later, he joined the faith of his paternal grandparents. His grandparents and their young child, Ron Taylor's father Frederick, made the arduous journey from Sydney, Australia, to the House of David in 1932. Frederick abandoned the faith, got married to Frieda Jonas, and they had three children, Ron, Robert, and Sylvia (Lieberg). When Taylor was a child, his mother died, and prior to his father remarrying, he went to live with his grandparents at Mary's City of David for a year and a half. At that time, he had no interest in religion. It was not until after he went to college and started exploring various religions, from Buddhism to Mormonism, that he decided to embrace the faith of his grandparents. He has thrown himself wholeheartedly into his religion, working more than eight hours each day at Mary's City of David. He does not have much time to pursue his art (he has a fine arts degree from the San Francisco Art Institute). His exquisite and delicate drawings of the female figure, as well as his photographs of nature, can be seen at local galleries and the museum store. Taylor, now in his 60s, will not slow down. Just like the Energizer Bunny, he never stops. He uses his talents in service to Mary's City of David and to the Twin Cities. (Photograph by Suzanne Snider.)

CHAPTER FIVE

Talented Titans of Sports and Recreation

From the turn of the century, the people of the Twin Cities, as well as tourists, participated in a variety of sports and recreational activities. Lake Michigan provided the ideal setting for summer play.

Entrepreneurs Logan Drake and Louis Wallace started out by giving boat rides on the lake. Beginning in 1891, they broadened their venture to a full-scale amusement park. Year by year, they added new attractions, including a dancing pavilion, roller coasters, a fun house, and a swimming pool. The amusement park on the shores of Silver Beach in St. Joseph delighted locals and tourists until it closed in 1971.

The mineral baths created another big draw for tourists during the first half of the 20th century. Osteopathic physician Dr. W.E. Salzman recognized the healing powers and business opportunity of the waters. Despite smelling like rotten eggs, his baths and others in the area brought in thousands of tourists each year. Salzman advertised that the baths would cure "rheumatism, skin, blood and nervous diseases."

The people of the Twin Cities enjoyed sports such as wrestling, boxing, baseball, basketball, and football. They were not only a means of recreation but also a way for the citizens of small-town USA to develop community spirit and to encourage young athletes. High school athletes, such as Joique Bell and Wilson Chandler, went on to develop stellar professional careers. Unfortunately, football player Sam Dunlap, because he was born black at the beginning of the 20th century, did not have the same opportunity. He faced discrimination at Western Michigan University and after graduation in 1919. A couple of his teammates at the university threatened to quit if he remained. The coach told them to take the next train back home. The player who remained became a close friend.

Award-winning Bobo Brazil broke the color barrier that existed in wrestling in the 1950s. At that time, African American wrestlers mostly fought other African Americans, with little chance at winning a title. Brazil wrestled Gorgeous George, André the Giant, Killer Kowalski, Buddy Rogers, and the Sheik. Brazil gained fame with his "Coco Butt." Holding the back of his opponent's head, he bumped him on the forehead with his head. Brazil's career in wrestling extended about 40 years.

Boxing, as well as wrestling, was a popular sport in the Twin Cities. Still talked about today is the 1920 boxing match between Jack Dempsey and Billy Miske, which determined who would be the heavyweight champion. Dempsey won in the third round. The fight, which was arranged by local promoter Floyd Fitzsimmons in his Benton Harbor arena, attracted more than 11,000 people.

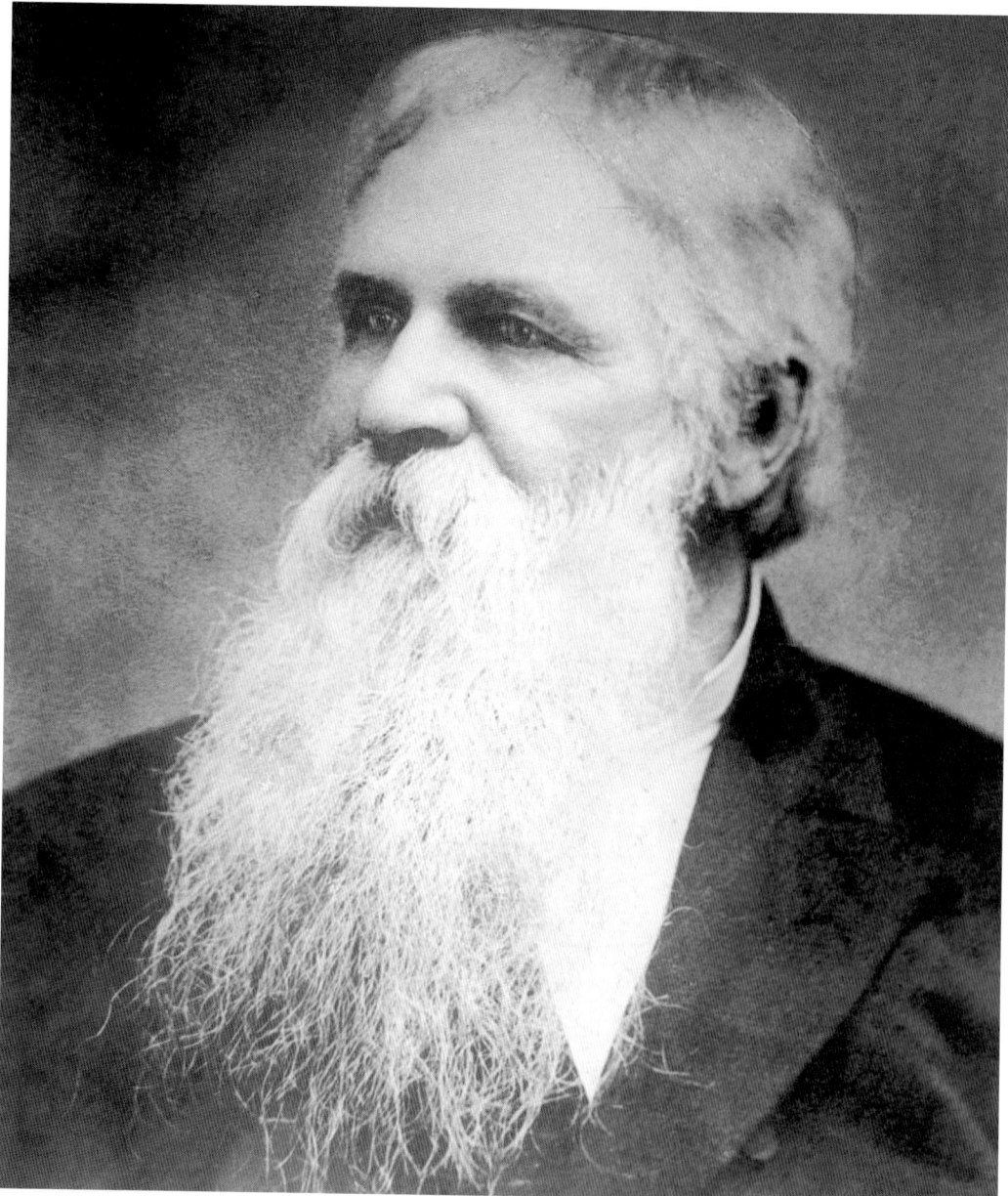

Col. Harry Eastman
Col. Harry Eastman, a retired Civil War colonel and former mayor of Green Bay, Wisconsin, purchased acreage in Benton Township in 1879–1880. There, he established Eastman Springs, a haven for those seeking a cure of their ills by drinking the clear spring waters. As described in the 1915 booklet, *The Metropolis of the Michigan Fruit Belt,* "twenty-seven springs have been analyzed all showing a different analysis. Their valuable and widely different properties make them cover a wide range of usefulness in the cure of various diseases. 'Silver King' and 'Silver Queen' are among the most famous and their free flowing, clear, cool and sparkling water are highly recommended by the best physicians as valuable remedies for rheumatism, gout, stomach and liver troubles etc." Eastman also shipped bottled water to Chicago. (Courtesy of HMCC.)

CHAPTER FIVE: TALENTED TITANS OF SPORTS AND RECREATION

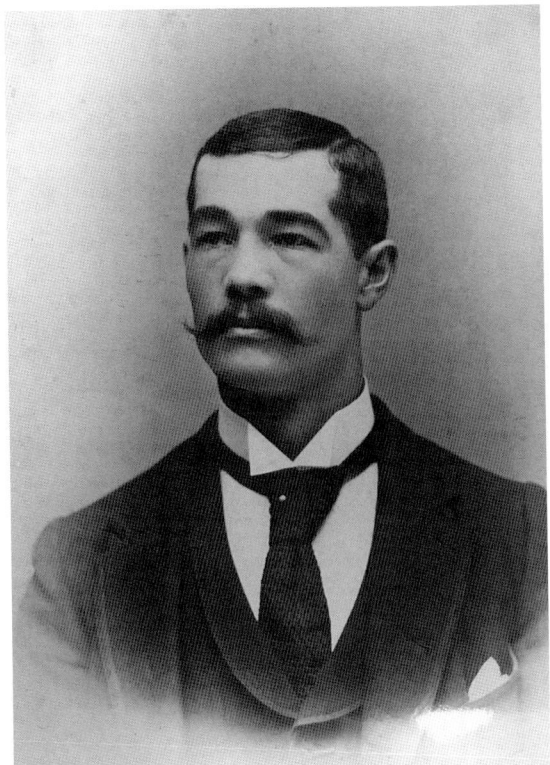

Logan Drake and Louis Wallace
In 1891, Logan Drake (left) and Louis Wallace (below, on the right) developed the Silver Beach Amusement Park on the shores of Lake Michigan in St. Joseph. The toboggan waterslide they installed on their 22-acre park created such a hit that they added a circular sea swing. Then came a tintype studio and a wooden boardwalk where visitors could shop for souvenirs or enjoy hot dogs. In ensuing years, they installed a dance pavilion, a roller rink, swimming pool, bowling alley, and rides such as the carousel and roller-coaster. Not only were Drake and Wallace business partners, but they also married the two Slanker sisters and became brothers-in-law. Their partnership lasted until the 1930s, when Wallace sold his share to Drake. The amusement park continued to delight visitors throughout the Midwest until 1971. (Courtesy of Silver Beach Carousel Museum.)

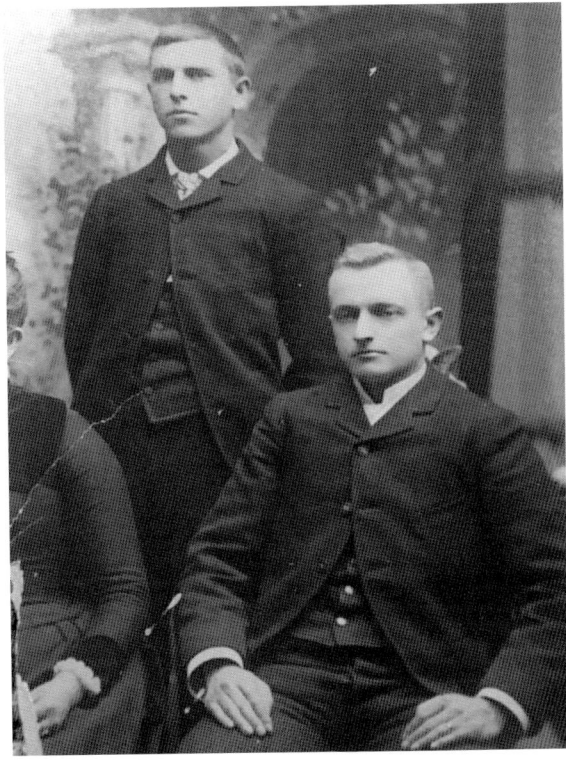

Roberta "Bobby" and Horace "Chief" Terrill

Bobby and Chief Terrill are shown with Chief Terrill's mother in the middle. Bobby, Logan Drake's daughter, met Terrill at a Shadowland Dance, and they married in 1945. Terrill took over the operation of Silver Beach in 1947. He added rides, including the Tilt-A-Whirl, Tarantula, and Rock-O-Plane. Silver Beach closed in 1971, after bringing joy to millions of people. (Courtesy of HMCC.)

W.E. Saltzman

Dr. W.E. Saltzman's Mineral Bath House in Benton Harbor could cure "rheumatism, skin, blood and nervous diseases." Saltzman, an osteopathic physician, operated the bathhouse and the adjacent hotel since the beginning of the 20th century. During the first half of the century, Chicagoans flocked to the Twin Cities to partake of the baths. (*Benton Harbor: The Metropolis of the Michigan Fruit Belt.*)

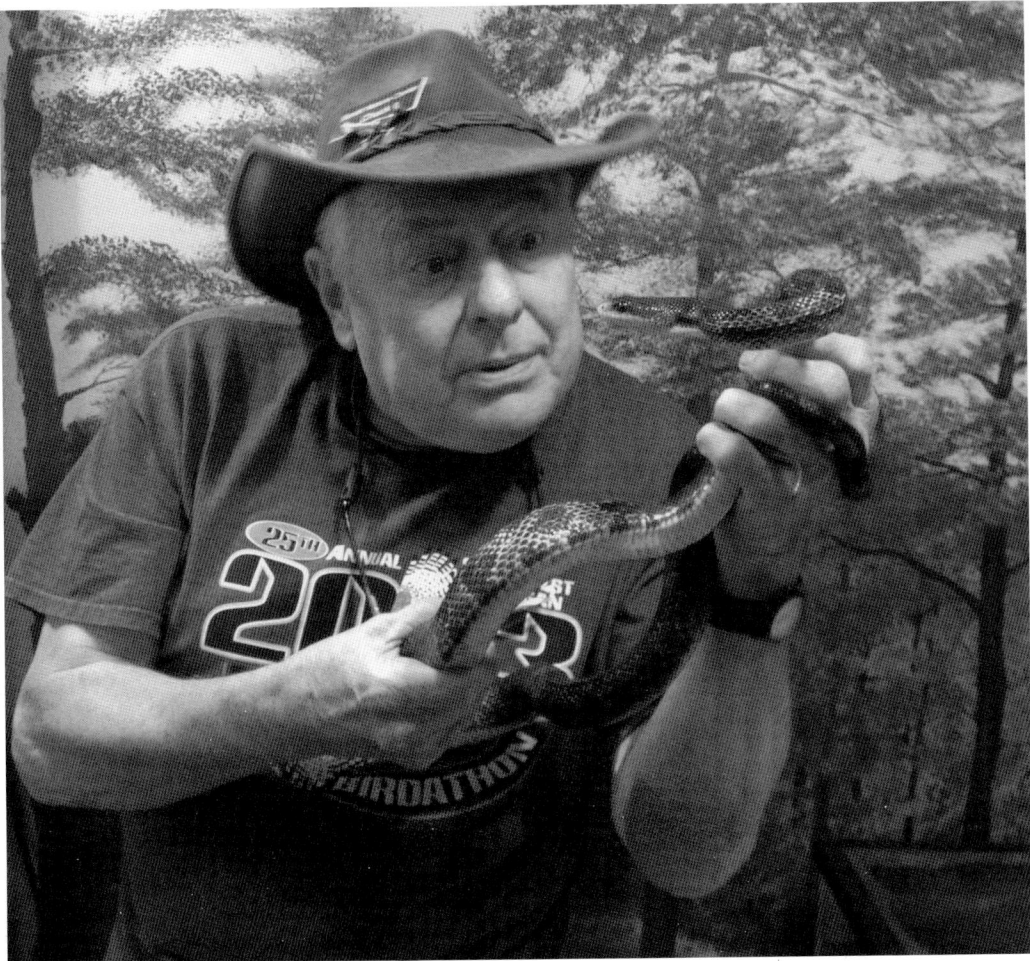

Chuck Nelson

For 43 years, Chuck Nelson has been the force behind the success of Sarett Nature Center in Benton Harbor. Nelson has a reassuring voice, a terrific sense of humor, a quick intelligence, and a bottomless well of knowledge about nature. His passion in life is to share his love of nature with others. Each year 25,000 children and adults take advantage of the various nature programs that Sarett offers. These range from trips in a Voyager canoe, lessons in cross-country skiing, and listening to the birds. Many years ago, Nelson took the author's four-year-old daughter Diana out for a cross-country ski lesson. On the trail with other youngsters, she could not get her breath and started to wheeze. Nelson lifted her on his shoulders and carried her back. He had her breathe into an inhaler to ward off her asthma attack. What could have been a tragedy was averted by his quick thinking and his gentle caring attitude. On another trip in the dark of night, Nelson demonstrated his famous owl call (hoo-hoo-hoo-hooooo) to a rapt audience of nature lovers. They were excited when his call was answered by another hoo-hoo-hoo-hooooo. They soon found out that it was not an owl that answered but another naturalist. Not perturbed, good-natured Nelson tried it once again. When Nelson came as the lone person to run the nature center in 1971, it consisted of 130 acres and a 2,200-square-foot building. Under Nelson's administration, it grew to 1,000 acres, an educational center of 9,240 square feet, and a staff of 12. Nelson retired in 2013. A naturalist he brought to Sarett, Diane Braybrook, has taken over as director. Nelson, as director emeritus, continues to open up the wonders of nature through his teaching and capable leadership. (Photograph by author.)

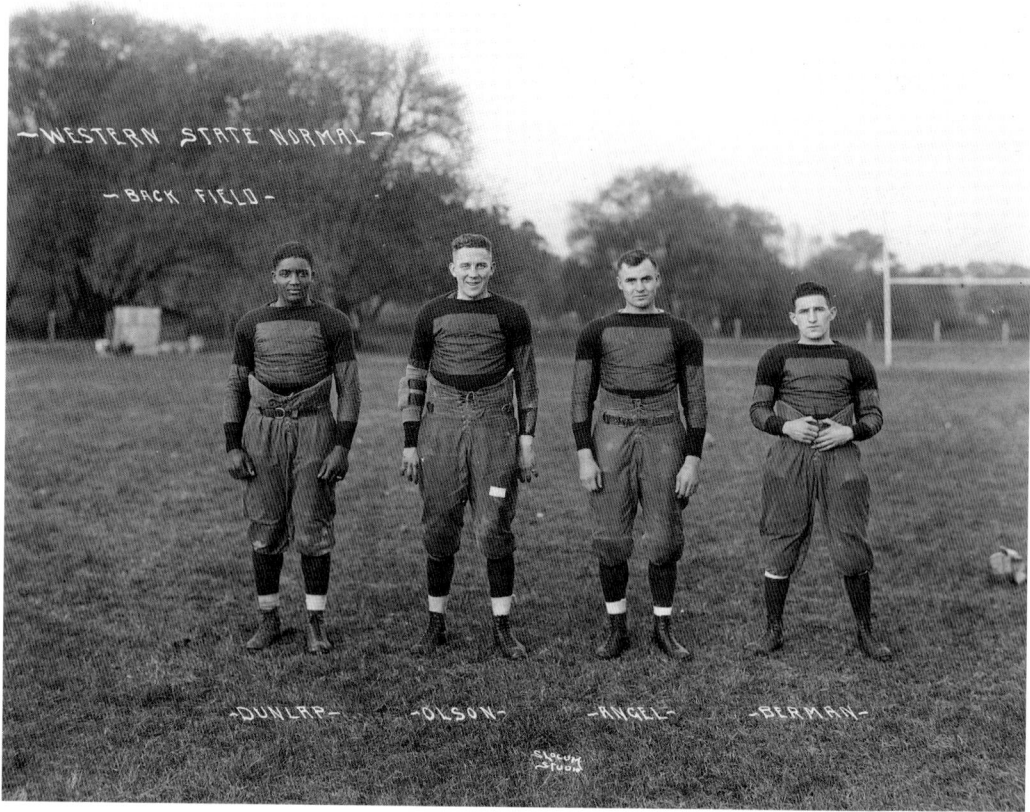

Sam Dunlap

Sam Dunlap is pictured on the left with teammates at Western Michigan University. "He was a leader. People would be drawn to him. People respected him highly, but also he respected people highly," said Carol Elam of her uncle. Dunlap's leadership skills were evident at Benton Harbor High School. Although he was the only black team member, he became the captain of the football team. Dunlap followed in the footsteps of his uncles Frank and Robert Busby, powerful athletes who played football for Benton Harbor at the turn of the century. Dunlap was named to the all-state high school football team. He also excelled in basketball, baseball, and track. After high school, Dunlap wanted to attend the University of Michigan, but they did not want a black athlete. He became the first black athlete at Western Michigan University, playing there in 1915–1917 and 1919. In 1918, he served in the Army. Dunlap participated in several sports and earned 11 letters. In 23 football games, he scored 188 points and 30 touchdowns. In 1916, he scored 19 touchdowns, the highest in the nation. Knute Rockne felt he would have been a sure All-American if he had been playing at a school that had a bigger football presence. Although Dunlap received accolades as an athlete, off the field he suffered discrimination. A couple of athletes at the university threatened to quit the team if he remained. The coach told them to take the next train back home. The player who chose to stay became a close friend. According to an article written by Nate Jackson for the *Western Herald*, after graduation, he became head coach at West Virginia Collegiate Institute, an African American college. The racial problem was so bad in the South (he could not get used to carrying a gun to defend himself) that he left after three years. Although he gave up this coaching position, Dunlap continued playing football until he was 42 years old. In 1951, Dunlap returned to his alma mater, thinking he would be hired as a coach. Unfortunately, the man who encouraged him to come died. He became a custodian. "The Black Ghost," as he was called by his football fans, finally achieved recognition 14 years after his death. In 1975, Dunlap was elected to the Western Michigan University Hall of Fame. (Courtesy of Western Michigan University Archives and Regional History Collections.)

CHAPTER FIVE: TALENTED TITANS OF SPORTS AND RECREATION

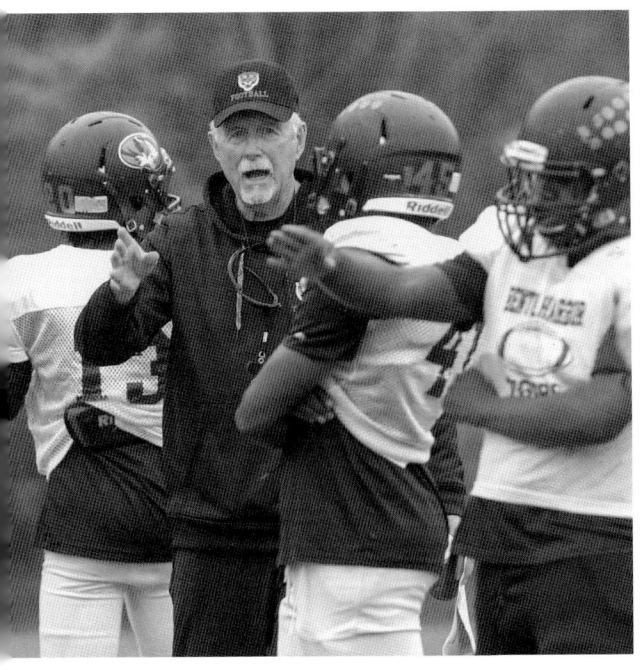

Elliot Uzelac
The Benton Harbor Tigers had never had a winning season since 1989, nor been to the playoffs until 2015, the year 74-year-old Elliot Uzelac came out of retirement to take over as football coach. He inherited a team that had lost 68 of its last 72 games. The former coach at Navy, Western Michigan, and St. Joseph High School embraced the challenge. He not only showed the Tigers how to run, tackle, and throw the ball, but he also took a personal interest in each player. He made sure they had decent meals and arranged for tutors. He helped find them jobs that would not interfere with practice. The players gained a sense of pride and self-esteem. What started out as just a game and a place to be with friends, ended up changing the direction of their lives. (© Kirthmon F. Dozier/*Detroit Free Press* via ZUMA Wire.)

Floyd Fitzsimmons
Benton Harborite Floyd Fitzsimmons, shown here with friend Jack Dempsey, had an exciting career, including the promotion of the 1920 Jack Dempsey vs. Billy Miske fight for the heavyweight boxing title. The fight, which attracted more than 11,000 people, took place at the Floyd Fitzsimmons Arena in Benton Harbor. Prior to being converted to accommodate the fight, the property had been used by Fitzsimmons's semiprofessional baseball team, the Speed Boys, as well as by the House of David baseball team. Fitzsimmons not only promoted boxing but also became active in horse racing, where he got convicted of bribing a Michigan State legislator. Because of his poor health, he got an early release from prison. He died of a heart ailment in 1949 at 63 years of age, just four months after leaving jail. (Courtesy of Chriss Lyon.)

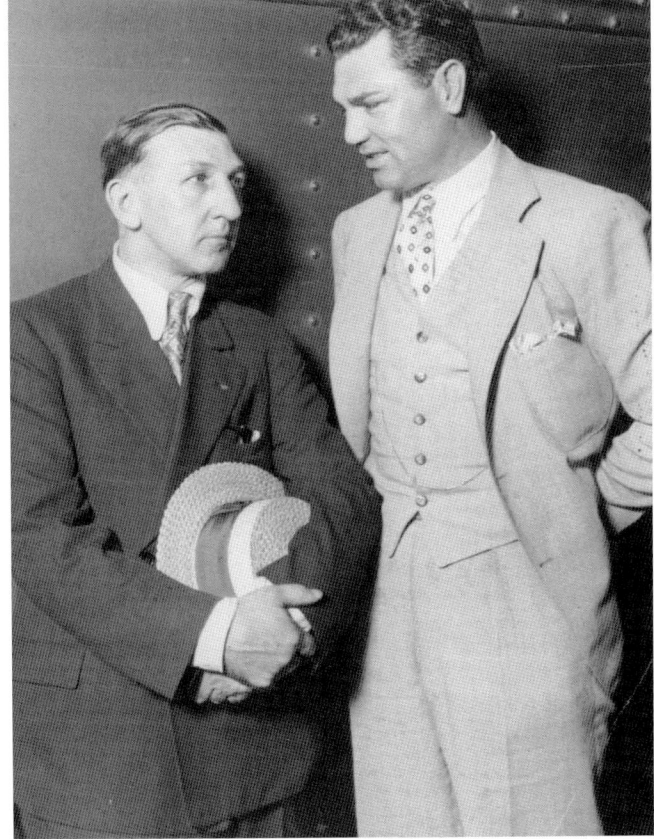

LEGENDARY LOCALS

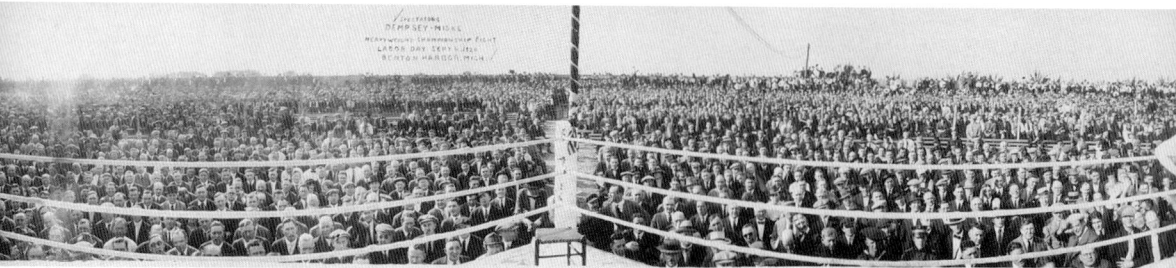

Jack Dempsey
The first fight broadcast on radio, the fight for the heavyweight championship, with Jack Dempsey vs. Billy Miske, happened in Benton Harbor on Labor Day 1920. Dempsey won the fight in the third round, retaining his title. According to Floyd Fitzsimmons, a local promoter, the fight brought 11,346 people to Benton Harbor. The fight was at Fitzsimmons Arena (as indicated in the 360-degree photograph above), built upon a baseball field in the southeast corner of the intersection of Fair and Britain Avenues. An article in the September 3, 1920, issue of the *News-Palladium* shows Dempsey with a blond 17-year-old girl, Lola Wallin, who had come from Rockford to see him fight. When she discovered that she did not have enough money, she took a job serving ice cream to earn the money. When Dempsey came in, along with Fitzsimmons, the girl recognized him and set up two "heaped up" dishes of ice cream, which

CHAPTER FIVE: TALENTED TITANS OF SPORTS AND RECREATION

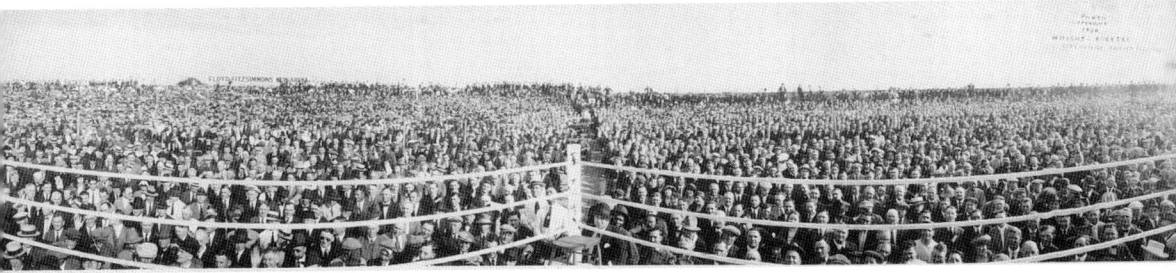

made a big hit with Dempsey. He offered her a $30 ticket to the fight. When she told him her story, he told her to quit work and enjoy herself in Benton Harbor. The article concludes, "In the minds of most people Jack Dempsey is just a big burly fellow who can punch harder than any other living man. Only close friends of the world's heavyweight champion, know, perhaps, that he also has a big heart and never misses an opportunity to do a kind act." Agreeing to fight Miske might have been another one of Dempsey's kind acts. Although not publicized in the media, Miske was suffering from Bright's disease. Dempsey knew Miske needed the money from the fight to support his wife and children. With improved treatment, Miske went on to fight 24 times in the four years before he died. He was never defeated. (Above, courtesy of the Library of Congress; below, courtesy of HMCC.)

Bobo Brazil (Houston Harris Sr.)
The fans of Bobo Brazil, the "Jackie Robinson" of wrestling, revered him—not only for his wrestling accomplishments but also for his charisma, positive outlook, and good heart. This "gentle giant," who was six feet, four inches, and 280 pounds, reached out to help others. Percival A. Friend recalls, "Bobo always took the time before and after his matches to be with the fans. He had a gentle handshake for the kids and spent many of his extra free hours in children's hospitals nationwide. He would call every child 'CHAMP' and make sure that they had a smile on their face when he left."

Brazil was born in Arkansas in 1924. When he was seven, his father died. His mother, Ruby, and his grandfather Ivy Jones raised him. After living in East St. Louis, the family moved to Benton Harbor. To help the family, he picked fruit during the summers. Brazil became a baseball player for the House of David team in the 1940s. Later, he played in the minors for the Minneapolis Millers. According to Ross Davies, author of *Bobo Brazil*, wrestler "Jumping Joe" Savoldi watched him play for the Millers. Noting his athleticism and sturdy build, Savoldi convinced him to try wrestling.

In his first matches, he got bruised and beaten. Bobo wanted to return to baseball. Savoldi persuaded him to keep at it, and with training and perseverance, he became a champion. His career in wrestling extended about 40 years. In the 1950s, African American wrestlers mostly fought other African Americans, with little chance at winning a title. Brazil shattered this color barrier, wrestling Gorgeous George, André the Giant, Killer Kowalski, Buddy Rogers, and the Sheik. Brazil gained fame with his "Coco Butt." Holding the back of his opponent's head, he bumped him on the forehead with his own head. When he first trained for this by hitting his forehead against a board, it gave him headaches.

In 1961, he became the first African American to win the National Wrestling Association United States Heavyweight Title. He held the title of Professional Wrestler of the Year from 1967 to 1972. The World Wrestling Federation inducted him into their Hall of Fame in 1994. When he died in 1998, the whole community mourned his death. In his honor, they named the Armory Building the Bobo Brazil Community Center. (Courtesy of Professional Wrestling Hall of Fame; photograph by Lil Al's.)

LEGENDARY LOCALS

Joique Bell
Each year, Joique Bell hosts a football and cheer/dance camp at Benton Harbor High School, his alma mater. Joique Bell received the 2009 Harlon Hill Trophy as Division II College Football Player of the Year when he was a senior at Wayne State University. From 2012 to 2016, he played as a running back for the Detroit Lions. (© Kirthmon F. Dozier/*Detroit Free Press* via ZUMA Wire.)

Wilson Chandler
Tattoos cover Wilson Chandler's six-foot, eight-inch, 220-pound body. One says, "Thrill." Spectators get thrills watching him play basketball with the Denver Nuggets, just like they did in 2005, when he led Benton Harbor High School to an undefeated season record. After he spent two years at DePaul University, the New York Knicks drafted him in the first round. He played for a Chinese team prior to joining the Nuggets in 2011. (Photograph by Jim Faklis.)

CHAPTER SIX

Creative Artists and Literary Geniuses

Since the days of the early settlers, the creative arts have given vibrancy and purpose to the communities of St. Joseph and Benton Harbor. In recent years, the arts have spurred the economic development of the area. In comparison to other small cities in rural areas, the Twin Cities seem to have nurtured an extraordinary number of artists and entertainers. One of the many colorful characters featured in this chapter is poet Ben King, who has a monument dedicated to him in St. Joseph's Lake Bluff Park. He belonged to the Whitechapel Club, a group of Chicago newspapermen and other prominent people who met in Chicago from 1889 to 1894. The club was named after the area where Jack the Ripper stalked young women, and their macabre meeting place was decorated with skulls, nooses, and knives. Another famous poet was Lew Sarett, a Northwestern professor who was much in demand as a speaker. He sometimes appeared dressed as an Indian or woodsman. Monte Blue, a silent film star, lived in Benton Harbor, as did Ruth Terry. As a child, Terry won many talent shows at the Liberty Theatre. As an adult, she acted in cowboy movies with Gene Autry and Roy Rogers. World-renowned jazz musician Gene Harris also got his start in the Twin Cities. As a young teenager, Harris had his own local radio show, with listeners calling in for him to play their favorites on the piano. His daughter Niki Haris, former backup singer for Madonna, comes to Benton Harbor almost every year to give a community concert in his memory. Octogenarian jazz trumpeter Ed Bagatini operates a downtown St. Joseph music store, as well as wows audiences with the music created by his ensembles. For decades, John Howard served as the inspiration to other musicians. He directed the St. Joseph High School Band and the St. Joseph Municipal Band. There have also been visual artists aplenty. They include internationally acclaimed sculptor Richard Hunt, a visionary who spurred the development of the Benton Harbor Arts District by opened a satellite studio there. He asked talented photonic artist Jesús López, who specializes in creating holograms, to become an artist-in-residence. Artists in both Benton Harbor and St. Joseph have reached out to the community by developing galleries, museums, and educational programs. Resident Benton Harbor glass artist Jerry Catania and other faculty offer various glass classes through the nonprofit school Water Street Glassworks, including Fired Up!, a free after-school program for local teens. Painter Anna Russo-Sieber, director of the ARS Gallery in Benton Harbor, reaches out to youth through the "I am the Greatest" art workshop, which is based on the life of Muhammad Ali. Painter Olga Krasl was an early founder of the Krasl Art Center in St. Joseph. The moral and financial support she and her husband, George, provided made it possible to build the center. Robert Williams, who has created award-winning portraits, was instrumental in the development of the Box Factory for the Arts in St. Joseph.

Benjamin "Ben" Franklin King

Ben King, a humorist and poet, was born in St. Joseph in 1857. He used two names, Ben King and Bow Hackley. Bow Hackley, an African American who was one of the town comedians, made such an impression on King that he adopted his name when he started publishing verses in the African American dialect. King's bronze bust was installed at Lake Bluff Park in St. Joseph, Michigan. His poem "The River St. Joe" is published on the granite base:

> Where the bumblebee sips and the clover's in bloom,
> and the zephyrs come laden with peachblow perfume.
> Where the thistle-down pauses in search of the rose
> and the myrtle and woodbine and wild ivy grows;
> Oh, give me the spot that I once used to know
> by the side of the placid old River St. Joe!

King was a member of Whitechapel Club, a gathering of newspapermen and other prominent men who met in Chicago from 1889 to 1894. They named the club after the London slum where Jack the Ripper stalked young women. The decor of the club created a macabre mood. As described in an article published in the winter 1989 issue of *American Journalism*, a member who was superintendent of a hospital for the insane donated some skulls he had used to try to determine differences between those of normal persons and those of the mentally ill. The club's "chaplain, decorator, and all-round handyman neatly sawed off the tops, implanted brightly colored glass in the eye holes and rigged the skulls as shades for the club's gas lighting fixtures." The article describes a room covered with Indian blankets, tomahawks, bows and arrows, nooses, knives, and a series of photographs showing pirates before and after beheading. The club was not for the weak-hearted. When a man rose to speak, whether member or guest, the members took pride in shouting insults at him. Ben King is mentioned in a list of the best of what they called the "sharpshooters." King died in 1894 while on a speaking tour at Bowling Green, Kentucky. He left a wife and two young children, ages nine and five. The poet's mother reported that her son had come to her in a dream the night he died and said, "Mother, I just went out after a thought, and went too far." (Courtesy of HMCC.)

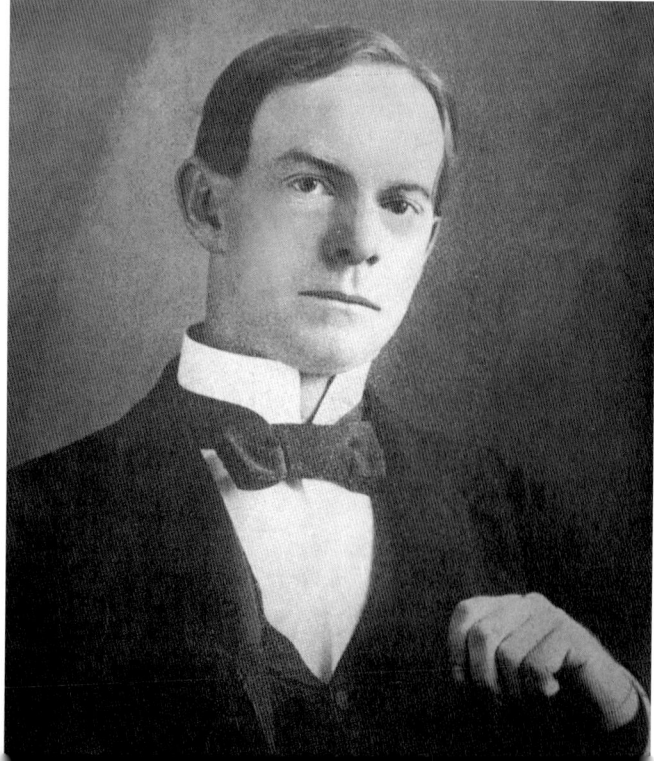

Lew Sarett

Lew Sarett had several monikers, including Lewis Saretsky, Lone Caribou, and Woodsman Poet. His Jewish immigrant parents named him Lewis Saretsky when he was born in Chicago in 1888. In 1895, the family settled in Marquette, Michigan, where he roamed the woods near the shores of Lake Superior. He was disappointed when he and his mother had to return to the Chicago slums, while his father searched for work. The family of three moved to Benton Harbor in 1902. At Benton Harbor High School, he excelled as an orator, debater, athlete, and scholar. After going to college, he changed his name and became a Christian. Sarett attended the University of Michigan, Beloit College, Harvard, and University of Illinois Law School. Sarett became a popular teacher of speech and poetry, first at the University of Illinois and then Northwestern University. His five books of poems and three books about speech won him critical acclaim. To honor him, Northwestern University created the Lew Sarett chair of speech. Sarett also gained renown as a horticulturist who produced six new award-winning varieties of dahlias. During his presentations throughout the country, he sometimes appeared as a woodsman or an Indian. The Chippewa Indians, with whom he had lived, gave him the name "Lone Caribou." He loved the outdoors, and he periodically took off from academia to work as a ranger in Montana and Wyoming or as a wilderness guide in northern Minnesota. The "Woodsman Poet" captivated audiences with poems such as "God Is at the Anvil":

> God is at the anvil, beating out the sun;
> Where the molten metal spills,
> At His forge among the hills
> He has hammered out the glory of a day that's done.
>
> God is at the anvil, welding golden bars;
> In the scarlet-streaming flame
> He is fashioning a frame
> For the shimmering beauty of the evening stars.

Sarett enjoyed sharing his love of nature with others. It is fitting that Sarett Nature Center in Benton Harbor bears his name. In 1965, 11 years after his death, Sarett's high school friend William Vawter and his wife, Elizabeth Upton Vawter, donated 130 acres as a legacy to him. By 2014, Sarett Nature Center had expanded to 1,000 acres. Sarett and his wife, Margaret, had two children, Lewis Hastings Sarett, a distinguished chemist who synthesized cortisone, and Helen Osgood Sarett Stockdale, an attorney. (Courtesy of Northwestern University Archives.)

Jill Culby

Jill Culby (also known by the pen names Jennifer Greene, Alison Hart, and Jeanne Grant) lives a quiet life on a Benton Township farm with her husband, Larry. The heroines of her 85-plus novels, on the other hand, experience excitement, adventure, and romance. She has received many awards, including the Nora Roberts Lifetime Achievement Award, one of the highest honors for romance writers. (Photograph by author.)

Jerry Kirshenbaum

For 30 years, Jerry Kirshenbaum worked at *Sports Illustrated*, where he covered five Summer Olympics and guided the investigations regarding the Pete Rose gambling scandal and the Ben Johnson Olympic doping disqualifications. He also worked for the *Minneapolis Tribune* and *Time* magazine. He got his start at the *News-Palladium* in his hometown of Benton Harbor. Northwestern University's Medill School of Journalism inducted him into their Hall of Achievement in 2011. (Courtesy of Jerry Kirshenbaum.)

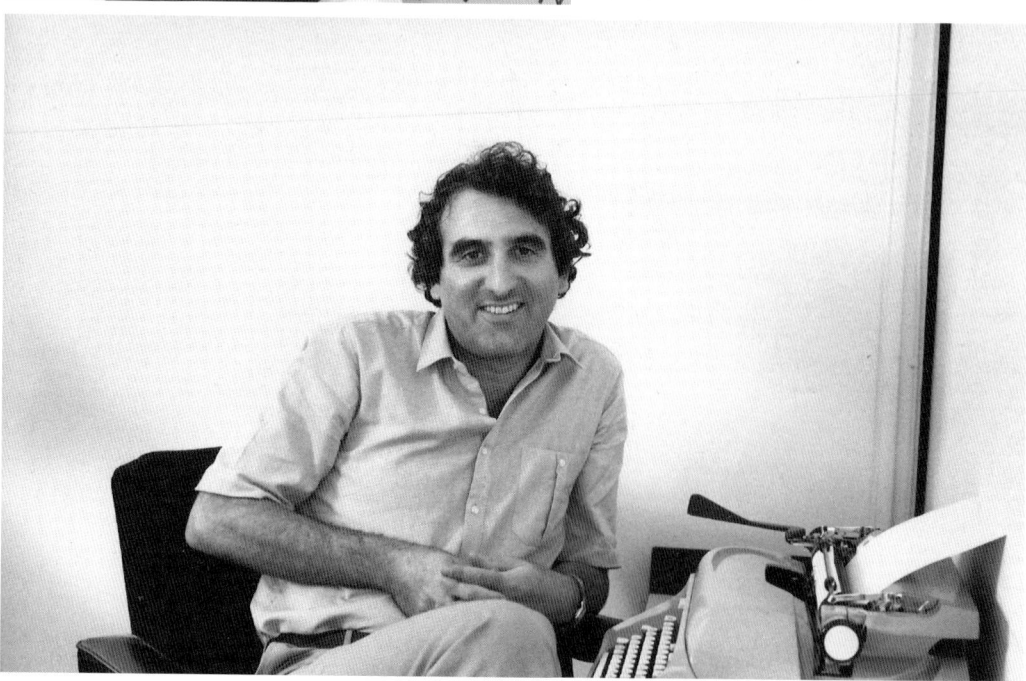

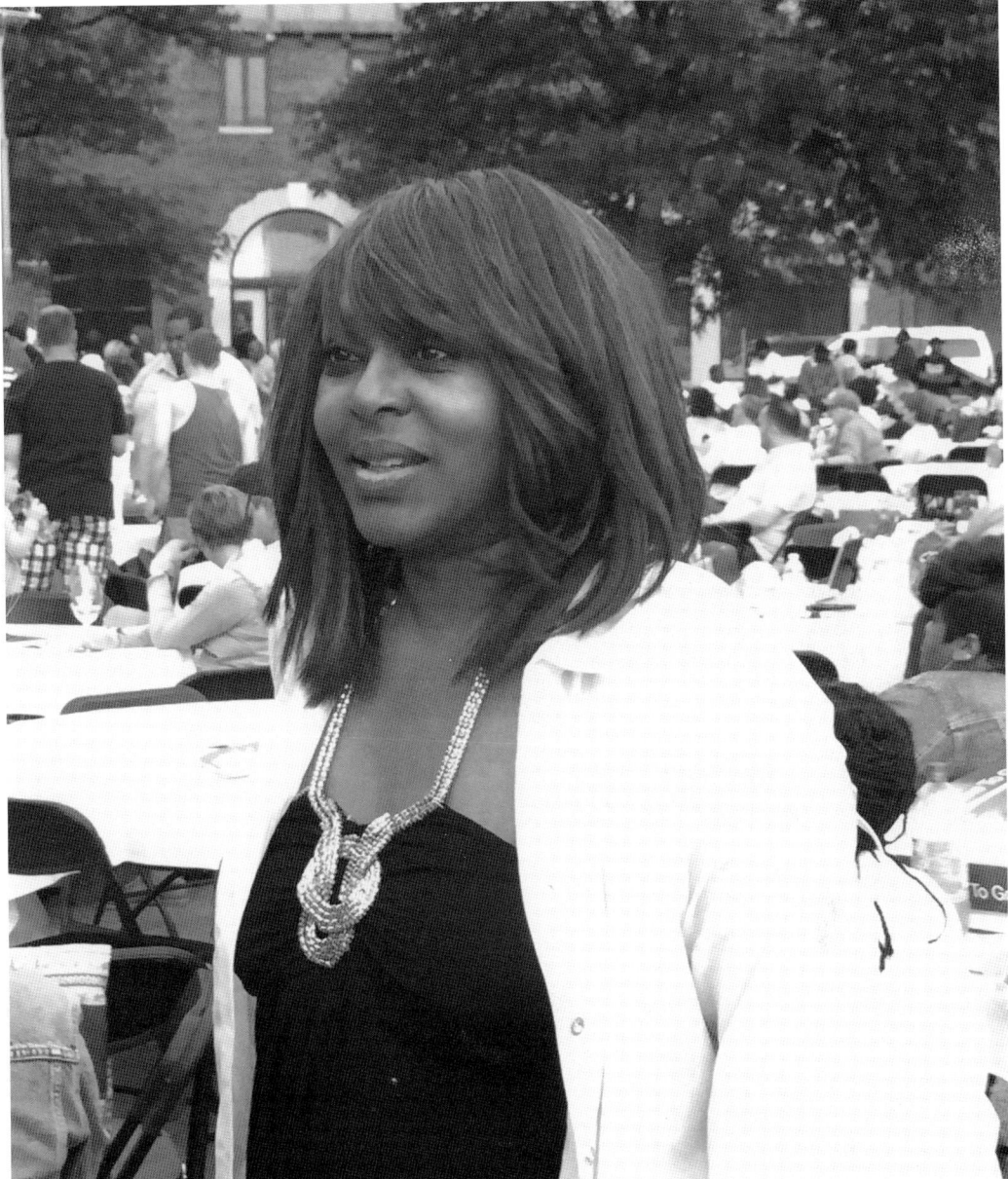

Princella Tobias

In 2001, Princella Tobias took the bold step of publishing the *Benton Spirit* (now known as the *Benton-Michiana Spirit*). She became the first female and first African American to found, own, and operate a newspaper in Southwest Michigan. The Twin Cities Area Business and Professional Women honored Tobias with its 2007 Woman of Achievement Award for "the significant and positive contribution the *Benton Spirit* has made to the community." They commended Tobias for giving the community "its voice, ownership of its image and sense of civic pride to its residents." The following year, Tobias received the Martin Luther King Legacy of Freedom Award from Andrews University because of her "passion, courage, commitment and generous service to Southwest Michigan." Tobias, a Benton Harbor native, continues to guide and inform the community with her positive outlook and generous spirit. (Photograph by author.)

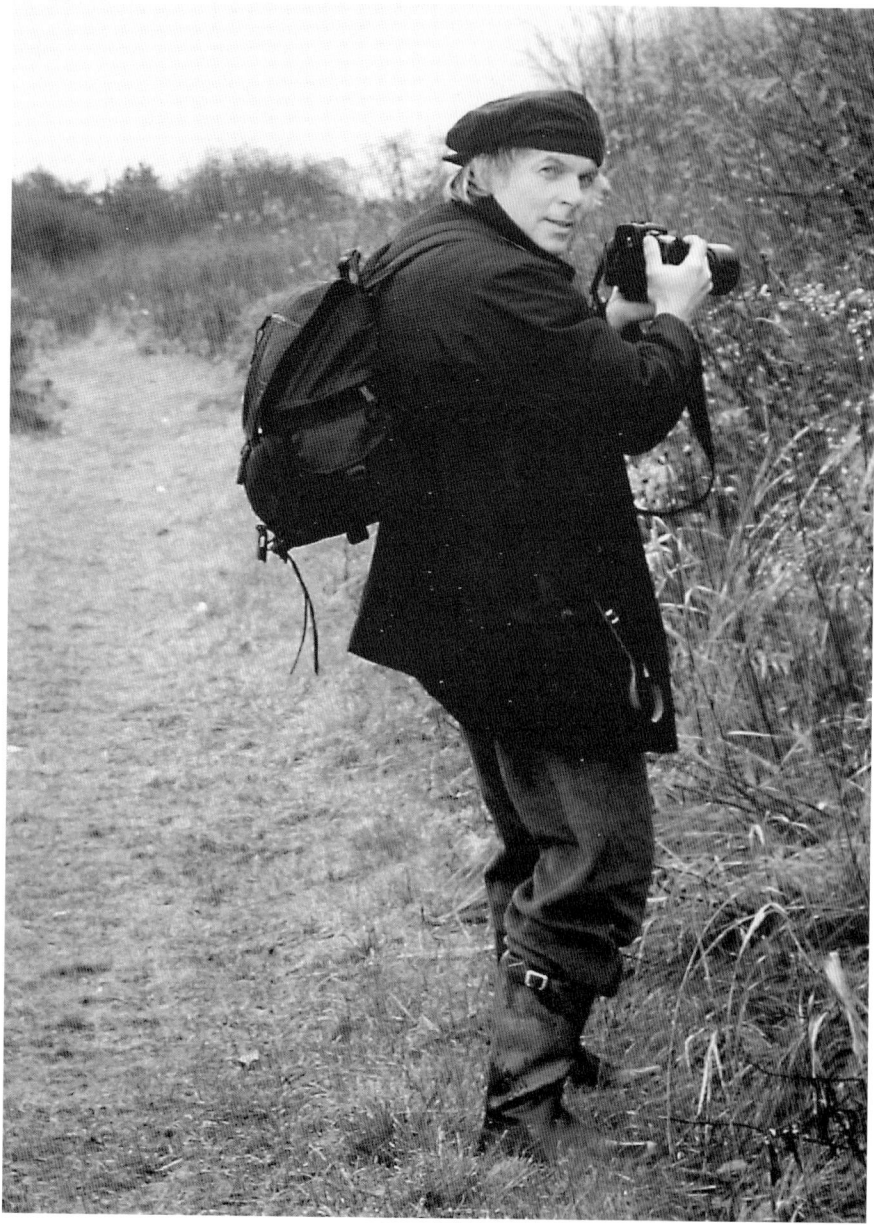

Jay Schadler

Jay Schadler, two-time Emmy Award-winning journalist, has tracked Bengal tigers, pursued poachers on the Old Silk Caravan route, mountain-biked in the rainforest to report on Mayan archeological discoveries, witnessed the tomb opening at the Great Pyramids, and hitchhiked 15,000 miles throughout America. He also examined the desperate search for an AIDS treatment in the underground drug network, investigated a hazardous waste incinerator plant in North Carolina, and reported on the notorious 1932 Tuskegee experiments. For three decades, the 1970 graduate of St. Joseph High School was a correspondent and anchor for *ABC News*. His work has also appeared on *20/20, PrimeTime, Good Morning America, World News, Nightline, National Geographic TV, Discovery, Bravo*, and *PBS*. He now has an art studio and gallery in Portsmouth, New Hampshire, that features his fine art photography. (Courtesy of Jay Schadler.)

Rodney "Rod" Seely Ruth

Rod Ruth demonstrated his talent in this card he sent to friends. The noted cartoonist and wildlife artist was born in Benton Harbor in 1912, but he and his wife moved to the Chicago area, where they raised their children. He started illustrating "The Tooties Family" for the *Chicago Sun* in 1940. The comic strip appeared there and in other newspapers until 1956. One of the many children's books that feature his drawings is *Peter Rabbit*. In *Grandfather's Stories*, he wrote about pioneer settlers Seely McCord and Will Ruth, his grandfathers. The book, filled with humor and whimsical illustrations, shows what Benton Harbor was like at the beginning of the 20th century. (Courtesy of HMCC.)

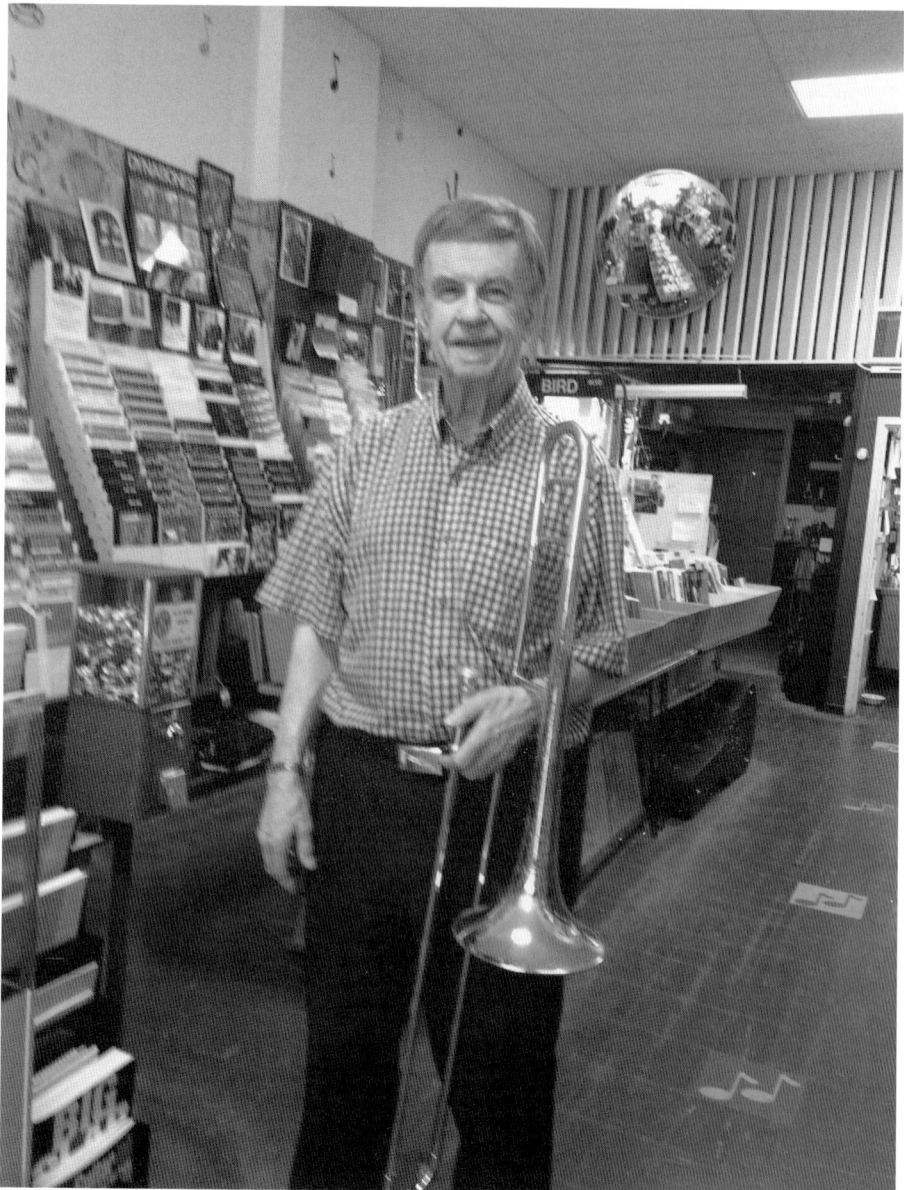

Ed Bagatini

Multitalented Ed Bagatini is renowned as a music teacher, trombone player, band leader, composer, and arranger. Since 1962, along with his wife, Adrienne, he has operated Bagatini's Music Store in St. Joseph, a popular gathering place for musicians. Besides selling instruments and sheet music, his clients report that he is a "genius" at fixing instruments. His fans rock to the jazz and swing music created by his ensembles. Although his father was a professional clarinet player, Bagatini chose the trombone. At age 14, he played for Carole Lombard during a World War II bond drive. After graduating from Eastern Michigan University, he joined the 5th Army Headquarters Band at Fort Sheridan. He also performed with a jazz octet at WJJD in Chicago, along with gifted musician Bill Evans. Raised in the Upper Peninsula, he does not mind the winters in St. Joseph, where he has resided since the 1950s. Bagatini continues with the same busy schedule he had decades earlier, with the same energetic fervor and drive. (Photograph by author.)

CHAPTER SIX: CREATIVE ARTISTS AND LITERARY GENIUSES

The Misfits
What started as a senior citizens' sing-a-long group morphed into The Misfits. They entertained thousands with musical comedy skits throughout Southwest Michigan, Indiana, and even Branson, Missouri. Joan Nozicka selected and arranged their programs. From the left are Nozicka, Martha Cabbage, Glenda Monteith, Esther Hahne, Marge Frohbieter, Millie Carney, Edna Paul, Beulah Reihle, Earl Kreiger, Imogene Keller, Sam Bigger, Irv Martin, and Louis Arent. (Courtesy of Joan Nozicka.)

John E.N. Howard
John E.N. Howard, seen with Mayor Franklin Smith receiving an award, imparted his love of music to thousands of students at St. Joseph High School from 1948 until he retired in 1963. In 1948, he also started directing the St. Joseph Municipal Band. He guided the band for 40 years. Howard, a generous philanthropist, donated money for the band shell named in his honor, as well as to many other causes. (Courtesy of HMCC.)

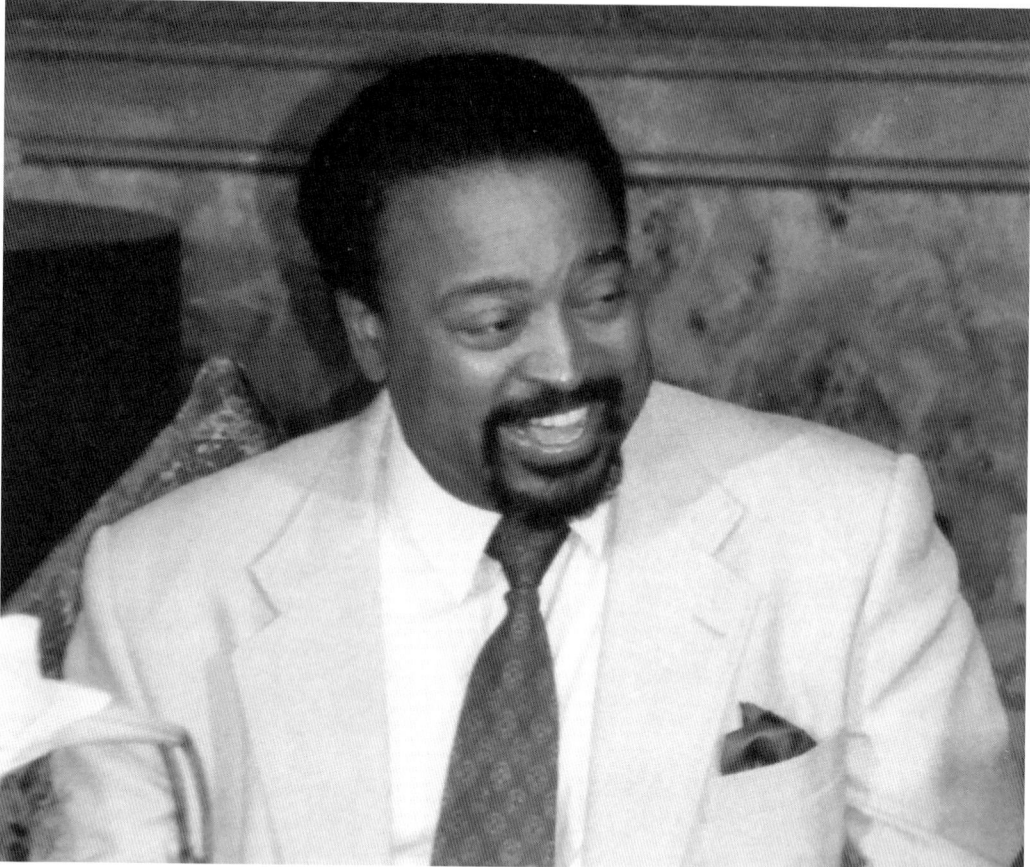

Gene Harris (Eugene Haire)
Gene Harris became a world-renowned jazz musician. At four, he imitated piano melodies he heard while listening to the Charles Metcalf Band practice downstairs from the family's apartment in Benton Harbor. Recognizing young Harris's talent, Metcalf became his mentor, and when Metcalf moved, he gave him his piano. As a teenager, Harris performed on radio and at local venues along with Bill Dowdy and Ohleyer Jones. After playing in the Army, Harris formed The Three Sounds, which performed and recorded from 1956 to 1970. In the 1980s and 1990s, he played with Ray Brown and then with his own quartet. Harris died at age 67 in 2000, while awaiting a kidney transplant. Almost every year, his daughter, jazz singer Niki Haris, comes to Benton Harbor to give a concert in his memory, while his other daughter Beth Haire-Lewis helps organize the concerts and serves as emcee. (Courtesy of the Haire family.)

MONTE BLUE & BETTY BRONSON in "BRASS KNUCKLES"—A Warner Bros Production

Monte Blue (Gerard Montgomery)

Movie star Monte Blue is pictured in the 1927 film *Brass Knuckles*. A handsome man of six feet, three inches, and 225 pounds, he made a dashing appearance when he returned to Benton Harbor after 45 years to participate in the 1960 Grand Floral Parade. Born in Indianapolis, Indiana, in 1887, by 1909, he had moved to Benton Harbor. His first moving picture experience took place on the pier in St. Joseph. According to a May 7, 1960, *News-Palladium* article by Woody Books, he said, "I was wearing a straw hat and carrying a basket full of fish and an old cane pole when I heard a loud cry and saw a man wrestling with a woman. The man threw the woman into the river. I dove in after her and had a difficult time as the current was swift. As I was dragging her ashore, I heard a man yell, 'Get out of there.' I looked up on the old Pere Marquette-railroad tracks and saw a camera crew cranking away. I foolishly climbed up a ladder, picked up my basket of fish and trudged away. I never dreamed at the time of the motion picture future ahead of me." Blue started out as a stunt man. By 1918, he appeared with Mary Pickford in a short film promoting the sale of Liberty War Bonds. He starred as a romantic leading man, playing with Hollywood's top silent stars, including Gloria Swanson, Clara Bow, and Norma Shearer. Blue made a successful transition to talkies. He played character roles as well as cowboy roles that were produced by another famous person from Benton Harbor, Harry Joe Brown. Blue acted in over 200 movie pictures. His television presence included the programs *Wagon Train*, *Wells Fargo*, *Rawhide*, and *The Deputy*. According to the article by Books, the 74-year-old reported that in Western shows he still runs out of saloons but does not jump on his horse. He said, "Nowadays, when I get to my horse, the camera man shifts to a view of a beautiful girl while three men help me on my horse . . . I then yell, 'Come on men, they went that away.'" (Courtesy of www.doctormacro.com.)

Ruth Terry (McMahon)

Ruth Terry is shown in a poster for the 1943 movie *Pistol Packing Mama*. She was born in Benton Harbor in 1920 to parents who encouraged her talents. She sang at the Liberty Theater when she was 10, winning their talent contests again and again, until she was asked not to come back. After the fourth grade, she stopped attending St. John's Catholic School and concentrated on her career, receiving her education from private tutors. Although she appeared in numerous films, she became best known for the Westerns, where she played opposite Robert Livingston, Gene Autry, and Roy Rogers. Terry liked working with Rogers, who joked with the crew and other actors. However, she does not recall that Autry even said good morning to her. (Courtesy of www.doctormacro.com.)

Joseph Marcus

People meeting Joseph Marcus for the first time did not forget him. He had a larger-than-life personality and a love of people. Marcus grew up Jewish and poor on a Benton Harbor farm during the 1920s and 1930s. He recalled the time that a teacher told him and a friend to put their hats and coats on a woodpile, instead of the coat room, saying that Jews were dirty and lice-ridden. He never forgot that incident. It probably contributed to his working for social justice. Marcus volunteered at the Benton Harbor soup kitchen and participated in marches in Benton Harbor, Washington, DC, Lansing, Grand Rapids, and Detroit. He served as a steward and officer of the bargaining committee of United Auto Workers Local No. 383. After retiring from Bendix, where he had worked for 35 years, he entered a new phase of his life. In 1991 he invented a beauty aid called LaMask, and then in 1992 he became an actor. For six years, as a young man living in Chicago, he had performed as a singer and comedian in burlesque shows. In his 70s and 80s, he played a character actor in films like *Hoffa*, *The Gathering*, *Natural Born Killers*, and *Road to Perdition*. He also appeared on television. According to his obituary in the *Chicago Tribune* on June 18, 2006, Diane Rowley, the director of the talent agency Baker and Rowley said, "When I speak about great actors that are a joy to work with, he's always the first one I mention. He had a very unique look, a great look, but more than that he was a great human being." (Courtesy of Michelle Rose Marcus.)

Richard Hunt

In 1995, Richard Hunt, an internationally acclaimed sculptor, became a catalyst in transforming the downtown of Benton Harbor, a victim of urban blight, into a vibrant art center. He opened a studio, a satellite to his Chicago studio, in the midst of decaying buildings. What had been an automobile showroom became a showcase for his inspiring sculpture and stunning collection of African art. Hunt, born in 1935 on Chicago's south side, has always been an innovator. He has embraced abstract art and used unique methods and materials. He welds corten steel, aluminum, copper, bronze, and stainless steel into unique, free-flowing forms to represent nature and human interaction with it. His talent has been richly rewarded. While he was a student, the Museum of Modern Art purchased his sculpture "Arachne." A few years after graduating from the School of the Art Institute of Chicago, he displayed his work at the 1962 Seattle World's Fair, the youngest artist to participate in this major international modern art exhibition. His art is in the collections of major museums, including the Art Institute of Chicago and the Museum of Modern Art, the Metropolitan Museum, and the Whitney Museum in New York. He has been awarded 15 honorary doctorates, as well as numerous awards, including the Lifetime Achievement Award from the International Sculpture Center. Hunt has inspired a new generation of artists by teaching at various universities, including Purdue, Indiana, Illinois, Harvard, Yale, and Cornell Universities. When he opened his studio in Benton Harbor, he offered holographic artist Jesús López an artist-in-residence position. Hunt's artistic creativity is not bound by his age; he does not intend to retire. It is his hobby, as well as his life's work.

In 2015, at 80, he was in the process of beginning or completing five commissions, including one for the National African American Museum of History and Culture in Washington, DC, to add to the over 125 monumental sculptures that now enliven public places throughout the United States as well as Austria and Jerusalem. Locally, Hunt has won admiration for his majestic 48-foot "And You, Seas," a stainless steel sculpture on the St. Joseph site where Lake Michigan and the St. Joseph River meet. The reflection of light off its surface causes this breathtaking sculpture, shaped like a "bird, a fish, a wave," to change color and character with the position of the sun or moon. (Photograph by author.)

Jesús López

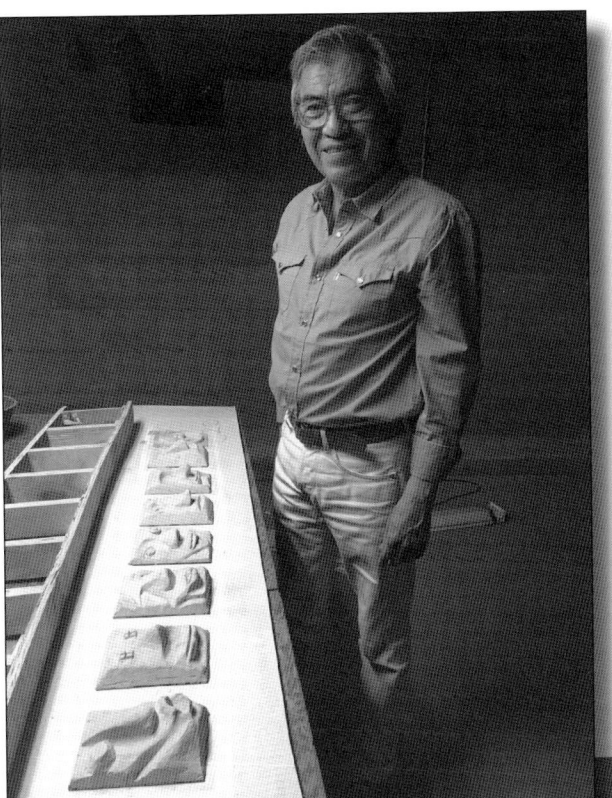

Photonic artist Jesús López came from Mexico to Chicago to study holography at the Art Institute. In 1995, he told a friend he was moving to Benton Harbor. "What? Desolation Row," his friend said. López responded, "I'll build a paradise." As an artist-in-residence at the Richard Hunt Studio, he created his paradise—spacious rooms where he creates breathtaking works of art. The photograph above illustrates one of the steps he uses to create magical holographic images. He strives for perfection. For years he searched for a camera that captured the texture of human skin. He found it in the technique used by Nobel Prize–winning Gabriel Lippmann 100 years ago. Pictured below is the camera "Gabriela" built by López. It is modeled after the one Lippmann used, but López perfected it so that it produces larger images. (Photographs by author.)

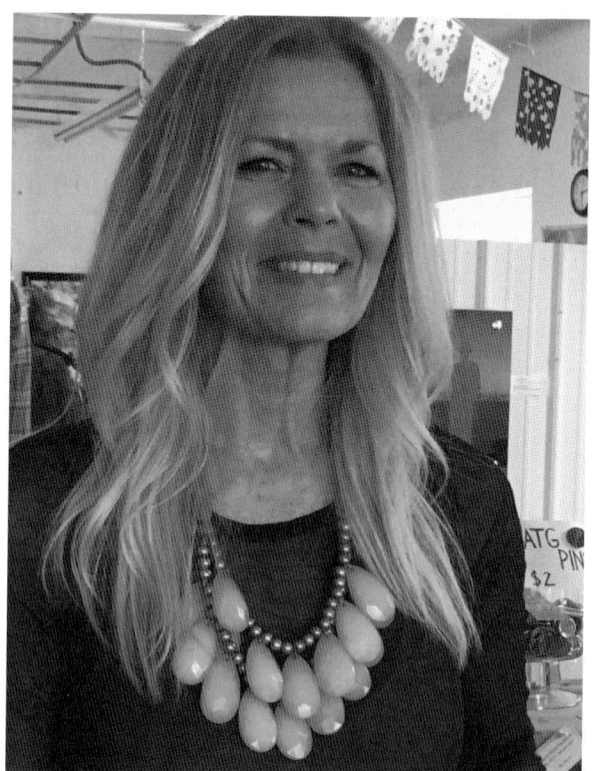

Anna Russo-Sieber

Artist Anna Russo-Sieber believes creativity is for "ALL ages, ALL people, ALL social and economic backgrounds." Russo-Sieber, at the ARS Gallery/Arts and Culture Center in Benton Harbor, organizes art exhibits as well as classes and workshops for children and adults. Through the popular "I am the Greatest" art workshop, she acquaints neighborhood children with Muhammad Ali's life and the principles that guided him toward his dream. (Photograph by author.)

Brad Bigford

Brad Bigford is pictured at his studio at 210 Water Street in Benton Harbor. He has achieved renown for his provocative art, as well as for his talent as a building contractor, where he transforms dilapidated buildings into works of art. He uses a variety of materials in his sculptures—wood, ceramic, steel, castings, and glass. He created the sculpture pictured from wood repurposed from a construction project. (Photograph by author.)

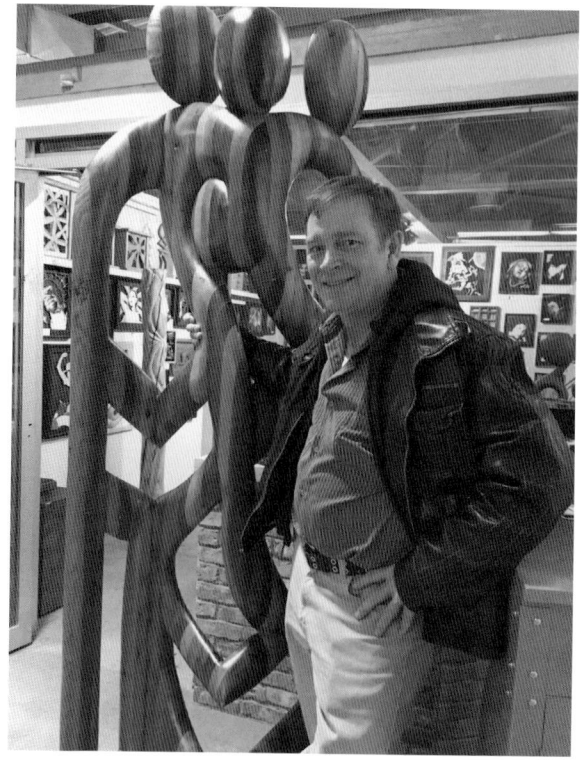

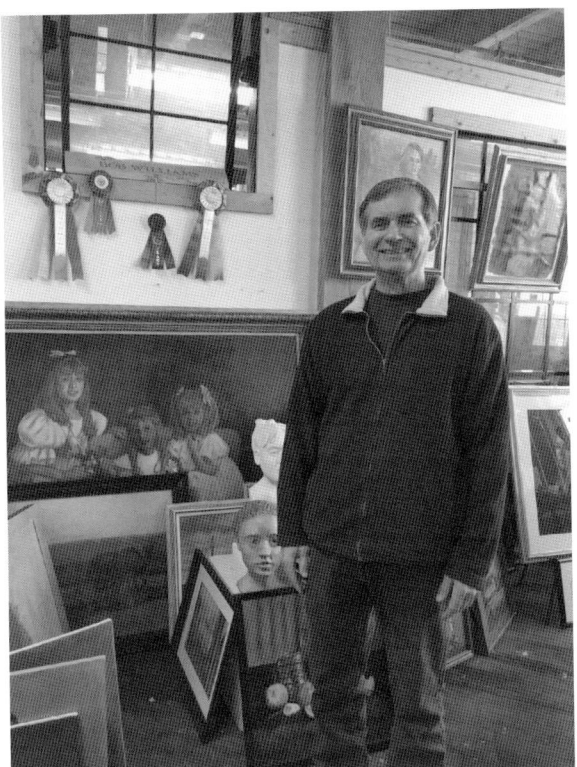

Robert Williams
After retiring as an electrical engineer from Whirlpool Corporation, Robert Williams pursued his passion. He created thousands of portraits at his studio at the Box Factory for the Arts in St. Joseph (an organization he helped establish), art fairs, school anti-bullying programs, workshops, and classes. His unique talent for capturing a person's personality has earned him many awards. (Photograph by author.)

Jerry and Kathy Catania
In 2004, award-winning glass artist Jerry Catania and his wife, Kathy Catania, opened Water Street Glassworks in Benton Harbor's newly formed arts district. For eight years, the couple worked to restore the condemned historic 1898 Hinkley Building to its former splendor. Water Street Glassworks offers classes in various glass techniques for adults and youth, including an after-school glass program called Fired Up! that offers scholarships for local teens. (Photograph by David Knight.)

Doris Hunter and Her Art Class
Every Tuesday this group gathers at the St. Joseph/Lincoln Township Senior Center. Pictured at the far right is teacher Doris Hunter, a volunteer teacher for 18 years. She takes pride in her students, some of whom started creating watercolor art in their 70s. Pictured are, from left to right, Lou Bergman, Helen Brant, Richard Findley, Robert Hatch, Betty Vega, and Doris Hunter. (Photograph by author.)

Marnie Heyn
Renaissance woman Marnie Heyn, librarian at the St. Joseph Library, excels as a poet, fiddler, gardener, artist, gourmet cook, knitter, philosopher, editor, and teacher of music, art, and creative writing. For decades, Heyn, a prizewinning poet who has a doctorate from the University of Iowa, has generously volunteered her services as a teacher of creative writing at St. Paul's Episcopal Church in St. Joseph. (Photograph by author.)

CHAPTER SEVEN

Unsung Heroes and Notorious Criminals

In any community, there are those who stand out because they make life more pleasant for those around them by the force of their personalities. They may not be rich and famous, but they keep things humming and make things happen. They volunteer their time, take on leadership positions in community organizations, are activists, or just brighten the day. The Twin Cities boast many of these people. These unsung heroes have a special charisma that shows through in their energy, humor, or philanthropic spirit.

They include policeman Gottlieb Koch, nicknamed "Cookie the Cop," who played Santa Claus from the late 1930s until 1966, or retired schoolteacher Miriam Pede. Elegantly dressed in period clothes, Pede has enthralled visitors with tours of pioneer Henry Morton's home since 1966.

The heroes mentioned in this chapter follow their passions. Col. Don Alsbro, cofounder and president of Lest We Forget, strives "to preserve, promote and disseminate the memories of the men and women who fought for the freedoms enjoyed by the citizens of the USA." The volunteers at Lest We Forget organize reenactments, teach continuing education classes about the various wars, publish books and CDs that tell the stories of local veterans, and march in parades.

Patty Howell's passion is to spread joy. Her T-shirts, with witty, humorous sayings, bring smiles. She wears a different one every day of the year!

At the other end of the spectrum from the unsung heroes are those who cause havoc in the lives of others, criminals like Al "Scarface" Capone or Fred "Killer" Burke, who behave outside the standards of human decency. Capone was a frequent visitor to the Twin Cities during the Prohibition Era. He often stayed at the Vincent Hotel, where he tipped generously. Another big-shot criminal during that era was Burke, wanted in connection with the St. Valentine's Day Massacre in Chicago. He was tried in the Berrien County Courthouse for another crime, the killing of St. Joseph policeman Charles Skelly. Chriss Lyon, who works behind the scenes as a 911 supervisor in the Berrien County Communications Center, has written about how he was caught and captured in her book *A Killing in Capone's Playground*.

Col. Don Alsbro
Vietnam veteran and Bronze Star recipient Col. Don Alsbro is the cofounder and president of Lest We Forget, a local organization. For the past eight years, Lest We Forget has organized reenactments of battles fought in World War II, the Korean War, and Vietnam. In the heat of the summer, thousands of spectators crowd onto St. Joseph's Tiscornia Beach to experience what it must have been like for the brave soldiers who fought at Normandy and Okinawa. They hold their breath as hundreds of soldiers jump off landing crafts onto the beach. The deafening sound of gunshot and bright red flames of the flame throwers assault their senses. The American soldiers fight hand-to-hand with their enemy, some of them collapsing to the ground. Besides reenactments of World War II battles, Korean and Vietnam battles take place at Southwest Regional Airport in Benton Harbor. When asked how Lest We Forget started, Alsbro explained that in 2002 and 2003, he and Marvin Fuller, Bill Miller, and Dave Ratajik worked with the Berrien County Intermediate School District to produce a series of videotaped stories regarding Word War II, Korean, and Vietnam veterans. Although the award-winning videos were very successful, they wanted to do even more "to preserve, promote and disseminate the memories of the men and women who fought for the freedoms enjoyed by the citizens of the USA." In 2006, Alsbro, Fuller, and Jim Brinkmann founded Lest We Forget. Their motto is "To Brighten the Future We Must Illuminate the Past!" Alsbro, a soft-spoken retired colonel who taught at Lake Michigan College in Benton Harbor, is a whirlwind of activity. He and other committed members of Lest We Forget volunteer their time. They organize reenactments and have published the stories of 250 veterans in three books. They have had a float each year in the Blossomtime Parade, a traveling exhibit, concerts, and programs honoring veterans. They have also taught classes at Lake Michigan College on World War II, the Korean War, the Vietnam War, the Civil War, and modern-day wars. Recently, they have given veterans who are in hospice a certificate of appreciation for their service. One veteran had been lying in bed for days without speaking or moving. When presented with the certificate, she saluted. (Photograph by author.)

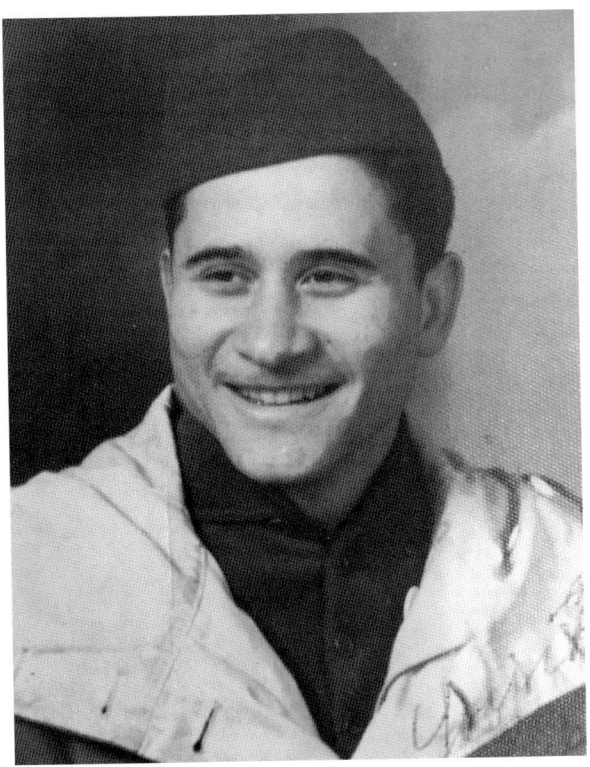

Charles Bassett Brown

Charles Bassett Brown, athlete, war hero, oral surgeon, and community activist, was born in Benton Harbor in 1923 and died in 2012. An expert in facial reconstruction, he helped victims of accidents or gunshot wounds. He educated colleagues by lecturing and publishing articles in professional publications. The people of Southwest Michigan knew he was an excellent oral surgeon, as well as a committed leader who served on several boards and advisory committees. They were not as aware of his role in World War II. At the end of his freshman year at Western Michigan University, he was drafted and served as a medic in the first black combat unit. He received two Bronze Stars. The citation awarding him the Bronze Star for his heroism in Italy on November 13, 1944, states, "Technician Fourth Grade BROWN was required to crawl 600 yards under sniper and machine gun fire to reach the wounded man and drag him back three hundred yards under the same hazards. During the remaining three hundred yards, he was subject to three enemy mortar barrages all of which failed to halt the successful accomplishment of his mission. His bravery and courage inspired all the men of his organization." Despite meritorious service, he was not awarded the position of Second Lieutenant. The reply to the request for promotion was as follows: "In view of the fact that no Tables of Organization vacancies exist to which colored personnel may be assigned, papers are returned with no further action taken." After the war, he returned to Western Michigan, where he played basketball—the first black player to play for the Broncos. His education continued at Fisk University, Meharry Medical College, and Northwestern University. Brown returned to Benton Harbor in 1957. There, he spearheaded the effort to build a swimming pool, tutored teenagers, and sponsored youth outreach programs. As a National Association for the Advancement of Colored People (AACP) life-member, he worked to end school desegregation. He lived the mission "of service, competence, and compassion" he had posted on his office wall. Outside the office, Brown dressed in flashy clothes, danced like Fred Astaire, and drove sharp-looking cars. Roy Shoemaker was a passenger in his blue convertible when he drove it into the river. "I thought he lost his marbles," he said, "but then we started floating." Another friend was treated to a river ride, but the car sank! Brown had forgotten to put in the plug. (Courtesy of Perla Tolentino.)

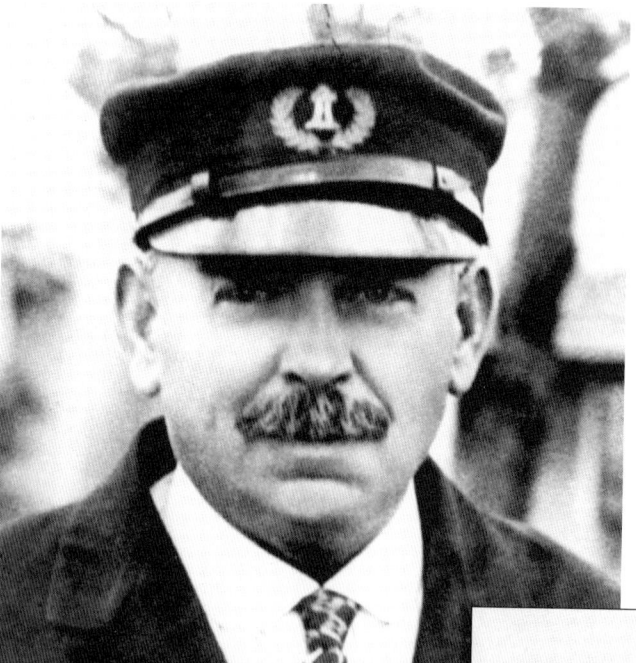

Ferdinand Ollhoff

From 1916 to 1927, lighthouse keeper Ferdinand Ollhoff kept the St. Joseph lighthouse lights burning 24 hours a day. As reported by his son Norbert in an April 16, 1955, *Herald-Palladium* article, "One winter day a storm covered the piers and river with a blanket of ice. I was 6 years old. . . . The blinker light went out on the South Pier. They had to crawl out there. I wondered if I'd ever see my dad again." Another time, when ice froze over the North Pier catwalk, they dug a trench 75 feet long to get to the lighthouse. When fog came, Ollhoff had to stoke the fires that ran the foghorn. Norbert recalls the time the foghorn ran for 30 days. The citizens complained, but the ship captains, no doubt, were grateful. (Both, courtesy of HMCC.)

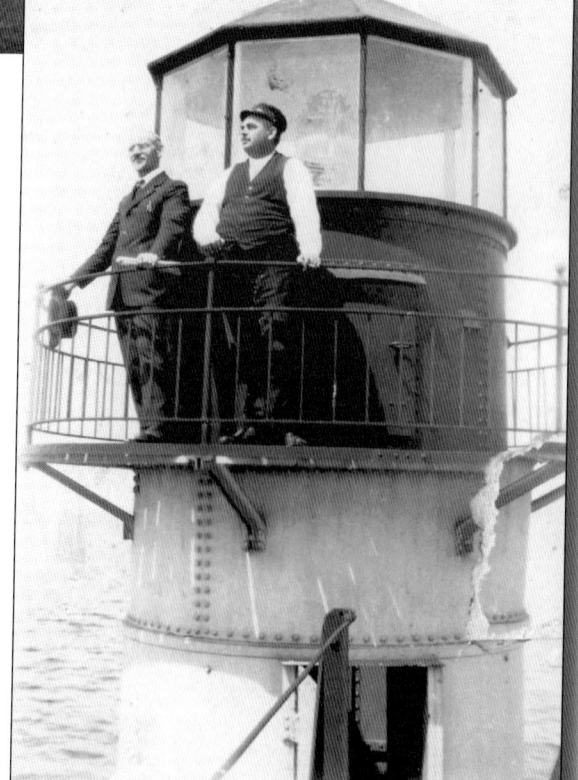

Junius Brutus Woods

Junius Brutus Woods, longtime resident of Benton Harbor, died in Berrien County's poor farm at age 104. Woods was born a slave in East Tennessee in 1803. He was reported to have been a body servant to Colonel Woods in the Black Hawk, Mexican-American, and Civil Wars. In the early 1870s, he came to Berrien County. Robert Brandt, in an August 10, 1968, *Palladium* article, wrote, "Let's not forget that crippled old man, born in slavery, who hobbled about our town on a homemade crutch, selling young maple trees gathered for free in neighboring woods, defying all the handicaps with which he struggles. Here was an ethical old-timer laded with honesty, for the next spring he kept his guarantee that his tree would grow. If it failed, you got another for free." The August 3, 1908, obituary in the *News-Palladium*, although meant to be a tribute to his memory, uses some words that would be not be politically correct today. It says, "Uncle June was typical of that class of southern Negroes known as the 'old plantation darky.' Kind, affectionate and faithful, he was respected by all classes of citizens, and many of the best homes of the city would open their doors to have 'Uncle June' come in and take dinner and tell of the days of long ago." (Courtesy of HMCC; photograph by Lloyd Bishop.)

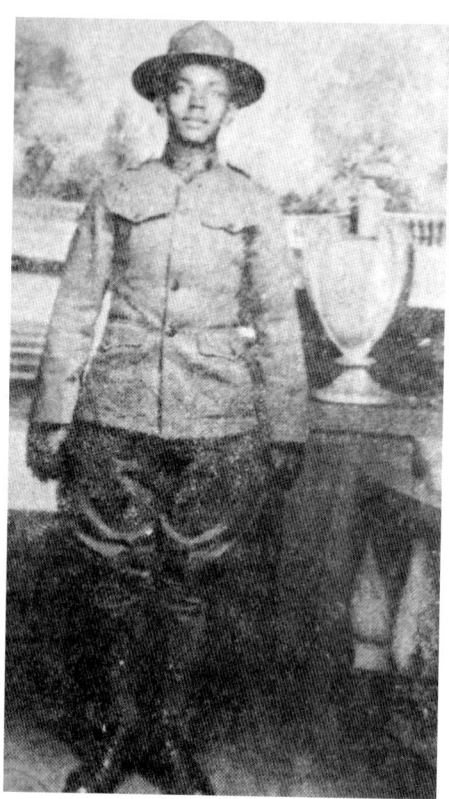

Glen Gaskin
Glen Gaskin served as a regimental sergeant and chef for Gen. John Pershing and his office staff in France during World War I, according to a 1977 *Herald-Palladium* article. Pershing led the American Expeditionary Forces to victory over Germany. Gaskin grew up in Benton Harbor, and his parents operated the Gaskin Hotel. He worked as a Benton Harbor baker and was known for his delicious breads. (*Herald-Palladium.*)

Patty Howell
Patty Howell's T-shirts, with witty, humorous sayings, bring smiles. She wears a different one every day of the year! Howell, who graduated from St. Joseph High School in 1960, acts like a teenager, giggling, laughing, and telling jokes. However, she is serious when competing in golf, tennis, pickleball, bowling, racquetball, and badminton and continues to win prizes and trophies. Indeed, she is fabulous. (Photograph by author.)

Nina Davuluri

Miss America 2014, Nina Davuluri (left) is pictured with Dawn Yarbrough, producer of *Harbor Lights TV*. The community burst with pride when Davuluri won the Miss America contest. "We are so proud of you," the electronic billboard at St. Joseph High School broadcast for many months after she was crowned queen. Davuluri, a 2007 graduate, played the clarinet in the marching and symphony bands, competed in varsity tennis, and was a cheerleader and a member of the National Honor Society. She and her older sister Meena, who was Miss St. Joseph during the annual Blossomtime competition and is now a physician, numbered among the few Indian students to attend St. Joseph High School. A September 17, 2013, *Herald-Palladium* article by John Matuszak mentioned that Nina's high school English teacher Bean Klusendorf used a paper of hers, titled "As Plain as Black and White," as an example of outstanding writing for other students. In the paper, Davuluri, who is Indian American, relates how the parent of a childhood friend broke up their friendship because of prejudice. The friendship was later renewed via Facebook. The prejudice she faced as a child resurfaced in Twitter after she won the Miss America contest. Some people mistook her for a Muslim (she is Hindu) or an Arab American. Nasty remarks such as "Asian or Indian are you kiddin this is america omg," and "[the anniversary of] 9/11 was 4 days ago and she get miss America?" were posted. In response to these remarks, Davuluri said that she would have to rise above that and that she always viewed herself as "first and foremost American." Davuluri takes pride in her Indian heritage. When she visited her grandparents in southeast India during summer vacations, she took Indian dance lessons daily. Despite advice to the contrary, she decided to do a Bollywood dance for the Miss America competition. She danced with the student Indian dance troop at the University of Michigan, where she studied cognitive science and brain studies.

Davuluri moved with her family to St. Joseph when she was 10. After her graduation from high school, her family relocated to New York. Even though she competed for Miss America as Miss New York, she has maintained strong ties to St. Joseph, Michigan. (Photograph by Richard Hensel.)

Ralph Kitron

Ralph Kitron, known as "The Wizard" and "Million Dollar Ralph," never let his bouts with strokes or cancer dampen his enthusiasm for cars or Silver Beach. He started his love affair with cars while he was in high school, becoming a member of the Road Barons Car Club in Benton Harbor. He continued racing cars even though others his age had retired. His passion for Silver Beach Amusement Park started when he was young. He loved the popcorn and cotton candy, dizzying rides, and the organ music of the carousel. He longed to bring back the pleasure he experienced there. While convalescing from a stroke, he built a model of the park he knew as a teenage boy, around 1958. He carefully constructed it of wood, adding tiny figures found on eBay. He gifted this treasure to his soulmate, Connie Yore. When Silver Beach Carousel became a reality, they donated it there. He not only constructed the Silver Beach model but also designed and refurbished other interactive exhibits that surround the carousel. One is the "Great Zandini," a wizard with a full black beard and a gold crown. When one slips a coin into a slot, he delivers a fortune. Kitron worked hard in making the Silver Beach Carousel a reality. However, as their website states, "Ralph's contributions to the Silver Beach Center were a small part of his colorful life. He had three children, three grandchildren and three great-grandchildren. His 'Swamp Fox' nostalgic AA top-fuel dragster was named one of the top 50 hot rods in America. He helped start the Venetian Festival, one of the biggest annual events in St. Joseph. But when asked, Ralph brushed those accomplishments aside and said he was proudest of a promise he kept to his father. When the senior Kitron had a stroke, Ralph cared for him for four years so he wouldn't have to go into an extended care facility. 'When I was 18 years old, I wasn't on the same page as my father,' he said. 'He bailed me out of situations more than once. Those four years were my way of finally showing my gratitude. But it is not what you do or say in life that matters in the end. What matters is what you leave behind that others will enjoy for years to come. That's your legacy.'" (Photograph by Connie Yore.)

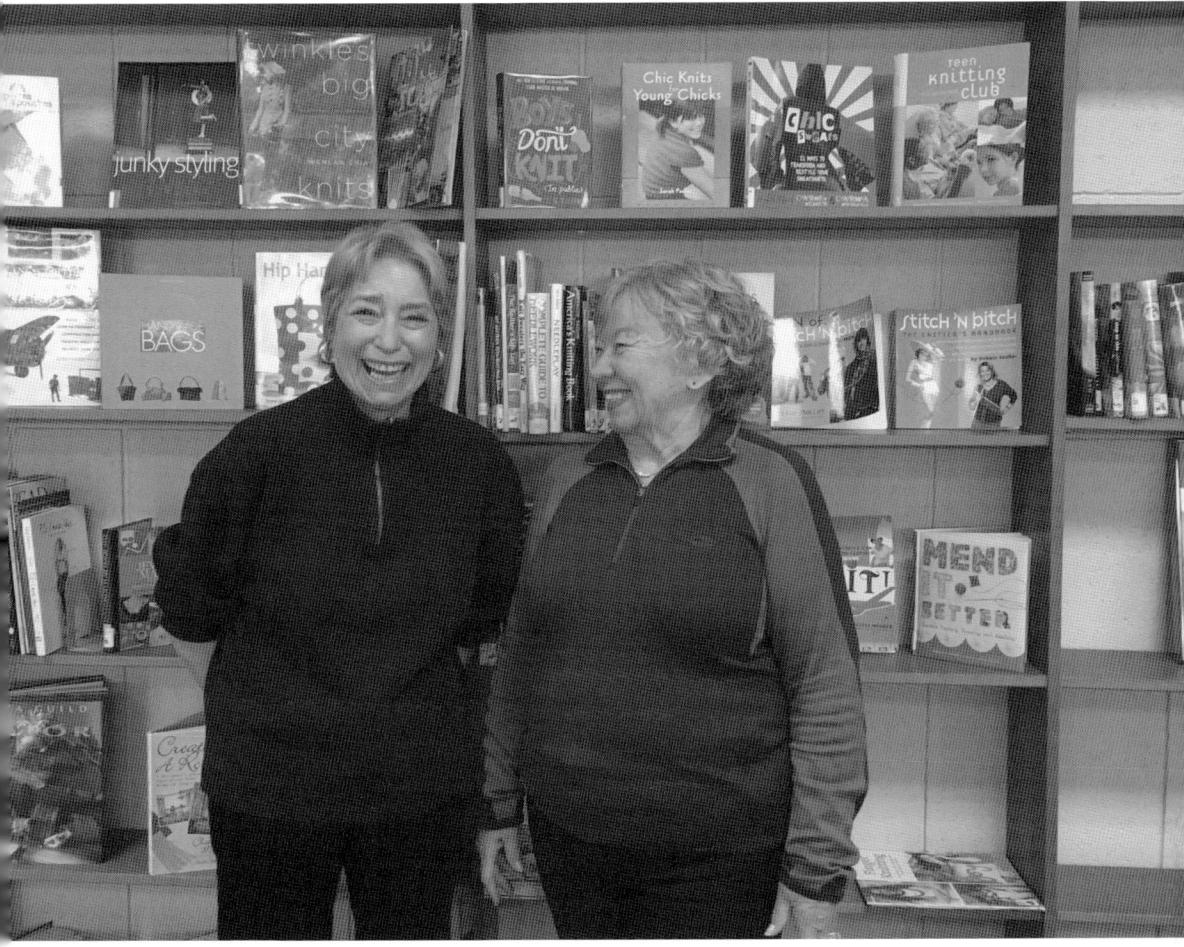

Enid Goldstein and Tiffany Butzbaugh
Enid Goldstein (left) and Tiffany Butzbaugh are working at the Benton Harbor High School Library, which had been padlocked for over two years. The two women, along with 25 other volunteers, transformed it into a place of learning by cleaning out the cobwebs, throwing out the trash and old books, bringing in new books, and organizing a tutoring/mentoring program. They did it with a shoestring budget, even bringing in their own cleaning supplies and brooms. Goldstein, a writer and talk show host, and Butzbaugh, retired librarian at St. Joseph High School, demonstrate what can be done with determination and grit. (Photograph by author.)

Margaret Ogata O'Neill
Margaret O'Neill spent her early childhood in Japanese internment centers in Arizona and Arkansas during World War II. She came to Benton Harbor with her family in 1947. O'Neill helps the community by volunteering at the St. Joseph/Lincoln Township Senior Center, where she serves lunch and teaches the intricacies of line dancing. On Sundays, she sings in the choir at St. Joseph's Peace Lutheran Church. (Photograph by author.)

Isabel Jackson
Talented poet Isabel Jackson of St. Joseph brings out the best of those in her writers' group with her gentle smile, words of encouragement, and love of the art of writing. For many years, she has been volunteering as the leader of the Day Writers' Group at the Box Factory for the Arts in St. Joseph. (Photograph by author.)

Gottlieb Bernard Koch ("Cookie the Cop")

Gottlieb Bernard Koch relished his role as Santa Claus. His jolly manner and sparkling eyes made him a natural. In the late 1930s, while he was serving as Santa's helper, the regular Santa Claus had too much to drink, and Koch took over. He greeted thousands of delighted children in downtown St. Joseph each holiday season until a few years before he died in 1966. Koch was born in Russia in 1893, and he immigrated to St. Joseph in 1901. Like many other Germans from Russia, his family lived below the bluff by the beach, which at that time was the poor section of town. Some in the town referred to the residents there as the "Sand Rabbits." Since the literal pronunciation of Koch's last name in German means cook or baker, he became known as "Cookie." True to his name, he became a baker in the Navy during World War I, and during the 1920s, he opened a bakery store. After he switched to a career as a St. Joseph policeman in 1931, his moniker became "Cookie the Cop." During World War II, he also had a second job as a lifeguard at Waterworks Beach. In addition to his swim trunks, he jauntily wore his sailor hat from World War I. Koch served as a policeman until 1956, and after retirement, he became a meter man. Thus, he continued spreading his good cheer throughout the town. According to his son Donald, Koch was also a great family man. He married Edna Schlutt in 1921. A graduate of Western Michigan Normal College, she taught school for 29 years. Their two sons, William and Donald, also both became educators. Koch enjoyed playing with his sons and was an enthusiastic supporter at all of their games. He also took pleasure in gardening, playing cards, and being active at Trinity Lutheran Church. Donald remembers that when the pastor at the church announced that Gottlieb Koch had died, he received blank looks from many in the congregation. They knew Cookie, but they had never heard his full name. Donald related the following: "That was straightened out shortly. When the funeral procession, over three miles long, went from the church to the cemetery North of Saint Joseph, there was a police officer at every intersection saluting as the procession passed." (Courtesy of HMCC.)

Diane DeFrance

In the early 1870s, Diane DeFrance's paternal great-grandparents, Thomas and Emily Phillips, moved from Ohio to St. Joseph, joining other African Americans who had settled there. Their children are pictured left. In 1967, Diane, her husband Joe, and daughters Deborah and Joy moved from Benton Harbor to St. Joseph. Many of their neighbors welcomed them, yet they also met opposition, including a threat to burn down their house. DeFrance is doing research for a book about the role African Americans played in the development of St. Joseph and Benton Harbor. In addition to her research, DeFrance has spent many years as a volunteer, including serving on the boards of The Heritage Museum and Cultural Center and Morton House Museum. She has also been active in the Union Memorial African Methodist Episcopal Church, the church her great-grandparents, the Phillips, helped found. (Both, courtesy of Diane DeFrance.)

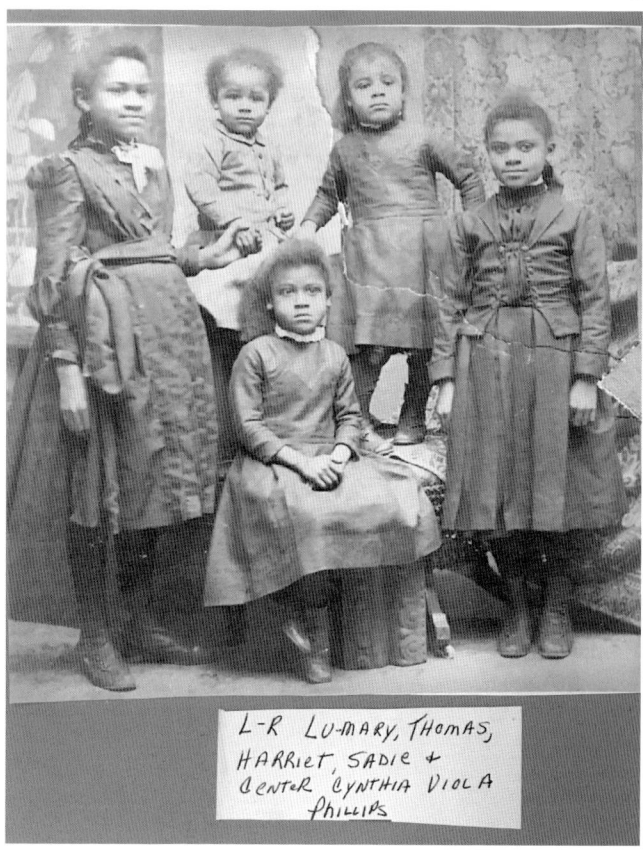

L-R Lu-Mary, Thomas, Harriet, Sadie + Center Cynthia Viola Phillips

Katherine Mitchell
Katherine Mitchell, Diane DeFrance's mother, put her education on hold to marry Don Mitchell and raise her eight children. In 1968, as a grandmother, she graduated high school together with her youngest child, Steven. After attending Lake Michigan College and Western Michigan University, she taught school and wrote poetry. DeFrance reports that her mother's poem about Benton Harbor continues to be requested for high school reunions. (Courtesy of Diane DeFrance.)

Chriss Lyon
Chasing tornados is just one of Chriss Lyon's many interests. She serves as 911 supervisor at the Berrien County Communications Center and authored *A Killing in Capone's Playground: The True Story of the Hunt for the Most Dangerous Man Alive*. Her passion for genealogy, Twin Cities history, and crime in the Midwest makes her in demand as a speaker, consultant, and television commentator. (Courtesy of Chriss Lyon; photograph by Mark Parron.)

Miriam Pede

Since 1966, nonagenarian Miriam Pede has enthralled visitors with guided tours of Benton Harbor's Morton House, the home of the noted pioneer family. After her retirement in 1978 as a St. Joseph High School English teacher, Pede became chairman of 20 guides and joined the board governing the Morton House. She served two terms as president. One of her most memorable experiences was when a Whirlpool employee introduced himself as Henry Morton Toy. His father, who was Stanley Morton's laundryman, had given his children Morton names. (Photograph by author.)

CHAPTER SEVEN: UNSUNG HEROES AND NOTORIOUS CRIMINALS

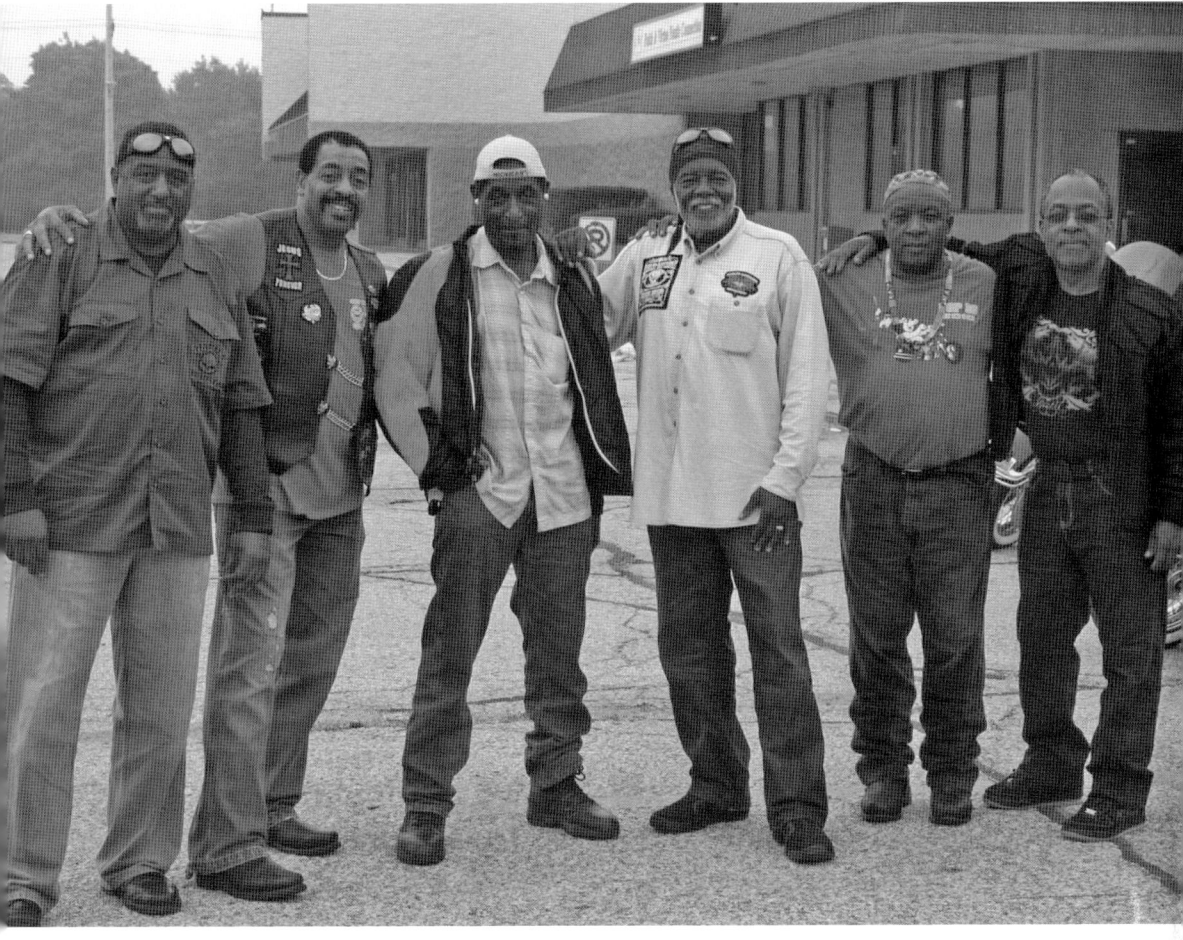

Brothers to the End Motorcycle Group
When customers walk into the dining room of Lark's Bar-B-Que Restaurant in Benton Harbor, they are greeted with a huge photograph of this troop ready to depart on a motorcycle trip to Memphis, Tennessee. The members of Brothers to the End share a "Common Spiritual Belief and Brotherly Bond!" Pictured from left to right are James Stokes, Bishop Eddie Miller, Tony Tisdale, Marvin Raglon, Pastor Willie Lark, and Pastor Ray Massey. Three of the "brothers," Stokes, Raglon, and Pastor Lark, are partners in Lark's Bar-B-Que Restaurant. This Benton Harbor institution was started as Lark & Son's Barbecue and Hand Car Wash by Lark and his father, Napoleon, in 1996. It was located at 440 West Main Street. In 2012, the aforementioned trio purchased property at 174 West Main Street and began the renovation that culminated in the grand opening of the new restaurant in 2013. Under the guidance of kitchen manager Marilyn Lark, Pastor Lark's wife, the restaurant continues serving the same tasty Southern-style foods, along with a heap of friendly Southern-style hospitality. Each of the Brothers to the End have ties to Southwestern Michigan. Stokes is the former owner of Popeye's Restaurants in Benton Harbor, St. Joseph, and Kalamazoo. Raglon, a Whirlpool Corporation retiree, was trustee on the Benton Harbor Receivership Transition Advisory Board (RTAB). Pastor Lark is the spiritual leader at House of Prayer on Eastland Avenue in Benton Harbor. Bishop Miller, who grew up in Buchanan, Michigan, heads Faith Apostolic Ministries in South Bend. Pastor Massey heads New Beginnings Ministries in Niles, Michigan. Tisdale, a native of Benton Harbor, is currently a contractor in Grand Rapids. He has deep connections to Benton Harbor, his hometown, where he makes frequent trips to visit his mother and ride with his Brothers to the End. (Photograph by Marvin Raglon.)

Scott Elliott and Eileen Cropley
Scott Elliott relaxes at his store at Wall Street Antiques in the Benton Harbor Arts District. Elliott and his wife, Eileen Cropley, initiated the development of the arts district. They saw the potential in the Citadel Building, which had stood vacant for three decades. In 1998, the Citadel Building was rededicated as the Citadel Dance Center, where Cropley developed an outstanding dance program. An internationally recognized dancer, she performed as a soloist with the Paul Taylor Dance Company in New York and with Rudolph Nureyev on Broadway. For many years, Elliott has battled government corruption and supported social justice issues. He has rallied for several prisoners who he believes have been wrongfully convicted, including Maurice Carter, who died three months after he was released from prison, and Efren Paredes Jr., a Lakeshore High School honor student who was arrested when he was 15. (Photograph by author.)

CHAPTER SEVEN: UNSUNG HEROES AND NOTORIOUS CRIMINALS

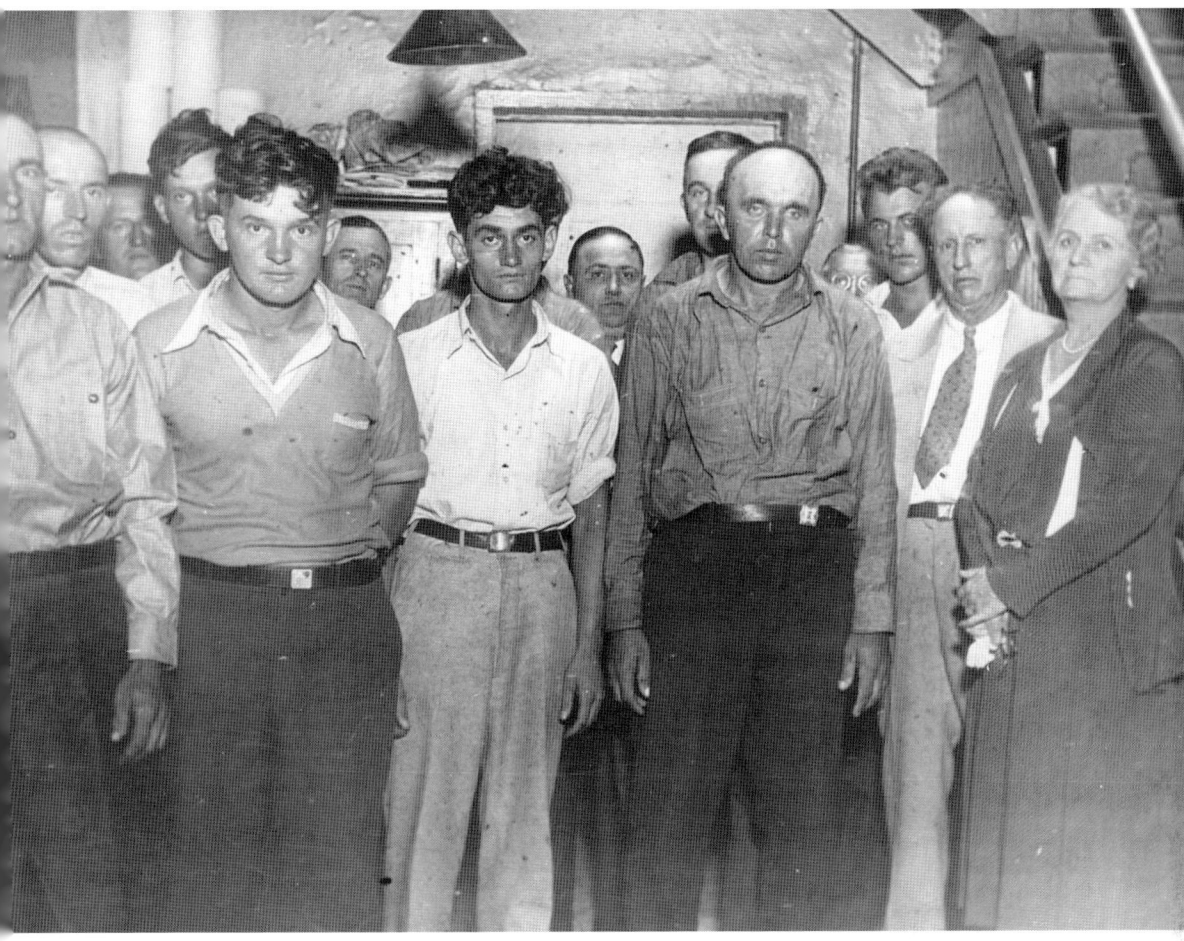

Jane Cutler
Jane Cutler, shown with unidentified men, around 1932, has been the only woman to serve as sheriff of Berrien County. During her administration, she directed the handling of 1,200 prisoners. She was appointed sheriff when her husband Sheriff Fred J. Cutler died in office in 1932. She decided not to seek election at the end of her 11-month term, although hundreds had asked her to do so. According to the articles that appeared in the *News-Palladium*, she was a hands-on kind of sheriff. Cutler and three officers who had machine guns and rifles combed the area looking for seven bandits who had held up a bank in Holland. Although she never captured a criminal, she did get confessions from prisoners that others were unable to obtain, using what she called the "fourth-degree method." The *News-Palladium* described it as follows: "Berrien's sheriff would plead with the unfortunate prisoners in a motherly way just as she would talk with her own children. She brought tears to the eyes of two young prisoners and both confessed to a series of crimes." She also played an important part in arresting women. A compassionate woman, if they were sick, she would nurse them constantly, and according to the *News-Palladium*, she devoted an equal amount of time to the male prisoners. The article states, "Mothers wrote hundreds of letters inquiring about their sons and daughters. Every letter was answered by Mrs. Cutler personally." When she completed her tenure, she said, "It has been a difficult task, but I have enjoyed the work very much. It was only through the splendid cooperation of my deputies and other officials that I was able to carry out the duties of the office. Women can do almost anything now, you know, and I am glad that I accepted the position, although I can advise other women never to run for this office." (Courtesy of Chriss Lyon; photograph by James Huber.)

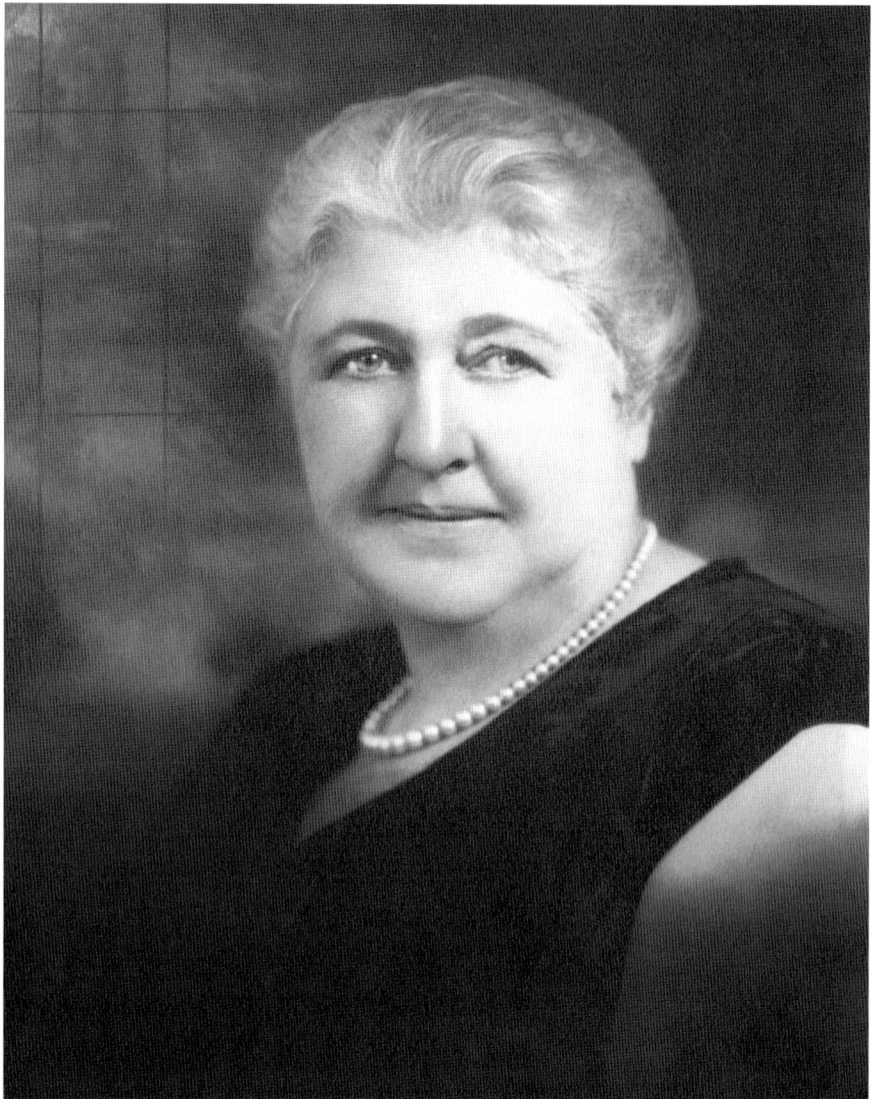

Minerva Olson

St. Joseph resident Minerva Olson was the lone woman amongst the 12 jurors who decided the fate of the Communist William Z. Foster at his trial in April 1923. She became the leader of the six jurors who wanted to acquit Foster. The government authorities arrested him, as well as others, who had attended a meeting in Bridgman of the Communist Party in America. The State of Michigan accused Foster of "criminal syndicalism," defined as "the doctrine advocating crime, sabotage, violence and other unlawful methods of terrorism as a means of accomplishing industrial or political reform." Olson received a handwritten letter from renowned trial lawyer Clarence Darrow shortly after the trial, which after more than 30 hours of deliberation resulted in a hung jury. He said, "Dear Madam I thought I should mail you a line to show appreciation of your action in the Foster jury. I have tried so many cases that I know the courage it takes to stand up against public sentiment Sometime the world will look back at the corrupt and ignorant persecutions as we now look at the cruelty of the witch craft trial and convictions." Olson, a 50-year-old grandmother, wife of the superintendent of an open shop factory, and active suffragist had the chutzpah to stand up for her convictions. (Courtesy of HMCC.)

Al "Scarface" Capone

Al Capone enjoyed his summertime jaunts to Southwestern Michigan. The mob boss, with his signature fedora perched sideways to cover the knife wound he had received in a 1917 fight, became renowned throughout the world. In 1920, when liquor sales became outlawed, he organized a crime syndicate to satisfy the thirst of the nation. He kept at it until 1931, when he was convicted of tax evasion and sent to prison for eight years. The Vincent Hotel in Benton Harbor, where he supposedly leased the eighth floor, was his getaway. In an August 5, 1990, *Herald-Palladium* article by Jim Dalgleish, Fred Sims, a bellboy at the hotel at that time, said, "The elevator, the freight elevator, and the stairway were watched by guards who carried handguns in shoulder holsters under their coats." Sims would get $5 tips from Capone for simply going to the drugstore to get a bottle of ointment. Like many other Chicagoans, Capone enjoyed the mineral baths and frequented those at the Dwan. He and his boys also played golf at the Twin Cities Golf and Aviation Club. A scandal of sorts, covered not only by the local papers but also by the *New York Times*, occurred when Capone and his gang usurped the Rose Room, a room at the Vincent that had been occupied by a group of 25 young women for the purpose of forming the Epsilon Sigma Alpha Sorority. According to the version that the hotel put forth, the women were politely asked if their meeting could take place in another room. According to a 1931 *News-Palladium* article with the headline "Society Ladies Are Peeved at Al Capone," the women were forced to leave, with the musical program unfinished. The article reports, "It is alleged that the entertainers, so carefully selected for the pleasure of the young ladies, were squelched while the Chicagoland baron and his shining haired henchmen made merry to the happy tinkle of ice cubes in tall glasses." To add fire to this story, as reported in the *Chicago Herald and Examiner*, Mayor Stouck of Benton Harbor, just a week before, said this of Capone: "He's a perfect gentleman. I've met him and talked with him. He and his men are peaceful and quiet, and I know our citizens have no objection to his presence." (Photograph by Chicago Bureau Federal Bureau of Investigation.)

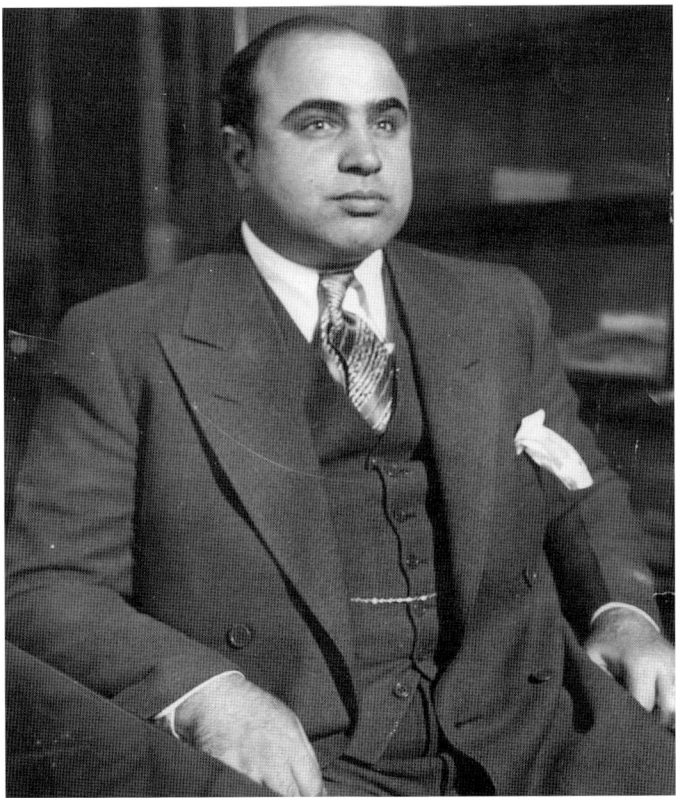

Charles Skelly and Fred "Killer" Burke

On December 14, 1929, while responding to a traffic altercation, 25-year-old St. Joseph policeman Charles Skelly's life was cut short by three bullets fired by Fred "Killer" Burke (seen below). Burke, known in town as Fred Dane, escaped. When the police officers searched his house in Stevensville, they found Burke's fingerprint and two Thompson submachine guns that were linked to the St. Valentine's Day Massacre in Chicago. Burke was wanted in connection to the Valentine's Day Massacre, as well as other crimes. Burke was eventually apprehended in 1931 in Green City, Missouri, and brought to trial in the Berrien County Courthouse for killing Skelly. He pled guilty to second-degree murder. (Left, courtesy of HMCC; right, courtesy of Chriss Lyon.)

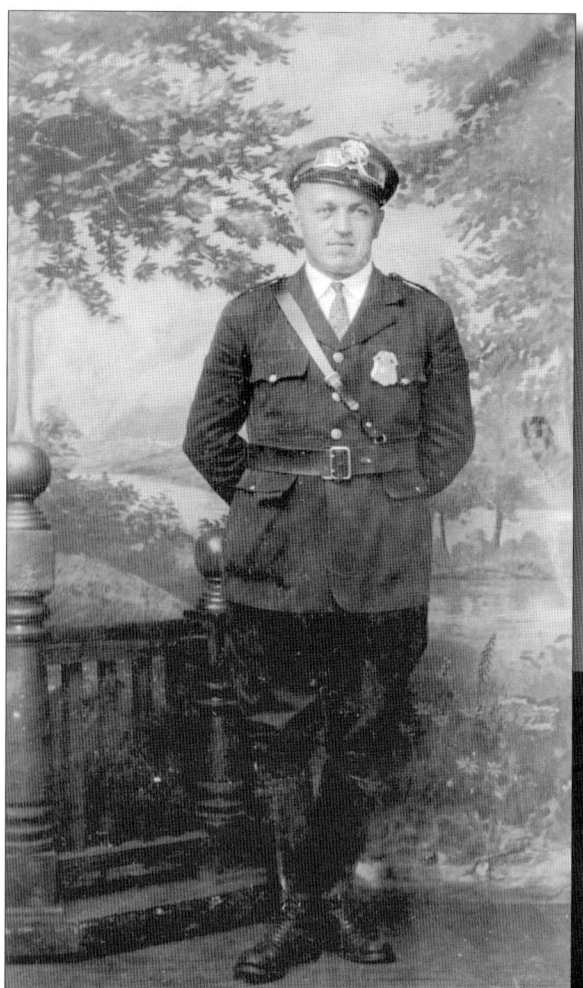

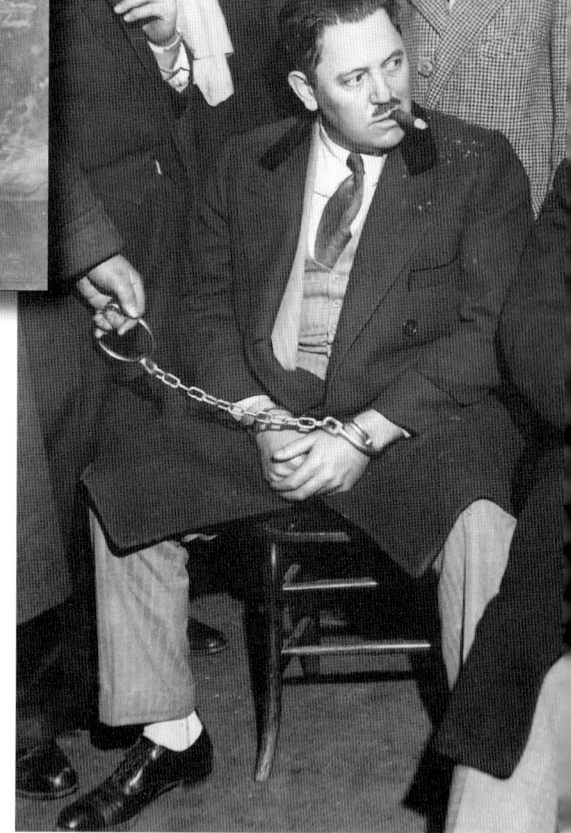

BIBLIOGRAPHY

Atkins, Clare. *Brother Benjamin: A History of the Israelite House of David*. Berrien Springs, MI: Michigan Andrews University Press, 1990.
Benton Harbor: The Metropolis of the Michigan Fruit Belt. M.W. Alder, 1915.
Hatch, Robert. *The Story of Junius Hopkins Hatch, Donor of St. Joseph's Lake Bluff Park and His Descendants*. St. Joseph, MI: self-published, 1994.
History of Berrien & Van Buren Counties, Michigan. Philadelphia, PA: D.W. Ensign & Co., 1880.
The History of Rosback: 1881–1981. Benton Harbor, MI: 1981.
Myers, Robert C. *Greetings from Benton Harbor*. Berrien Springs, MI: Berrien County Historical Association, 2011.
———. *Greetings from St. Joseph*. Berrien Springs, MI: Berrien County Historical Association, 2008.
Coolidge, Judge Orville W. *A Twentieth Century History of Berrien County*. Chicago, IL: The Lewis Publishing Company, 1906.
Portrait and Biographical Record of Berrien and Cass Counties, Michigan. Chicago, IL: Biographical Publishing Co., 1893.
Preston. A.G., Jr. *The Story of St. Joseph*. St. Joseph, MI: The Fort Miami Heritage Society of Michigan, Inc., 1972.
Reber, L. Benj. *The History of St. Joseph*. St. Joseph, MI: St. Joseph Chamber of Commerce, 1925.
Schlender, Daryl T. *Silver Sands and Golden Memories: The History of Silver Beach Amusement Park, St. Joseph*. Benton Harbor, MI: Batson Printing, 2008.
Taylor, R. James. *Mary's City of David*. Benton Harbor, MI: Mary's City of David, 1996.
———. *Portraits: The Face of a Century in Faith, The Israelite House of David, 1903 and the Reorganization by Mary Purnell, 1930*. Benton Harbor, MI: Mary's City of David, 2005.
Vail Rubber Works Celebrating 100 Years! 1904–2004. St. Joseph, MI: Vail Rubber Works, Inc., 2005.
Winslow, Damon A. *History of St. Joseph, Michigan, Containing a General Outline of Events Connected with St. Joseph and the St. Joseph Valley since 1669, Its Early Settlement and Improvement, Its Commerce, and Commencement and Progress of Fruit Growing*. Chicago, IL: Beach & Barnard, 1869.

INDEX

Aber, Edgar, 16, 17
Aber, Susan Haberle, 17
Allen, Robin, 55
Alsbro, Don, 106
Andrews, John, 53
Andrews, George, 53
Andrews, Harriet, 53
Andrews, Helen, 53
Andrews, Leo, 52
Andrews, Stavroula, 53
Andrews, Zacharias, 53
Andrikopoulos, George, 53
Anthony, Helen, 54
Anthony, Howard, 54
Arent, Louis, 95
Argoudelis, Joantha, 53
Arnold, Theodosia
 Falkingham, 25
Bagatini, Adrienne, 94
Bagatini, Ed, 94
Banyon, Stanley, 32, 45
Banyon, W.J., 32
Baushke, Albert, 65
Baushke, Louis, 65
Bean, Col. William Worth, 18
Bell, Clarence "Chic," 71
Bell, George, 28
Bell, John, 28
Bell, Joique, 86
Bigford, Brad, 102
Bigger, Sam, 95
Blue, Monte (Gerard
 Montgomery), 97
Bock, Austin, 59
Bock, Kelsey, 59
Brammall, Edward, 45
Bratzel, G.G., 21
Braybrook, Diane, 79
Brazil, Bobo (Houston
 Harris Sr.), 84, 85
Brinkmann, Jim, 106
Britain, Calvin, 13, 14
Brothers to the End Motorcycle
 Group, 119
Brown, Bassett, 107
Brown, Harry Joe, 97
Brunson, Sterne, 12
Burke, Fred, 124
Burnett, William, 10
Butzbaugh, Tiffany, 113
Byrns, Priscilla Upton, 26
Cabbage, Martha, 95
Capone, Al "Scarface," 123
Carney, Millie, 95
Carter, Maurice, 120
Catania, Jerry, 103
Catania, Kathy, 103
Cavelier, René-Robert, de La
 Salle, 10
Chandler, Wilson, 86
Collins, Dorothy Bell, 28
Collins, Jane Bell, 28
Cooper, Samuel, 49
Cousins, Jayme, 57
Couvelis, James "Babe," 60
Couvelis, Jim, 60
Couvelis, Jennie, 60
Couvelis, Pauline, 60
Couvelis, Steve, 60
Couvelis, William, 60
Cropley, Eileen, 120
Culby, Jill, 90
Cunningham, Wilbur M., 38
Cutler, Fred, 51
Cutler, Jane, 121
Darrow, Clarence, 122
Davuluri, Meena, 111
Davuluri, Nina, 111
DeFrance, Deborah, 116
DeFrance, Diane, 116
DeFrance, Joe, 116
DeFrance, Joy, 116
Dempsey, Jack, 1, 29
Dewhirst, H.T., 64, 68, 69
Dorotheon, Evdokia, 53
Dorotheon, John, 53
Dorotheon, Nick, 53
Dowdy, Bill, 96
Drake, Logan, 77
Dunlap, Sam, 80
Eastman, Harry, 76
Edgcumbe, George, 24
Elliott, Scott, 120
Fead, Louis, 62
Fitzsimmons, Floyd, 81–83
Foster, William Z., 31, 122
Frohbieter, Marge, 95
Fuller, Marvin, 106
Gaskin, Glen, 110
Gerard, Ryan, 56
Gillespie, Bill, 47
Gillespie, Collins, 47
Gillespie, Frank, 47
Gillespie, Helen, 47
Gillespie, Robert, 47
Gillespie, Ruth, 47
Gillespie-Karsten, Kelly, 47
Gillespie-Zimmerman, Amy, 47
Goldstein, Enid, 113
Gore, James, 20
Graham, John, 15
Gray, Eleanor, 25
Gray, Elisha "Bud," 42
Gray, Humphrey S., 31
Gray, Lumen, 31
Gray, Martha, 31
Green, Martin, 12
Gust, Alex, 53
Hackley, Bow, 88
Hahne, Esther, 95
Haire-Lewis, Beth, 96
Hanley, Joseph "Bill," 44
Hanley, William M., 44
Hannaford, Joseph, 70
Haris, Niki, 96
Harris, Gene (Eugene
 Haire), 96
Hatch, Edward, 14
Hatch, Junius, 13, 14
Hatch, Junius II, 14
Heath, Edward, 54
Hensel, Richard, 36
Herring, Augustus, 40
Heyn, Marnie, 104
Hornbeck, Estelle, 68
Hornbeck, Mabel, 68
Howard, John E.N., 95
Howell, Patty, 110
Hunt, Richard, 100, 101
Hunter, Doris, 104
Jackson, Isabel, 114

Jones, Ohleyer, 96
Keller, Imogene, 95
King, Benjamin Franklin, Jr., 88
Kirshenbaum, Jerry, 90
Kitron, Ralph, 112
Klock, Carrie, 32
Klock, John, 32
Koch, Donald, 115
Koch, Edna Schlutt, 115
Koch, Gottlieb "Cookie the Cop," 115
Koch, William, 115
Koehler, Diane, 55
Krasl, Olga, 36
Krasl, George, 36
Kreiger, Earl, 95
La Salle, 10
Lark, Marilyn, 119
Lark, Napoleon, 119
Lark, Willie, 119
Lieberg, Sylvia, 74
López, Jesús, 100, 101
Lyon, Chriss, 117
Lyon, Lucius, 13, 14
Marcus, Joseph, 99
Martinez, Abel Abarca, 57
Massey, Ray, 119
McCord, Seely, 93
Metcalf, Charles, 96
Miller, Cheryl, 50
Miller, Eddie, 119
Miller, Phyllis, 50
Miller, Stanley, 50
Miller, Walter, 50
Miller, Victor, 50
Misfits, 95
Miske, Billy, 2, 81–83
Mitchell, Don, 117
Mitchell, Jackie, 72
Mitchell, Katherine, 117
Monteith, Glenda, 95
Moody, Pat, 35
Mooney, Cora, 66
Mooney, Paul, 66
Mooney, Silas, 66
Morton, Eleazar, 11
Morton, Joanna, 11
Morton, Henry, 12
Morton, James Stanley, 15
Moulas, Christos, 23
Moulas, Demetra, 23
Moulas, Evangeline, 23
Moulas, Patty, 23

Moulas, Vasiliki, 23
Moutsatson, John, 55
Nelson, Chuck, 79
Nozicka, Joan, 95
O'Hara, Barratt, 34
Ollhoff, Ferdinand, 108
Olson, Minerva, 122
O'Neill, Margaret Ogata, 114
OutCenter, 36
Palenske, Fred, 37
Palenske, Maud Preston, 37
Paredes, Efren, Jr., 120
Paul, Edna, 95
Pearl, Phineas, 14
Pede, Miriam, 118
Phillips, Emily, 116
Phillips, Thomas, 116
Pritchard, Isabella, 62
Prushak, Emil, 50
Purnell, Benjamin Franklin, 1, 62–64, 68, 69
Purnell, Coy, 63
Purnell, Hettie, 63
Purnell, Mary, 1, 62–64, 69
Raglon, Marvin, 119
Ratajik, Dave, 106
Ricaby, Mary Bell, 28
Reihle, Beulah, 95
Rosback, F.P., 41
Rosetta, Frank, 67
Russo-Sieber, Anna, 102
Ruth, Rodney "Rod" Seely, 93
Ruth, Will, 93
Saltzman, W.E., 78
Savoldi, "Jumping Joe," 85
Sarett, Lew, 89
Sarett, Lewis Hastings, 89
Sarett, Margaret, 89
Schadler, Jay, 92
Schwarz, Joseph, 22
Schwarz, Anneliese, 22
Schwendener, Hattie, 27
Sims, Fred, 123
Skelly, Charles, 124
Souliotis, Margie, 53, 55
Stockdale, Helen Osgood Sarett, 89
Stokes, James, 119
Taber, R.B., 27
Tamim, Steven Moustapha, 57
Taylor, Frederick, 74
Taylor, Frieda Jonas, 74
Taylor, James "Ron," 74

Taylor, Robert, 74
Terrill, Horace "Chief," 78
Terrill, Roberta "Bobby," 78
Terry, Ruth (McMahon), 98
Thorpe, Francis, 64
Tiscornia, Bernice, 46
Tiscornia, James, 46
Tiscornia, Lester, 46
Tiscornia, Waldo, 46
Tisdale, Tony, 119
Tobias, Princella, 91
Toy, Henry Morton, 118
Truscott, Edward, 48
Truscott, Henry, 48
Truscott, James, 48
Truscott, Thomas, 48
Tucker, John, 73
Tutton, Harry V., 29
Upton, David, 43
Upton, Emory, 42
Upton, Fred, 34
Upton, Frederick, 43
Upton, Kate, 43
Upton, Louis, 42
Upton, Margaret, 43
Upton, Stephen, 43
Uzelac, Elliot, 81
Vail, William, 44
Vawter, Elizabeth Upton, 89
Vawter, William, 89
Wallace, Louis, 77
Wells, Abel, 49
Wells, J. Ogden, 49
Whitney, Dora, 30
Whitney, Eleanor, 25
Whitney, Harris, 30
Williams, Robert, 103
Wims, Henry, 45
Womer, Betty, 58
Womer, Bill, 58
Wood, Carol Upton, 43
Woods, Junius Brutus, 109
Woodworth, Manna, 72
Wyland, Frank, 68
Yarbrough, Dawn, 111
Yore, Connie, 58, 112
Yore, Michael, 58
Yore, Patrick, 18

AN IMPRINT OF ARCADIA PUBLISHING

Find more books like this at
www.legendarylocals.com

Discover more local and regional history books at
www.arcadiapublishing.com

Consistent with our mission to preserve history on a local level, this book was printed in South Carolina on American-made paper and manufactured entirely in the United States. Products carrying the accredited Forest Stewardship Council (FSC) label are printed on 100 percent FSC-certified paper.